ARTY PARTIES

For Nana, who lived life in anticipation of the next party, and who went to sleep only to dream of tomorrow's breakfast. Whoop-de-doo! This one's for you.

ARTY

An Entertaining Cookbook
from the Creator of Salad for President

PARTIES

Written and photographed by
Julia Sherman

Select art by Daniel Gordon

Abrams, New York

Contents

Foreword

HANNAH GOLDFIELD,
FOOD CRITIC FOR *THE NEW YORKER*

In my capacity as a food critic, I've been to hundreds of world-class restaurants. For as long as I've known Julia, I've joked that her house is my favorite of them all. I can recall the beautiful meals I've eaten there with eerie precision. Perfectly seasoned pistachio butter, smeared on crusty sourdough toast, sprinkled with shredded root vegetables and fried capers, and served with rosy-fleshed seared duck breast. Crisp, lacy *socca*, a.k.a. chickpea-flour pancakes, topped with a salad of homegrown arugula, thinly sliced apple, and ribbons of celery. Tempura-fried smelt as the crown jewels of Japanese-inspired rice bowls, offset by fermented peppers and dollops of *yuzu kosho* whipped with Kewpie mayonnaise.

But when I stopped to really think about it, I realized that the pleasure of eating at Julia's is not only about the wonderful food—she's an incredible, intuitive cook—and the enviable interior design—an optimally eclectic mix of art, textiles, tiles, and tableware. Great restaurants have those things in spades. What Julia offers that they don't is a marked disinterest in, and even disdain for, pomp and circumstance. Julia likes to get messy; Julia knows that's where the magic lies. Julia doesn't stand on ceremony. (She hosted a recurrent pop-up called "Fuck Brunch.") When she lived in Brooklyn, her front door opened directly into her kitchen, where the island was invariably covered in a jumble of unidentifiable exotic fruit, bottles, jars, and dishcloths, each a conversation piece in their own right.

Perhaps the best part of being Julia's guest, what sets Chez Julia apart, is the invitation to dive headlong into her process, to be pulled along for the ride. When she throws a dinner party, it's not unusual to find people milling about, dressing their own portions of heirloom beans or making their own experimental tacos, and maybe never even sitting down. The night we ate the rice bowls, it was my job to remove the smelt from the pan and fling them onto the previous day's New York Times to absorb excess oil. (It was especially satisfying to slap fish onto Donald Trump's face.)

The pistachio butter—made in homage to a memorable meal Julia once had at a restaurant in Paris—wasn't finished when I arrived the day she served it for lunch. "Taste this?" she said as she handed me a spoon and gestured toward her food processor. "What do you think of the texture?" When it was time to eat, she pushed aside a stack of books and papers on her glass dining table to make room for our plates and for her then-infant daughter, placid in her bouncer chair, which Julia simply incorporated into the tablescape. And the fun was far from over after we'd finished eating. Julia and I were both on maternity leave, so, naturally, she had decided that we should make beeswax candles in the shape of our newborns' feet.

This sounded, to me, like an impossible task, requiring some sort of technical certification, but before I could express reluctance, Julia was ripping open a bag of powdered alginate and mixing it with water. She transferred the creamy concoction to a small plastic pint container and then plunged my sleeping son's foot into the goop; within seconds, it had set around his tiny toes to create a soft rubbery mold, which we then filled with melted beeswax that had been simmering on the stove. It took a few tries to get it right, but Julia resisted frustration and reveled in the trial and error. In the absence of wicks, which she hadn't been able to obtain in time, she declared our would-be candles to be sculptures, instead. The adorable, if ever so slightly creepy, honey-colored disembodied foot immediately took place of pride on my mantle.

My biggest revelation about Chez Julia, though, is that it's not so much a place as it is a state of mind. One day, after, I'm embarrassed to say, years of being friends, I tentatively invited her to have lunch at my place for the first time. Like many of Julia's nearest and dearest, I found the idea of hosting the ultimate host to be more than a little intimidating. I didn't have anything exciting to serve. Or so I thought. When Julia arrived, she immediately got to scouring my refrigerator and kitchen shelves, plucking jars and tins from dusty, long forgotten corners. She grabbed a ceramic serving tray that I had possibly never used before, and together we composed a beautiful salad: something like a niçoise featuring thick slices of tomato, olives, and hard-boiled eggs, drizzled in olive oil, vinegar, and a wedge of lemon I'd forgotten I saved in the fridge, plus a healthy sprinkling of flaky sea salt.

It was delightful, and it was eye-opening. I've never looked at my kitchen, or myself, the same way. She might have done more than half of the meal prep but I felt as empowered and capable as Martha Stewart—yet infinitely more laid back. And this point is key; Julia is wildly creative, and ambitious, but she is never

aiming for perfection. What makes her a truly successful host is her willingness to fail. Case in point: A couple of summers ago, she decided to throw a Labor Day tie-dye-your-whites party, for which she would make the dye herself out of carefully hoarded leftover kitchen scraps—hibiscus leaves, avocado pits, and onion skins. She had never tried it before but wasn't self-conscious about experimenting in front of a few dozen friends who would trickle in and out of her backyard throughout the day. After steeping her gathered ingredients in enormous stockpots of boiling water, she arranged the finished dyes on her patio so that people could rubber-band and dip their whites, while warning gaily that she wasn't exactly sure what she was doing.

The avocado pits turned my old white shirt a shade of muddy brown that faded almost completely after it dried in the sun. The hibiscus-pink disappeared from my white dishcloth the first time I washed it. But the fact that the activity didn't go according to plan did not remotely detract from the fun. It only enhanced it, turning the afternoon into a sort of madcap (and extremely low-stakes) disaster, with Julia laughing the loudest. The lesson couldn't have been clearer: Your guests can only be as relaxed as you are. Your guests will have as much fun as you do. Give them, and yourself, that gift, and let this book be your guide.

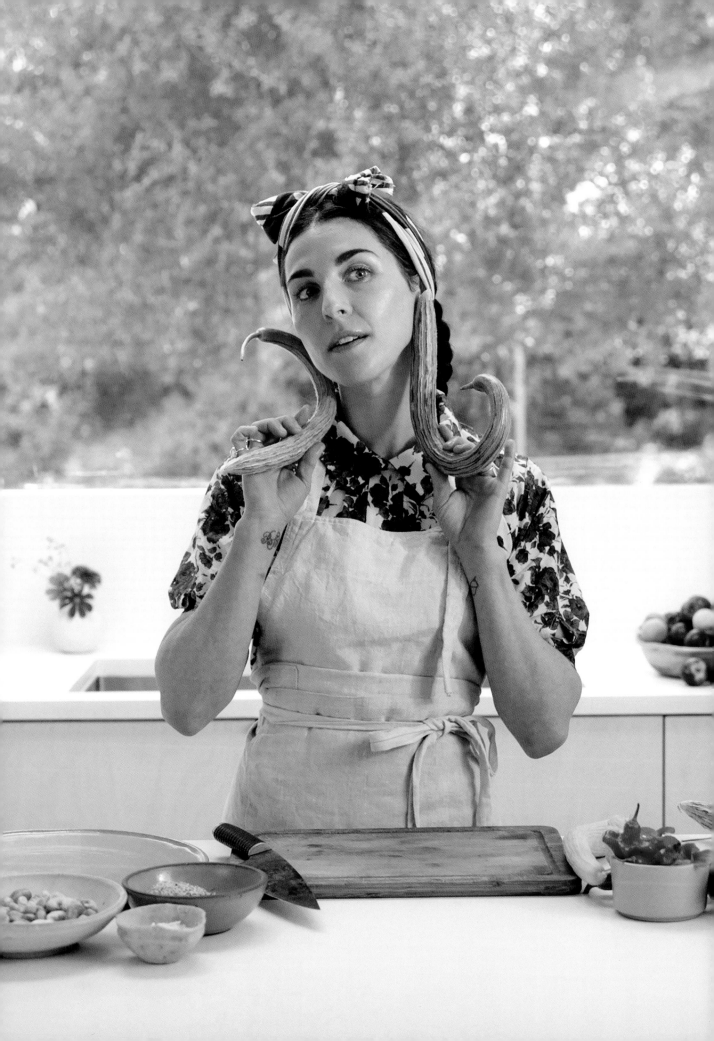

Introduction

I am a professional cook, but at the most memorable dinner I have ever hosted the food was of no consequence at all.

The best party I have ever thrown took place the night before my daughter, Red, was born. We had gone long on the "natural birth" plan. We had the doula and the midwife, the hospital bag packed with battery-operated candles, matching vintage "No Fear" T-shirts, and labor-inducing essential oils. (My husband had even designed handicraft stations to entertain me between contractions.) But pre-labor complications left us no choice but to schedule a C-section. Disappointment aside, I had found myself in the most unnerving position imaginable—we knew at precisely what time our lives would change forever. How would we endure the nerve-racking night before?!

True to form, I turned to the thing that puts me most at ease: a big, messy party. I pride myself on my ability to feed people healthier, tastier, higher-quality food from my home kitchen than they can get at most restaurants. For me, having people over, day or night, is a release valve for an excess of creative steam; it's an excuse to seek out rarefied ingredients, to pillage the greenmarket and spend the day (or two, or three) cooking. So, I invited my closest friends to toss their coats on the bed, to crowd around our kitchen island, to open all of the bottles of wine at once, and to use every glass and mug we owned. We hosted a "C-section party."

Photograph by Christopher Gill.

But with a major surgery slated for 6 A.M. (and a year of sleep deprivation in my future), I knew better than to go down the rabbit hole of cooking for thirty friends. So, we did the unthinkable: We ordered pizza, and it didn't suck. OK, I'll admit, in the end I complemented the tower of pies with a generous heap of fresh arugula with lemon and Parmesan. (I live and die for salad pizza.) But that's all, folks!

To my surprise, my friends were tickled to be eating takeout at my house, where the food is usually so demanding of my focus. This time was different—I was leaning on them. They brought the wine, the sides, and a profound sense of community. It can be easy for a serial host to forget: The only thing more satisfying than being catered to is the pleasure of making a meaningful contribution. As people milled about, gabbing with the characters they'd met in my kitchen so many times before, the energy in the room was through the roof. No matter the menu, the spirit of the night was too big to fail. I'm not sure I have ever enjoyed a party of my own so much.

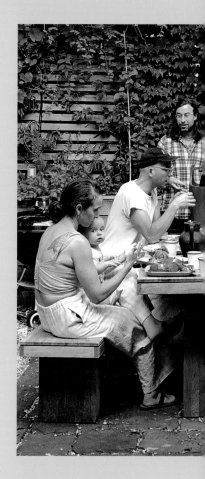

A lobster cookout (bibs included), in my Brooklyn backyard.

GETTING DIRTY IS PART OF THE FUN.

This book is an homage to process.

As anyone who knows me can attest, I am a tornado in the kitchen. I spend my time creating occasions for people to come together and spill things on my couch. I don't live for the big reveal, I live for the planning, the brainstorming, the research, and the thrill of new ideas. The performance of ease is quite beside the point. That book has been written time and time again, yet people are more intimidated than ever to assume the role

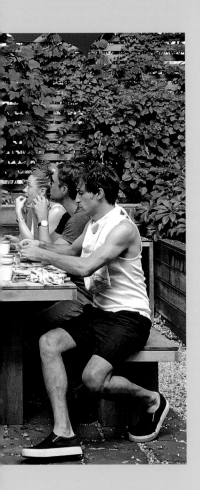

A family-style garden party at my Brooklyn home in 2018. Photograph by Emily Wren.

of host. Have filtered images of domestic life on social media made the thought of pulling back the curtain on reality too raw to bear? Maybe it's no different now than it was in the fifties, rustic linens and hand-thrown ceramics stand-ins for passed hors d'oeuvres and a well-appointed bar cart. But in the face of this virtual performance of Boho perfection, my experience shows that entropy does not wait for any hostess. There's an art to putting it all together, but there is also art in letting go.

My mother, a visual artist who raised me in her studio, gave me a mantra: Getting dirty is part of the fun. It stuck with me. Indeed, entertaining requires more effort and more cleanup than eating out ever will. But this is the calculation, as I see it: You can spend fifty dollars on a restaurant meal that you will surely forget; or you can spend less to eat at home, where the food is both sustenance and entertainment. With a pittance you can host a pancake breakfast for six friends. But don't attempt to do it all yourself; where's the fun in that? You can make the world's best, healthiest pancake batter (I have a recipe for that; see page 76) and punt it to your friends to bring the toppings. Let them cook their own breakfast to order. By letting them take a turn behind your range, you might pick up a technique for flipping flapjacks or discover a novel topping that makes it into your regular rotation. In this way, you reframe entertaining not as extra work, but as a space for personal growth. You tip the dominos to initiate a ripple of infinite exchange. It's low risk, high reward—a gift to friends and, most important, a gift to yourself.

TAG, YOU'RE IT.

I would like to believe that everything I put out into the universe will come back to me tenfold. But if that's the case, I have to wonder at the infrequency with which I am invited to other people's homes. I started this book by interviewing those of my friends who have never had me over for tea, for lunch, or for a holiday meal (there are more than I would like to count) to address a gaping hole in my own social life: reciprocity. Sure, it sounds confrontational, but I was as open to critique as I was to confessions of fear and anxiety. It was really helpful, like pro-bono behavioral therapy.

Here are some conclusions, based on my (light) investigative reporting:

In 2018, I hosted a party at Ceramica Suro, a family-run ceramics and fine art production studio in Guadalajara, Mexico. Local artists were invited to paint plates, and the following day we had a potluck, serving ceviche and tacos off these functional works of art, hot out of the kiln.

- **Don't put the food under a microscope.** As a food professional, I have a habit of turning to my guests to workshop my recipes. "You critique the food you make because it's your work," my friend, illustrator Joana Avillez, told me, "but at the same time, you really know what you do and don't like, so I worry you would find faults in my cooking, too." If you ever want to take a night off and have someone else cook for you again, let go of culinary perfection. The food should be as delicious as you can make it, and that's good enough (luckily, you hold nearly one hundred approachable recipes in the palms of your hands right now).

- **Sit when you're dead.** Most people's dining tables seat four or fewer. I've eaten dinner blissfully perched on the edge of a friend's bed, and I have never looked back on those

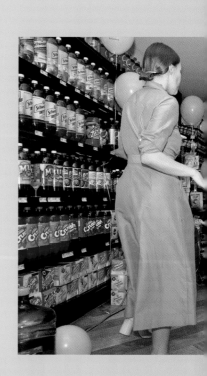

nights and wished there had been a more well-appointed table. If you never have a sit-down dinner party again, you will be better off for it. (Or, take a cue from chapter 1 and find a way to make your own table, a conversation piece better than any that money could buy.)

- **Space is a concept.** The most common excuse I hear is that people's apartments are too simple and cramped to properly host. Ever been to a party in a huge room? It sucks. Parties in small spaces are buzzy and fun. It should go without saying that anyone who cares about the floorplan of your apartment doesn't deserve to be your guest. But, of course, there are countless reasons why one might not feel comfortable hosting in one's home (aggressive pets, acerbic roommates, black mold). Who said we had to go to yours, anyway? I've been invited to unforgettable gatherings in public parks, potluck picnics at the tops of hiking trails, and lunches at artists' studios. The world is your dining room.

My 2017 book launch at my local Key Foods supermarket. Guests ate and drank, danced in the snack aisles, and donated food to the non-profit Wellness in the Schools. Photography by Laura June Kirsch.

- **Optimize for leftovers.** My friend, artist Pooneh Maghazehe, is a knockout home cook, but in the eight years that we have been tight, I have never been to her house. Not even for a snack. When I finally asked her why, she told me a harrowing tale of preteen rejection. "I love to cook, but being Persian, I am pro-grammed to make an overabundance of food. At the same time, I am afraid nobody will show up to eat it," she explained. "I am haunted by my sixth-grade birthday party. Nobody came, and all that food became a visual representa-tion of rejection." Whoa. That's a lot to unpack.

Rejection is real! But who said you had to invite the entire sixth-grade class to dinner? Start small, invite your best friend over for tea and a delightful nosh—that's hosting, you're doing it! And, in an attempt to chip away at legitimate anxiety around food waste, the recipes in this book are coded to flag those that will taste even better the next day. Your next failed birthday party could be a boon for the coming week's meal planning.

WHAT'S SO GREAT ABOUT ARTISTS' PARTIES?

If there's one thing I know, it's that artists throw superior parties. Whether it's a dance party in a warehouse, a food-based performance, or an imaginative take on a national holiday, artists cultivate a sense of discovery in the everyday. They draw outside the lines, choose character over perfection, and most importantly, they actually enjoy the process of feeding their friends.

An artist finds contagious wonder in everything from the architecture of a salad to the alchemy of a complex soup. For myself and for the people featured in this book, there are no rules, only guiding lights and deeply personal recipes for how to tangle family, friends, or utter strangers into a net with food, drink, and twinkling ambience. An invitation to dinner is a passport to another dimension, where store-bought "good taste" is of little-to-no importance. Forget the rules around classical floral arranging, or the right way to set a table. Let's make it up as we go along.

LET'S COOK.

Every meal is an opportunity, a chance to make something, anything! Your bronze sculpture will outlive us all, but the lentils you overcooked? Here today, gone tomorrow. No matter how good or how bad, you can't take it with you. There's always another meal that needs planning.

Having had the pleasure of watching you cook through my first book, I was newly determined to dream up easy-to-follow recipes that celebrate inventive flavor combinations over technical gymnastics. I, too, flip to the next page when an ingredient list reads as a public decree. I've tried to take that with me into the long, delicious process of developing these recipes designed to feed a group but flexible enough to work for two.

This book is inclusive; it encourages and demystifies. I champion ingredients like cabbage, celery, and canned sardines, making them the raison d'être of the meal—an unlikely centerpiece, easy on the budget, and impressively resourceful. I offer recipes, but also nuggets of practical information and techniques—novel ways to slice, peel, infuse, and preserve, spendthrift ways to use ingredients one might otherwise discard (a particular passion of mine).

Veggie piñata smashing at my annual Artists' Tag Sale at Night Gallery in L.A. in 2018. Contemporary artists were invited to sell their work for fifty dollars or less. Piñata by Amanda Benevides.

15

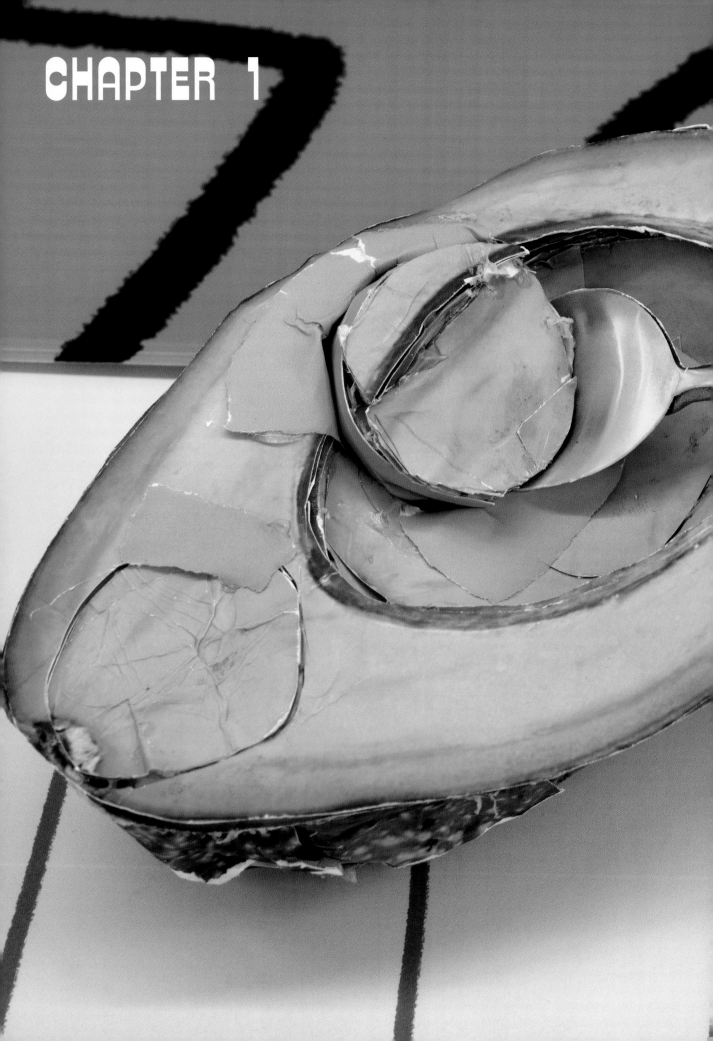

THE TABLE IS A CONSTRUCT
Finger Foods without Furnishings

I knew how to use a fish fork before I had graduated from a booster seat. In my childhood home, table manners were of religious importance. But for years, when my parents went out, my brother and I furtively ate like dogs, pie-faced down in our bowls of spaghetti, until one night: I broke out in an angry facial rash and had to come clean about how the Bolognese had reached the upper regions of my forehead. To this day, I jump for any opportunity and any cuisine that requires me to eat with my hands, unmoored by the constraints of conventional flatware.

My early appreciation for the finger foods of the world has come in handy, as formal dining tables assume a greater footprint than most New York apartments (and it's actually hard to find one you love enough to throw down for!). But that doesn't mean you can't have people over for a meal. Save your excuses—if you can rustle up a flat surface, you're fit to host. Chairs? Icing on the cake. Sitting on the floor is good enough for the finest Japanese restaurants, and it's good enough for you.

In this chapter, we explore creative ways to reimagine the dining table using found and everyday materials. We address the limitations of the spatially restricted host, with recipes for finger foods and handheld delights, from squid-ink deviled eggs to dips, spreads, and other delicious party plasma.

BOUNDARIES

Hugh Hayden

Architect-turned-artist Hugh Hayden has a history of messing with mealtime. It all started with his 2016 culinary installation, *In Tension,* in which a small group of patrons, curators, and fellow artists were invited to a dinner in the middle of the White Cube gallery and unwittingly assumed the role of performer themselves. Seated at a long table that ran down the center of the exhibition space, they slipped their arms through matching white overcoats. Their cuffs were tethered to their dinner partner's by a system of ropes and pulleys that ran along the floor. They negotiated the sharing of a family-style meal of roast chicken and mashed potatoes, the push and pull of their interdependence making the dining experience at once familiar and strange. When Hayden hosts, our most innate, codified behaviors are thrown into high relief, and mealtime is reframed as a space of experimentation.

Hayden recreated his birthday party dinner table concept, "Boundaries," at Lisson Gallery in New York City, 2019.

On the occasion of his thirty-fifth birthday back in 2018, Hugh found himself wanting to celebrate at home with friends but without a table or an apartment large enough to accommodate. As an artist is wont to do, he turned these limitations into opportunity. He drew up some plans, reached into

The table was the centerpiece, the menu Chinese takeout.

his toolbox, and dreamt up an affordable solution that reframed the table itself as the evening's entertainment. Using prefab materials and a jigsaw, he created a surface to fill every square inch of his shoebox space. He called the piece, *Boundaries*.

The ingredients were nothing fancy: square laminate Ikea tabletops and detachable table legs. Hayden cut a quarter-circle off of each corner, screwed on the supports, pushed the pieces together, and voilà, he had transformed his living room into an installation—and the installation doubled as a dining table. His entire apartment took on the landscape of a whack-a-mole, waiting for friends to crawl inside.

The menu? Takeout Chinese food and BYOB champagne. His work was done.

THE TABLE IS A CONSTRUCT

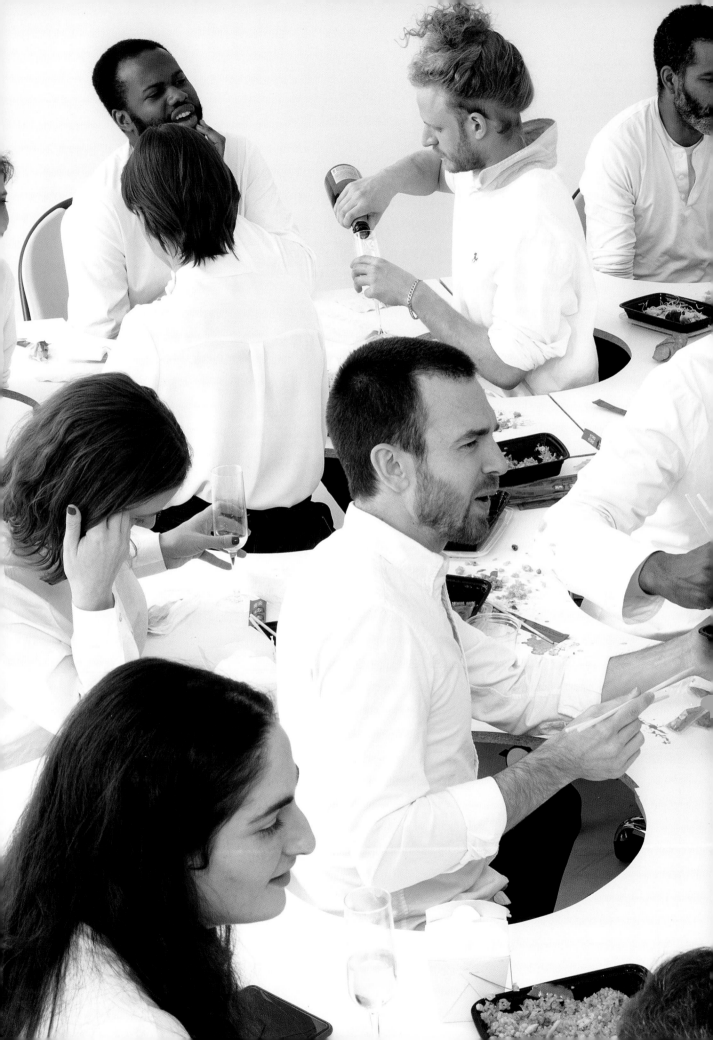

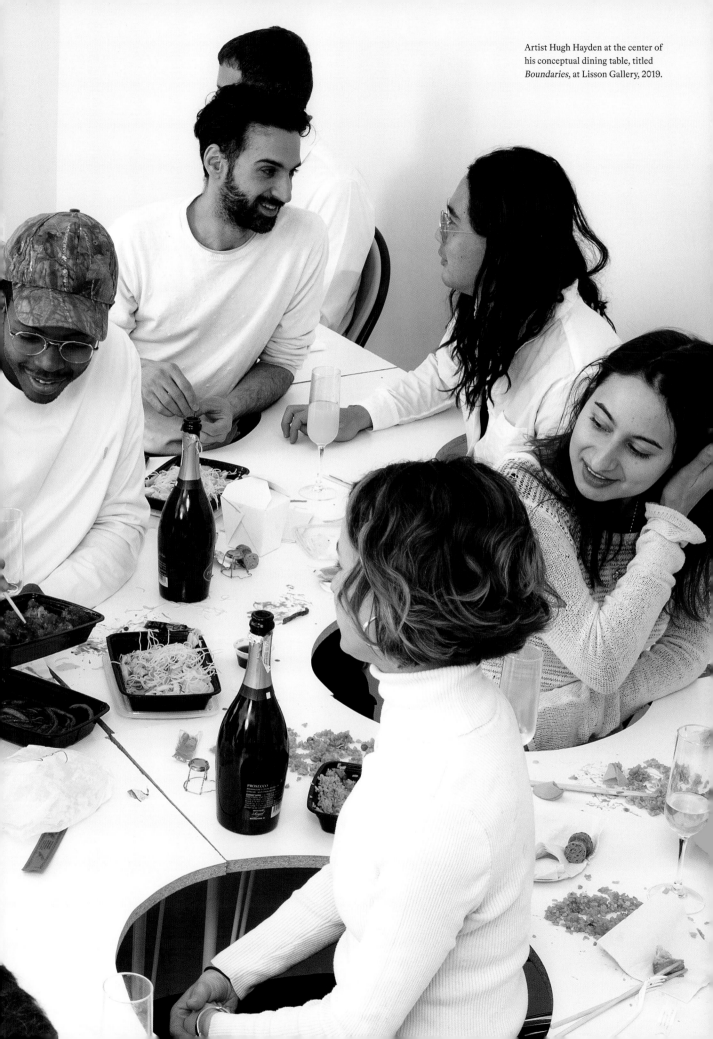

Artist Hugh Hayden at the center of his conceptual dining table, titled *Boundaries*, at Lisson Gallery, 2019.

FLEXIBILITY IS SUCCESS Olivia Sammons

"We never strive for perfect." That's not how I expected prop stylist–turned–interior designer Olivia Sammons to describe her vision for her Stoneridge, New York, home of the past thirteen years. Sammons is the founder of the Brooklyn-based interior design firm Wherewithal, and her husband and long-time collaborator, Jamie Gray, is the founder of the design-retail concepts Matter and Matter Made, selling curated and bespoke lighting and furniture. For them, home is an ever-evolving testing ground for ideas and pro-totypes. "We live with process, but we joke that that means we live with a lot of broken things," says Olivia. Versatility is a tenant of Sammons's design philosophy. Things should be beautiful, but they also need to support the unpredictable flow of everyday life. It's one thing to craft a home for oneself, but to successfully design a space for someone else, you need the hybrid skills of a seasoned therapist and the world's greatest mom. Sammons tells me, "Creating residential in-teriors is so emotional. To

Matter Made's bestselling Champ stool.

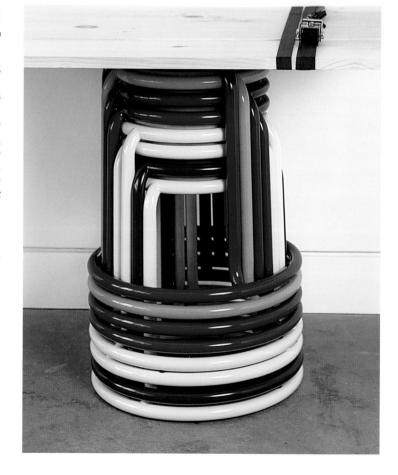

THE TABLE IS A CONSTRUCT

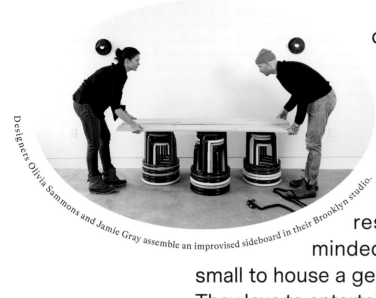

design well is to be as supportive as possible."

Putting her philosophies to the test, I asked Olivia to design a table for a fictitious client. This person is an out-of-the-box thinker, resourceful, and aesthetically minded, but with an apartment too small to house a generous dining table every day. They love to entertain, but they don't adhere to the format of the traditional dinner party—sometimes they host cocktail parties or family-style buffets.

At other times, they orchestrate hands-on group activities involving food or crafts. Their ideal table can be easily thrown together and broken down in an instant, and it can be stored in a closet when not in use.

To meet the challenge, Sammons turned to the Champ stool, a piece created for Matter Made by industrial designers Joseph Guerra and Sina Sohrab. A nod to a champagne cage in form and in name, the Champ stool is a casual tubular steel structure with infinite stacking capabilities. "It can be used as a plant stand, as a footstool, or as a bedside table," Olivia tells me. "They are so compact that they can sit in a corner and take up very little space, or they can expand into seating for twelve." In the instance of this readymade table, the stools double as a base

The tabletop is made from raw lumber, held together with ratchet straps.

(you can use any compact stackable stool). The top is nothing more than raw lumber held together with twenty-dollar ratchet straps. Use two planks of wood and the surface makes a sideboard. Add a third and you can gather around for a seated meal.

On a visit to Jamie and Olivia's Brooklyn Navy Yard studio, I watched as the pair whipped the table into existence in a moment's time. Olivia stepped back, squinting with a discerning eye. She grabbed a fluted terra-cotta bowl piled high with winter citrus and placed it on the table. She stepped back again, and with another motion, she reached for a set of spindly matte-black candlesticks. She lit the candles and the room turned on. "I love when furniture has multiple uses and can be looked at from different perspectives." Olivia tells me. "Flexibility in all areas in life—that is the key to success."

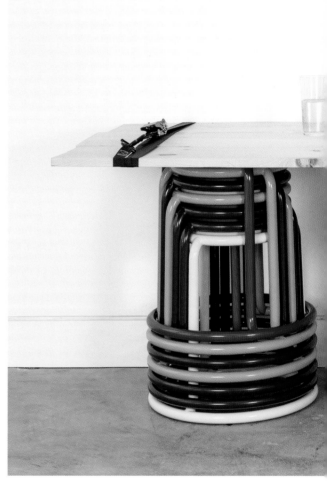

The finished table can be used as a sideboard or a dining table.

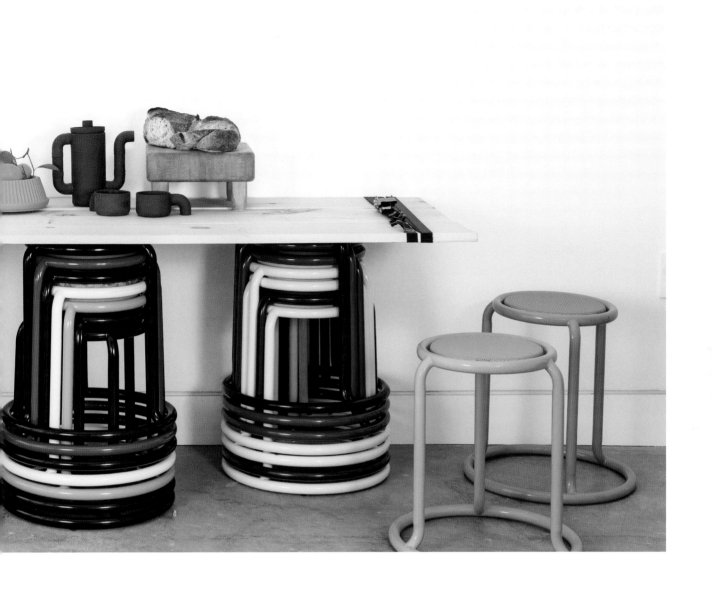

Goth Deviled Eggs (with Squid Ink)

Time: 25 minutes
Yield: 32 pieces (16 servings)

Squid ink is a natural wonder. Thick and slightly gelatinous, a tiny smidge goes a very long way. You may have had it folded into pasta dough or stirred into risotto, but here it adds brininess and a lot of character to the old party favorite: the deviled egg. You can find it at specialty food stores, at upscale fish markets, at any Italian grocer, or online. If you feel like experimenting with my fermented chile peppers (page 268), top the eggs with those in lieu of the fresh bird's eye chile.

16 large organic eggs
1 tablespoon squid ink
2 ¾ teaspoons Dijon mustard
½ cup plus 2 tablespoons (140 g) Kewpie or mayonnaise
¾ teaspoon Sriracha hot sauce

To serve:
2 ounces (56.7 g) salmon or trout roe, for garnish
1 bird's eye chile, sliced thin, or Fermented Chiles and Kombu Seaweed (page 268) for garnish
Flaky sea salt

1. Place the eggs in a large saucepan and cover with 2 inches (5 cm) of cold water. Bring to a boil, cover, and remove the saucepan from the heat. Let the eggs sit in the hot water for 10 minutes, then remove them with a slotted spoon and run them under cold water. Place the eggs in the fridge to cool for 10 minutes before peeling carefully, keeping the whites intact.

2. Put the squid ink, mustard, mayonnaise, and Sriracha in a food processor.

3. Slice the eggs in half lengthwise. Carefully remove the yolks from the whites and transfer the yolks to the food processor. (You can mix the filling by hand using a fork, but it will be difficult to achieve the perfectly silky-smooth texture.) Pulse the filling until just smooth and creamy. If you go too far, the filling will break and become greasy. If that happens, just add 1 raw egg yolk to the mixture while the food processor is running—the addition of the fat will bring the mixture back together.

4. Scoop the filling into a zip-tight bag using a rubber spatula. Seal the bag and squeeze the filling toward one of the bottom corners. Using kitchen scissors, snip the tip of that corner. Wipe the surface of the whites with a damp paper towel to remove any yolk smudges. Pipe the filling into the egg whites in a pleasing soft-serve formation.

5. Garnish with fish roe to taste. Top each deviled egg with a thin slice or two of chile pepper or fermented chile peppers, sprinkle with flaky sea salt, and serve.

MAKES GOOD LEFTOVERS: Yes.

MAKE AHEAD: Make the filling ahead; assemble just before serving.

SEASON: Year-round.

THE TABLE IS A CONSTRUCT

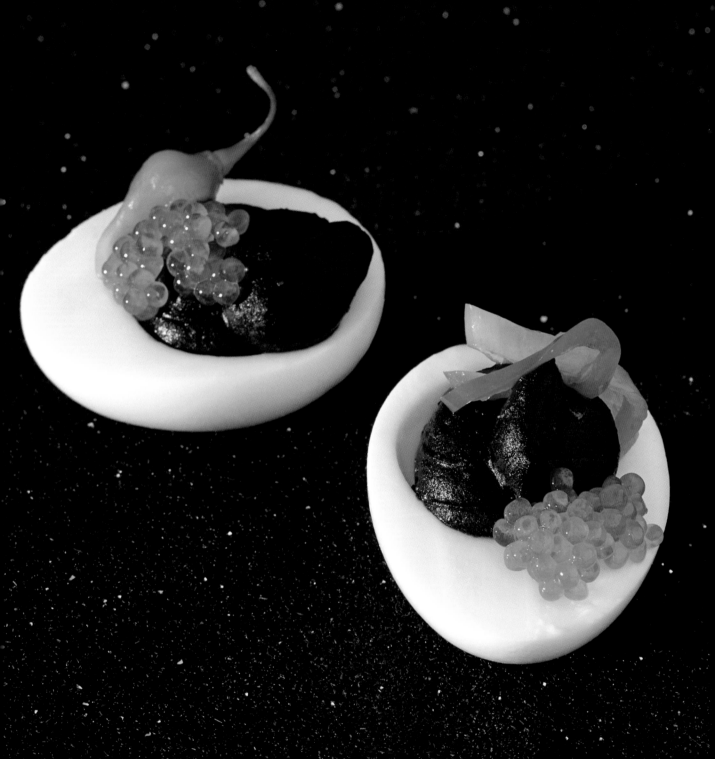

Gem Lettuce Boats with Grilled Lemon-and-Almond Salsa

Time: 25 minutes
Yield: Serves 4

This bright, crunchy salsa can be eaten by the spoonful in a simple lettuce boat. It can also be a tangy sauce for chicken or fish, or you can spoon it over pan-seared zucchini (see page 234). Prepare the nuts according to the toasted almond recipe on page 293.

Note: If you can't find a Meyer lemon and are working with a Eureka, have no fear. Boil the Eureka for 8 minutes in a small saucepan with the lid on. Remove the lemon and cool before slicing into ½-inch-thick rounds. Scoop as much of the runoff juice from the cutting board as you can into a small bowl and reserve for the salsa. Grill the parboiled slices as directed below. (Meyer lemons have a thin, sweet skin, so there's no need to par-boil before grilling them).

For the salsa:

- 1 Meyer or Eureka lemon (see Note), sliced crosswise ½-inch thick
- ⅛ to ¼ teaspoon red pepper flakes
- ¼ teaspoon kosher salt
- 1½ teaspoons honey
- 2 tablespoons plus 2 teaspoons roughly chopped fresh parsley leaves
- ⅓ cup (47 g) raw almonds, toasted and roughly chopped (see page 293)
- 3 tablespoons extra-virgin olive oil

For the salad:

- 1 Meyer or Eureka lemon, cut in half
- ½ tart, crisp apple (such as Pink Lady or Gala), cored and halved
- 3 or 4 small gem lettuce heads or hearts of romaine, stem-ends removed, leaves separated and intact
- Drizzle of extra-virgin olive oil
- Flaky sea salt and cracked black pepper
- Thick shavings of Parmesan cheese, for finishing

Make the salsa

1. Coat a grill pan with vegetable oil and set over high heat. Grill the lemon slices in the hot pan for 3 minutes on each side, or until char marks appear on the skin and flesh. Remove the seeds and roughly chop the lemon slices, peel and all. In a small bowl, combine the lemon and any runoff juices with the red pepper flakes, salt, and honey. Mix to combine. Add the parsley, almonds, and olive oil and mix to combine.

Make the salad

2. Slice the apple quarters on a mandoline into paper-thin slices and squeeze one-half of a lemon over the top to coat the surface of the cut apples.

3. Arrange the lettuce on a large platter. Drizzle with olive oil and the juice of the remaining half lemon. Season with flaky sea salt and cracked black pepper to taste. Spoon the lemon salsa into the lettuce leaves and tuck apple slices into each one. Finish with thick shavings of Parmesan cheese and serve.

MAKES GOOD LEFTOVERS: No.

MAKE AHEAD: No.

SEASON: Fall and winter.

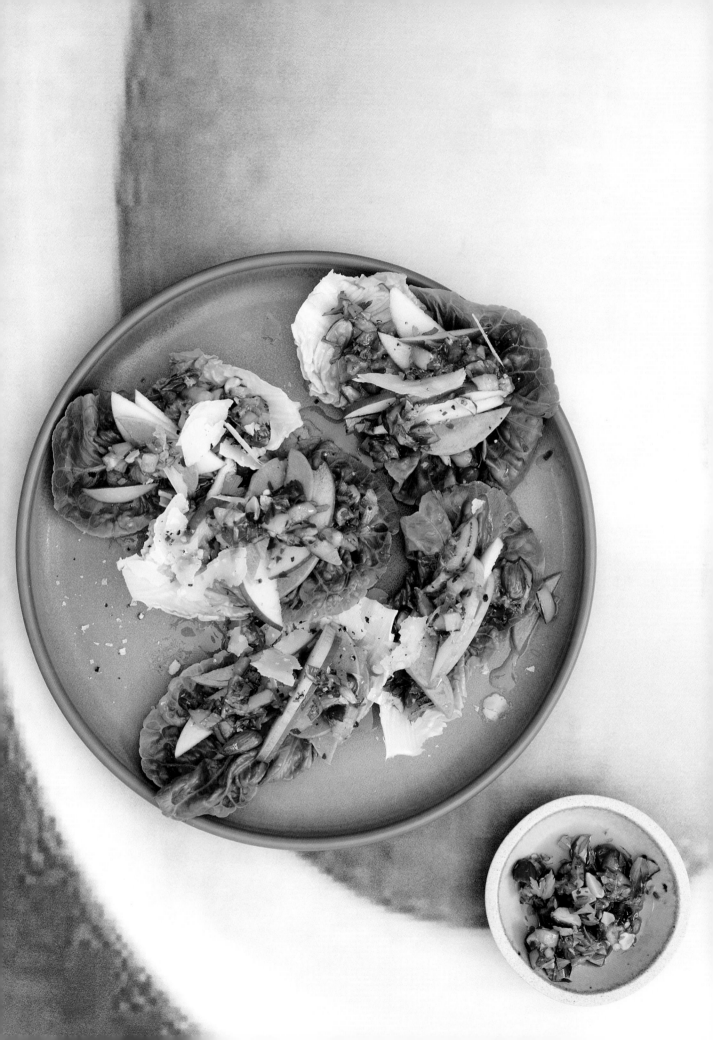

Shredded Beet Salad with Pistachio Butter and Capers

Time: 15 minutes
Yield: Serves 6 to 8

In our house, pan-toasted bread is a lifeline for any meal that feels skimpy or too monkishly vegetarian for my semivegetarian husband (only carbs can take the place of meat). This dish takes a really tasty side salad of sweet-and-sour shredded beets and makes it a meal with rich, homemade pistachio butter slathered on toast. You'll feel like a big spender making butter from pistachios, and if you have any leftovers you can spread it on toast with honey for breakfast the next day.

For the dressing:
1 teaspoon mirin
2 tablespoons plus 1 teaspoon sherry vinegar
1 teaspoon light honey
½ teaspoon Dijon mustard
3 tablespoons extra-virgin olive oil

For the pistachio butter:
2 cups (260 g) shelled unsalted raw pistachios
½ teaspoon kosher salt
¼ to ⅓ cup (60 to 80 ml) neutral oil (see page 291)

For the salad:
3 small beets (about **8 ounces/225 g**), peeled
2 small carrots, peeled
¼ red onion, thinly sliced
½ teaspoon kosher salt, plus more to taste
2 tablespoons neutral oil
2 tablespoons plus 1 teaspoon brined capers, squeezed dry

For serving:
6 to 8 slices (¾-inch/2-cm thick) sourdough bread
Extra-virgin olive oil, for frying
Flaky sea salt

MAKES GOOD LEFTOVERS: Yes; the beet salad and the nut butter can be stored separately and saved, but toss the dressed toast itself.

MAKE AHEAD: Prepare the ingredients for the beet salad and the dressing ahead, but fry the capers and dress the salad just before serving. Make the nut butter and store in the fridge; bring to room temperature before serving.

SEASON: Year-round.

THE TABLE IS A CONSTRUCT

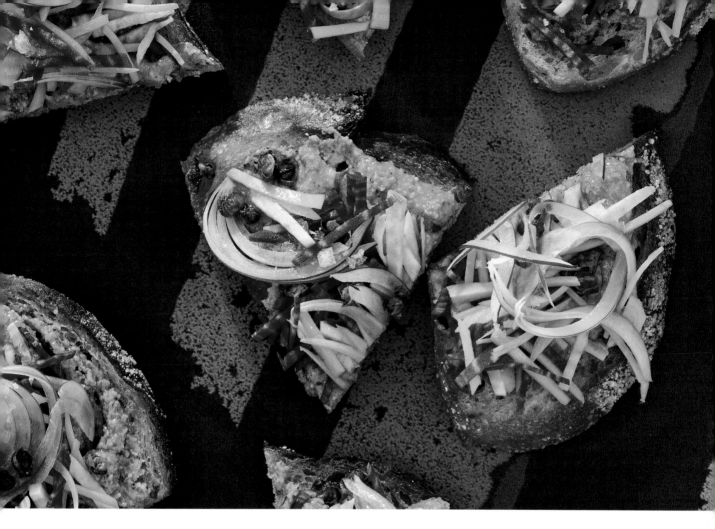

Make the salad dressing

1. In a medium bowl, combine the mirin, sherry vinegar, honey, and Dijon. Add the olive oil in a slow stream, whisking to emulsify.

Make the pistachio butter

2. Place the pistachios and salt in a high-speed blender. Pulse on medium speed to pulverize the nuts. With the blender running, add the oil in a slow stream, stopping the machine to scrape down the sides to ensure even blending and adding just enough oil to make a textured but spoonable nut butter.

Make the salad

3. Shred beets and carrots into a bowl using the largest holes on a box grater (or use a food processor with the shredder attachment). Add the red onion, salt to taste, toss to combine, and set aside. Heat a small sauté pan over medium heat. Add the oil. Squeeze as much liquid from the capers as possible and add them to the hot pan. Fry for 2 to 3 minutes, stirring occasionally. They should be brown on the edges and crispy. Using a slotted spoon, remove the fried capers to a plate.

For serving

4. To toast the bread, keep the sauté pan over medium heat and drizzle olive oil generously into the pan. Add the bread and brown on one side for 1 to 2 minutes, pressing it down against the pan with the back of a pair of tongs. Flip and toast on the opposite side for an additional 1 to 2 minutes. Season with a pinch of flaky sea salt. Smear each slice with about 1 tablespoon of the pistachio butter. Top with the beet salad and sprinkle each toast with fried capers. Finish with flaky sea salt to taste.

Avocado-Lemongrass Panna Cotta

Time: 1 hour plus at least 4 hours to set
Yield: Serves 6 to 8, depending on vessel

Mint green and retro in look and feel, this is, in fact, a very of-the-moment dessert—low in sugar, rich and creamy with avocado, tangy with Greek yogurt and lime, and fragrant with lemongrass. Make these ahead and serve one per person. Have fun with the garnish and toppings.

¾ cup (180 ml) heavy cream

1¼ cup (300 ml) whole milk

¼ teaspoon kosher salt

¼ cup plus 2 tablespoons (75 g) sugar

1 lemongrass stalk, sliced ¼-inch thick crosswise

1 packet (2½ teaspoons/7.75 g) unflavored gelatin

2 ripe medium avocados

Juice of 1 lime

¾ cup (180 ml) plain full-fat Greek yogurt

For serving:

A few torn Thai, lemon, or small Genovese basil leaves

¼ cup (30 g) pistachio or macadamia nuts, toasted and crushed (see page 293)

Make the panna cotta

1. In a small saucepan, combine the cream, milk, salt, sugar, and lemongrass. Simmer for 20 minutes, careful not to let the milk bubble over. Remove from the heat.

2. While the milk is simmering, place ¼ cup (60 ml) water in a small bowl. Sprinkle the gelatin over the water and stir. Set aside until the gelatin softens, 5 to 10 minutes.

3. Strain the cream mixture through a fine-mesh sieve into a large bowl and discard the lemongrass. Whisk the hydrated gelatin into the cream to dissolve. Let the mixture cool to room temperature, stirring occasionally to prevent a skin from forming, about 30 minutes. Remove ¾ cup (180 ml) of the cooled cream-and-gelatin mixture and set aside.

4. While the cream mixture is cooling, purée the avocado, lime juice, and Greek yogurt together in a food processor or with an immersion blender until completely smooth.

5. Add the puréed avocado mixture to the bowl with the majority of the cooled cream and whisk well to combine. Ladle the mixture into glass tumblers or ramekins, leaving about an inch of headspace on the top. Refrigerate the tumblers for 30 to 45 minutes until the surface is firm to the touch. Gently spoon 1 to 2 tablespoons of the reserved cream mixture onto each to just cover the surface. Return the panna cotta to the fridge to set up for at least 4 hours.

For serving

6. Garnish with crushed pistachios and basil leaves and serve.

MAKES GOOD LEFTOVERS: Yes, without the garnish.

MAKE AHEAD: Prepare up to 48 hours ahead.

SEASON: Year-round.

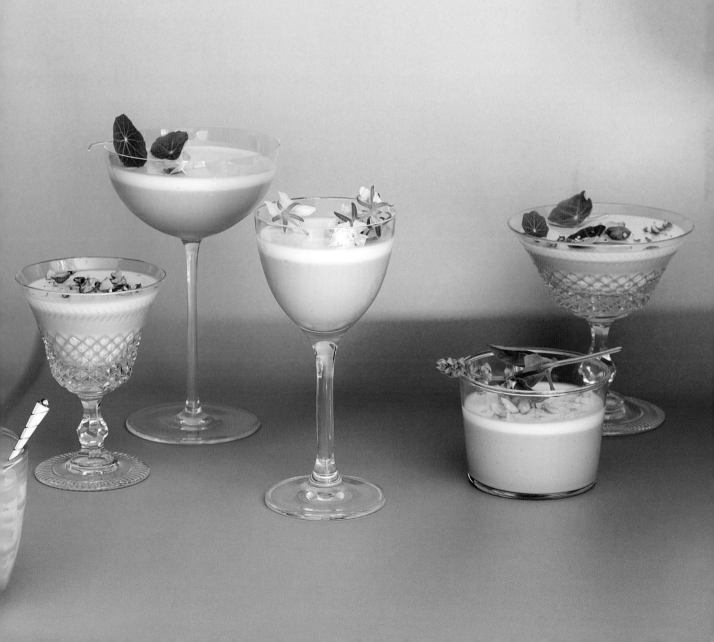

Avocado with Furikake

Time: 2 minutes
Yield: Serves 2 to 4

Less recipe, more household habit: We eat avocados dressed this way as we stand over the kitchen sink multiple times a week. It's an on-the-go snack, and a tasty no-mess option for entertaining as well. Shop for smaller avocados and serve 1 to 2 halves per person (explore the lesser-known avocado varieties too, like the itsy-bitsy Mexicola). Experiment with different flavors of the Japanese rice seasoning *furikake* (you'll use furikake for the onigiri on page 170 as well). We drizzle our avocados with toasted sesame oil most often, but on special occasions, I'll treat myself to fancy squash seed oil instead—butternut or pumpkin seed oil is so rich and nutty, and a really fun item to keep in the pantry.

2 small ripe avocados
1 lemon or lime, halved
Toasted sesame, pumpkin, or squash seed oil, for drizzling
Flaky sea salt
Furikake, for sprinkling

1. Slice the avocados in half lengthwise and remove the pits.

2. Squeeze the citrus juice over the open avocados and season with a modest dash of oil and a generous pinch of flaky sea salt. Sprinkle generously with furikake and serve with spoons.

MAKES GOOD LEFTOVERS: No.

MAKE AHEAD: No.

SEASON: Year-round.

THE TABLE IS A CONSTRUCT

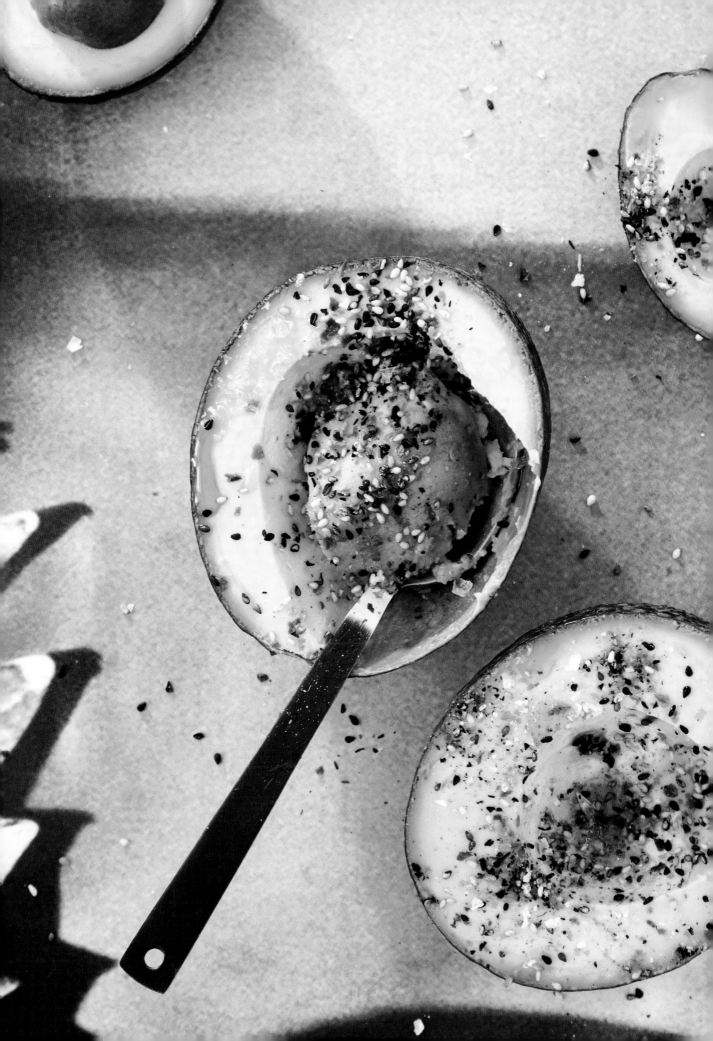

Vegetarian "Chopped Liver" Dip with Cauliflower and Sunflower Seeds

Time: 40 minutes
Yield: Serves 6 to 8

Somehow, the combo of puréed sunflower seeds and cauliflower results in an uncanny stunt double for my Nana's chopped chicken liver (OK, she ordered it from the Jewish deli, but it was damn good).

¼ cup (35 g) sunflower seeds, toasted (see page 293)

3 tablespoons plus 1 teaspoon unsalted butter or ghee

1 large sweet onion, sliced thin

1¼ teaspoons kosher salt

Scant ¼ teaspoon freshly grated whole nutmeg

½ head cauliflower (about 1 pound/455 g), cut into ½-inch (12 ml) steaks

Cracked black pepper

4 large organic eggs, hard boiled

1. Set the toasted sunflower seeds in a small bowl with just enough hot water to cover. Set aside to soak and soften.

2. Put 2 tablespoons plus 1 teaspoon of the butter in a large skillet over medium-high heat. When the butter is melted, add the onions and season with ¾ teaspoon kosher salt and the nutmeg. Sauté for 20 to 25 minutes, adding a splash of water periodically when the pan dries out. When the onions are jammy and smell like heaven, remove them to a food processor and set aside.

3. Put the remaining tablespoon of butter in the large skillet. When the butter has melted, add the cauliflower and season with the remaining ½ teaspoon kosher salt and a twist of black pepper. Cook for 8 minutes on high heat, letting it brown on one side before flipping to brown the other side. Add a splash of water to deglaze and cook uncovered for another 4 minutes before adding an additional splash of water, covering, and cooking for 3 to 5 minutes more, until the cauliflower is soft and the water has evaporated.

4. Drain the sunflower seeds and add them with the cauliflower to the onions in the food processor. Process until creamy and smooth, then transfer the dip to a serving bowl. Remove the hard-boiled yolk from one of the eggs and set aside. Finely chop the egg white and the three additional hard-boiled eggs and fold them into the dip. Using a Microplane, grate the remaining hard-boiled yolk over the dip and serve it with crackers.

MAKES GOOD LEFTOVERS: Yes.

MAKE AHEAD: Yes; bring to room temperature before serving.

SEASON: Year-round.

Watercress Romesco Dip

Time: 5 minutes
Yield: Serves 4

A leprechaun shade of green, this Romesco can be served with crackers or toasted bread, or as a dip for crudité or quick-grilled shrimp.

⅓ cup plus 1 tablespoon (95 ml) extra-virgin olive oil

½ cup (70 g) raw unsalted almonds, roughly chopped

1 clove garlic

Juice of 1 lemon, plus zest of ½ lemon

½ teaspoon kosher salt

2 small bunches watercress or upland cress, stems included if tender

1. Place 1 tablespoon of the olive oil in a small sauté pan and bring to medium heat. When the oil is hot, add the nuts and sauté for 2 to 3 minutes, stirring constantly, until golden brown. Place the nuts in a blender.

2. Blend the nuts along with the garlic, lemon juice, zest, and salt, adding the remaining ⅓ cup (75 ml) oil in a slow stream until incorporated. Add the cress to the blender and stream in 4 tablespoons (60 ml) water, 1 tablespoon at a time, until smooth and creamy.

MAKES GOOD LEFTOVERS: Yes.

MAKE AHEAD: Yes; prepare up to 5 days ahead.

SEASON: Year-round.

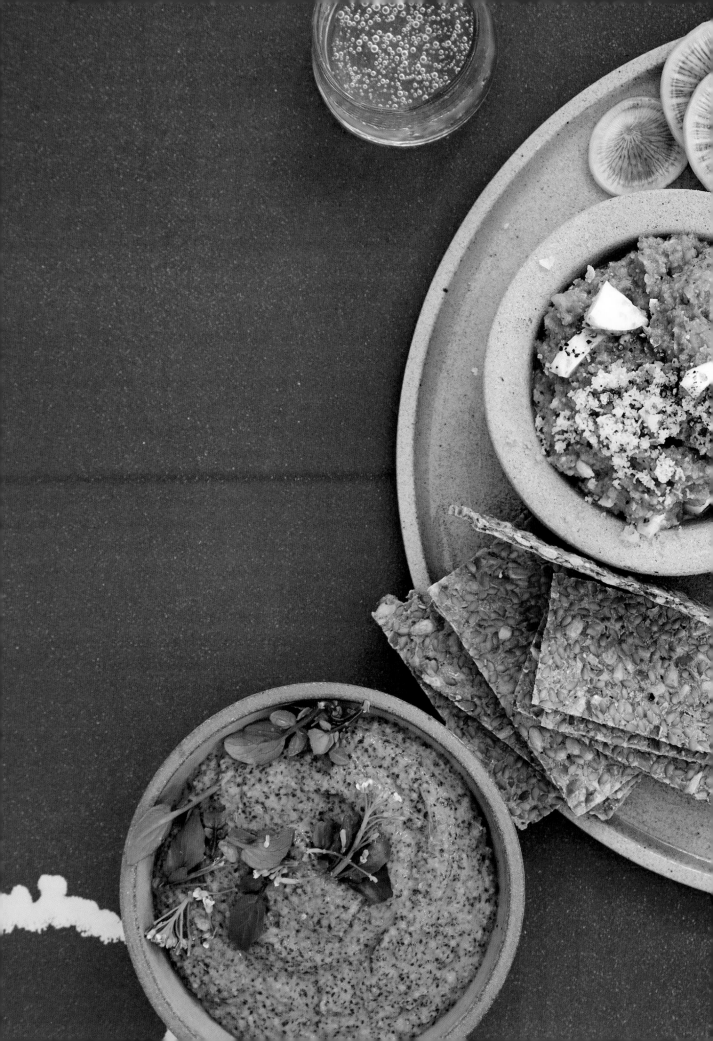

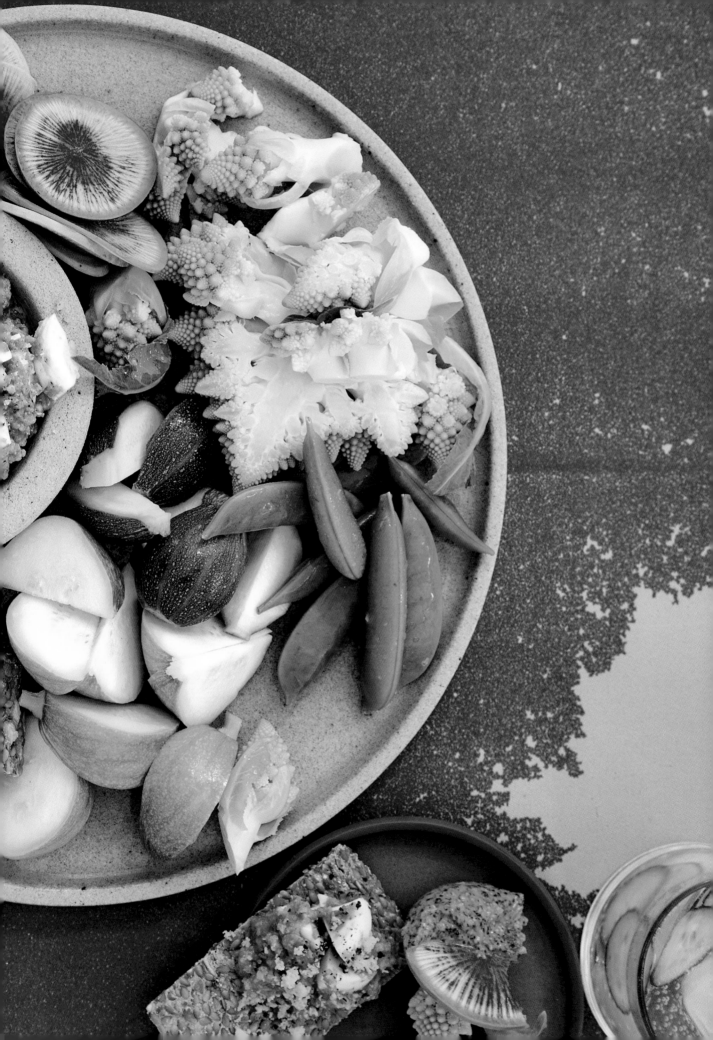

Roasted Red Pepper Spread

Time: 35 minutes, plus chilling
Yield: Serves 5

A gluten-free take on a classic Lebanese *muhammara*, this dip gets its sweetness from charred red peppers and its richness from toasty walnuts.

Pomegranate molasses can be found at any Middle Eastern grocer. It's an oozy, blood red reduction of pomegranate juice that is infinitely useful in mixed drinks, for glazing and braising meats, and as a pop of sweet and tart in salad dressings or, in this case, a dip.

1 pound (454 g) sweet red peppers, whole
1 clove garlic
1 small shallot, roughly chopped
¾ cup (90 g) walnut pieces, toasted (see page 293)
1 tablespoon plus 1 teaspoon pomegranate molasses
¾ teaspoon kosher salt
1 teaspoon sumac, plus more for serving
⅓ cup (75 ml) extra-virgin olive oil
Pomegranate seeds and thinly sliced fresh mint, for garnish

1. Set the peppers directly on a gas range over a medium flame. Cook, rotating constantly with tongs, until their skins are black and the flesh is softened, about 20 minutes. Transfer to a bowl and cover with plastic wrap or a plate for at least 10 minutes.

2. While the peppers are cooling, set a small frying pan over medium-high heat. Place the clove of garlic in the pan for 5 to 7 minutes, flipping occasionally, until the skin is lightly browned and the flesh begins to soften. Peel the clove and transfer it to a food processor or blender.

3. Uncover the bowl and rub the blackened skin off the peppers, running them under water to help get the last bits of char. Pull off the stems and discard the seeds, rinsing again if needed. Add the peppers to the food processor with the garlic.

4. Add the shallot, walnuts, molasses, salt, and sumac to the food processor or blender and run until well combined but still a little chunky. Add the oil in a slow stream and process until smooth. Transfer the dip to a small bowl, cover with plastic wrap, and refrigerate for at least 10 minutes. When ready to serve, bring the spread to room temperature, garnish with a pinch of sumac, a scattering of pomegranate seeds, and some thinly sliced mint leaves.

MAKES GOOD LEFTOVERS: Yes.

MAKE AHEAD: Yes.

SEASON: Summer (for seasonal peppers).

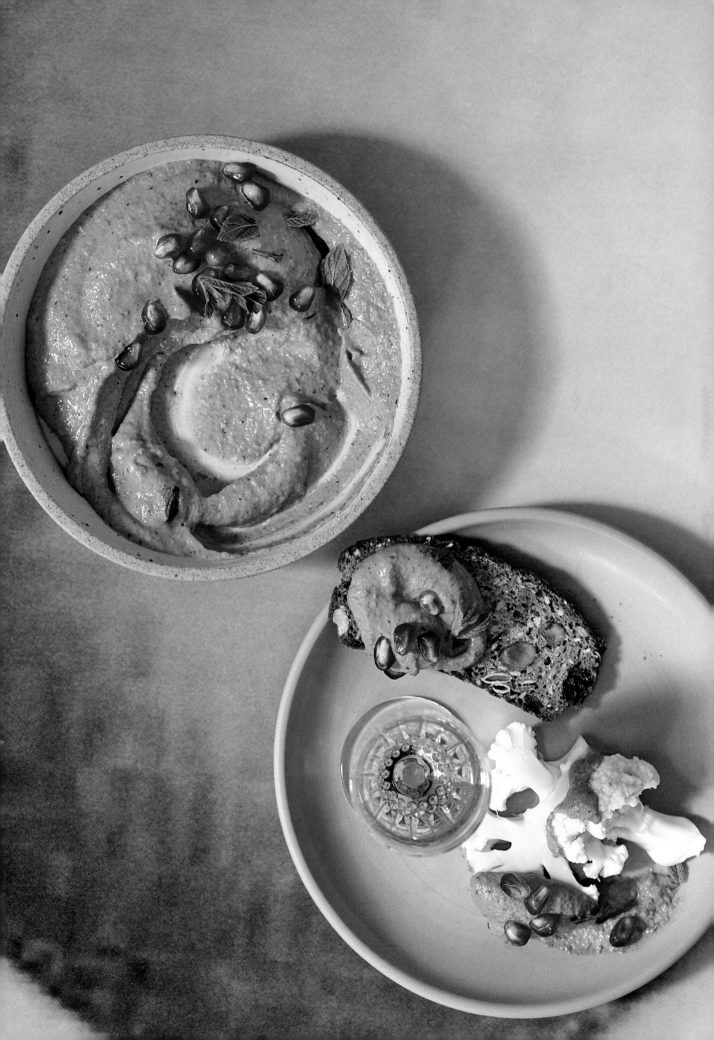

Fluffy Butternut Squash Tahini Dip

Time: 1 hour
Yield: Serves 8

Serve this dip still warm, light, and airy, straight from the blender. Pair with toast or crackers, or smear it on the base of a grain bowl as a sauce.

1 small butternut squash
2 tablespoons extra-virgin olive oil, plus more for roasting squash
3 cloves garlic, unpeeled
1¼ teaspoons whole cumin seed, crushed in a mortar and pestle
3 small shallots, minced
¼ teaspoon kosher salt
3 tablespoons high-quality tahini
1 teaspoon Urfa chile flakes, plus more for serving
½ teaspoon sesame seeds, toasted, for serving (see page 293)

1. Preheat the oven to 350°F (175°C) and line a baking sheet with aluminum foil. Slice the butternut squash lengthwise and remove and discard the seeds. Drizzle the open faces with olive oil and place them cut side down on the foil. Drizzle the garlic cloves (with their skin on) with olive oil, place them on the baking sheet with the squash, and bake on the center rack for 40 minutes.

2. While the squash and garlic are roasting, place a medium sauté pan over medium-high heat. When hot, add the olive oil and the cumin and stir for 10 seconds. Add the shallots and the salt, lower the heat to medium, and cook until translucent and soft, stirring frequently, 6 to 8 minutes. Transfer the cumin and shallot to a food processor with the tahini and chile flakes.

3. When the squash is tender, remove the baking sheet from the oven and let cool for 10 minutes. Peel the garlic and add it to the food processor with 1⅓ cups (about 600 g) of the cooked squash. Blitz until smooth and creamy. Transfer to a serving bowl and garnish with a pinch of Urfa chile and the toasted sesame seeds. Serve immediately.

MAKES GOOD LEFTOVERS: Yes.

MAKE AHEAD: Yes; bring the dip to room temperature just before serving and blend to recoup the light texture.

SEASON: Winter and fall.

Roasted Beet and Goat Cheese Dip

Time: 1 hour 35 minutes, plus time to chill
Yield: Serves 6

Serve with bread or crackers, or add a dollop to roasted potatoes. The recipe calls for just one roasted beet, but it's silly to fire up the oven for a single beet, so roast the whole bunch and keep the marinated leftovers in the fridge for use in a salad, a grain bowl, or a soup later in the week.

1 bunch medium beets, tops removed and peeled
¼ cup plus 1 tablespoon (80 ml) extra-virgin olive oil
2 teaspoons kosher salt
1 tablespoon sherry vinegar
8 ounces (225 g) chèvre cheese
1 teaspoon pink peppercorns, crushed, plus more for garnish
¼ preserved lemon (see page 272), peel only, minced

1. Preheat the oven to 375°F (190°C). If the beets are not close in size, cut them into equivalent pieces about 3 inches (7.5 cm) in diameter. Place the beets in a shallow baking dish and toss with 1 tablespoon of the olive oil. Season with 1 teaspoon of the salt and pour 2 tablespoons of water into the bottom of the dish. Cover with a tight-fitting lid or aluminum foil and roast for 1 to 1½ hours, until the beets are fork tender. Allow to cool.

2. When the beets are tender, transfer them, along with the residual roasting juices, to a container with a tight-fitting lid. Toss the beets with the sherry vinegar and the remaining ½ teaspoon salt. Set aside 1 medium beet and about 2 teaspoons of the runoff for use in the dip and refrigerate the rest of the beets for later use.

3. Combine the reserved beet and its juice, the goat cheese, and the pink peppercorns in a food processor. Blitz until the beet is completely broken down, stopping to scrape down the sides with a spatula if needed. If you need some more liquid to get the blender going, add some of the marinade from the extra refrigerated beets, 1 teaspoon at a time. Continue to process, pouring in the remaining ¼ cup (60 ml) olive oil in a slow stream, and blend until creamy and smooth.

4. Scoop the dip into a serving bowl and refrigerate for 30 minutes. When ready to serve, garnish with a pinch of crushed pink peppercorns and finish with minced preserved lemon peel.

MAKES GOOD LEFTOVERS: Yes.

MAKE AHEAD: Yes.

SEASON: Year-round.

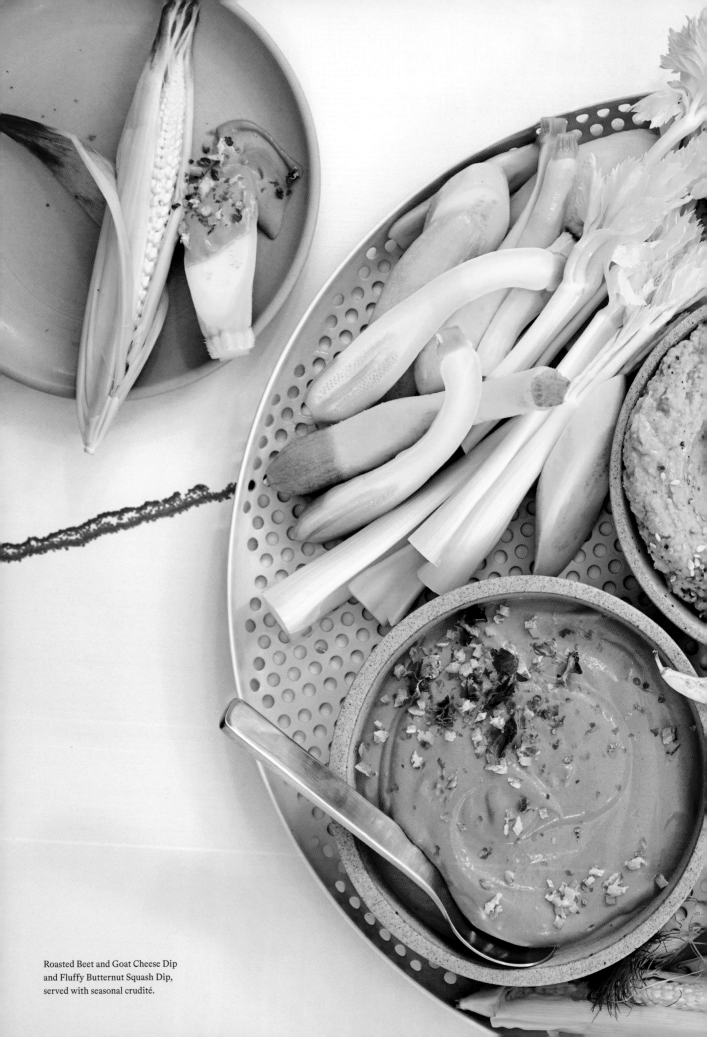

Roasted Beet and Goat Cheese Dip
and Fluffy Butternut Squash Dip,
served with seasonal crudité.

Popcorn: It's a Crowd-Pleaser

I am a snack monster. I cannot be trusted to keep anything salty in the house that I can shovel into my mouth with my over-eager hands. Something about the cacophonous crunch of a tortilla chip alters the chemistry of my brain. I morph into a lab rat, pressing the button for more, more, more, after just one bite.

Popcorn is my loophole. At some point, I decided it was the lesser of all the snacky evils (high in fiber, homemade, no preservatives). It satisfies when served with just olive oil and salt, and it can be also be the blank canvas for endless herbs and spices, from fresh rosemary and garlic to makrut lime and Korean chile flakes.

Serve these variations at movie night, as a late-night snack, or for an afternoon treat for a friend who unexpectedly shows up with the munchies. For the kettle corn, look for organic "mushroom" popcorn kernels (fun, but not required). Those are the variety they use at the amusement park to make puffy, light-as-air popcorn.

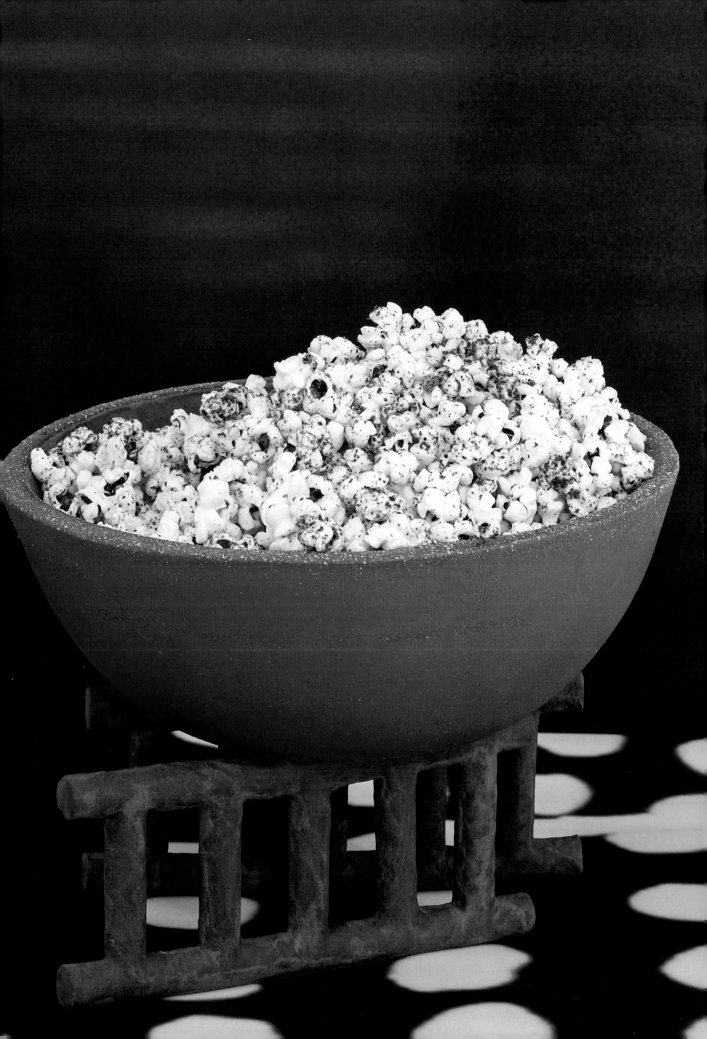

Japanese Popcorn

Time: 10 minutes
Yield: Serves 2 to 4

Make a big batch of this seasoning mix and store it in your pantry in a large shaker for easy regular use. If you are experimenting with dried fig leaves for the Fig Leaf Chicken (page 100), you can use that as your green element instead of spirulina.

For the seasoning mix:

2 teaspoons black sesame seeds

2 packages (0.17 ounces/8.5 g) nori snack

3 tablespoons nutritional yeast

1½ teaspoons powdered spirulina, moringa, or fig leaf

¾ teaspoon togarashi

⅛ teaspoon garlic powder

½ teaspoon fine sea salt

For the popcorn:

2 teaspoons butter or ghee (or more)

3 tablespoons neutral oil (see page 291)

½ cup (100 g) popcorn kernels

2 tablespoons or more Japanese popcorn seasoning

Make the seasoning

1. Place the sesame seeds in a high-speed blender and process to a fine powder. Add the nori snack, nutritional yeast, spirulina, togarashi, garlic powder, and salt to the blender and process into a dust. Remove from the blender and store the mix sealed in a jar for up to 2 months.

Prepare the popcorn

2. Melt the butter in a small saucepan and set aside.

3. Put the oil and two or three popcorn kernels in a medium pot with a tight-fitting lid.

4. Cover and cook over medium-high heat, shaking the pot occasionally until you hear kernels pop, 2 to 3 minutes. Immediately pour in the remaining kernels. Cover the pot and drop the temperature to cook over medium or medium-low heat, shaking every 30 seconds to ensure kernels pop evenly.

5. Once you can count a few seconds between each pop, remove the pot from the heat and give the pot one final shake. Lift the lid so it remains ajar and let the popcorn cool slightly before transferring half of the popcorn to a large serving bowl.

6. Drizzle half of the melted butter over the top, sprinkling the seasoning mix, 1 tablespoon at a time, to taste. Toss to coat. Add the second half of the popcorn, drizzle with remaining butter, and sprinkle with additional seasoning. Toss and serve.

MAKES GOOD LEFTOVERS: No.

MAKE AHEAD: Prepare the spice mix ahead and store it in the pantry.

SEASON: Late summer, early fall.

Turmeric-Poppy Kettle Corn

Time: 10 minutes
Yield: Serves 2 to 4

This one is all about texture—crystalline corn kernels coated in spice and crunchy poppy seeds. The color is half the fun, bright orange with black polka dots.

Note: If you don't have superfine sugar, pulse your sugar in your food processor to break it down. The finer the crystals, the less likely they are to burn.

3 tablespoons neutral oil (see page 291)
½ cup (100 g) popcorn kernels
¼ cup (50 g) superfine sugar (see Note)
1 tablespoon plus 1 teaspoon poppy seeds
½ teaspoon kosher salt
1 teaspoon ground turmeric

1. Put the oil and two or three popcorn kernels in a medium pot with a tight-fitting lid. Cover the pot and cook over medium-high heat, shaking occasionally until you hear the kernels pop, 2 to 3 minutes.

2. Immediately pour in the remaining kernels and the sugar, poppy seeds, salt, and turmeric and stir swiftly with a spoon to coat the kernels.

3. Cover the pot and drop the temperature to cook over medium or medium-low heat, shaking every 30 seconds to ensure the kernels pop evenly and the sugar does not burn on the bottom of the pot.

4. Once you can count a few seconds in between each pop, remove the popcorn from the heat and give the pot one final shake. Lift the lid so it remains ajar and let the popcorn cool slightly before transferring to a bowl. Taste (careful—the sugar makes the popcorn very hot!) and season with more salt if you like.

MAKES GOOD LEFTOVERS: No.

MAKE AHEAD: No.

SEASON: Year-round.

Spicy Lime Leaf Kettle Corn

Time: 10 minutes
Yield: Serves 2 to 4

Makrut lime leaves are intoxicatingly aromatic and the flavor that I most closely associate with Thai curries. You can buy them frozen or fresh at the Asian market. I also use them to flavor my drinking water, in soups, and steeped with milk or cream in desserts.

3 tablespoons neutral oil (see page 291)
½ cup (100 g) popcorn kernels
3 makrut lime leaves, center veins removed with a paring knife
¼ cup (50 g) superfine sugar (see Note, page 53)
1 teaspoon kosher salt
½ teaspoon Korean chile flakes

1. Put the oil, two or three popcorn kernels, and the makrut lime leaves in a medium pot with a tight-fitting lid.

2. Cover and cook over medium-high heat, shaking the pot occasionally until you hear the kernels pop, 2 to 3 minutes.

3. Immediately pour in the remaining kernels with the sugar and salt and stir swiftly with a spoon to coat the kernels. Cover the pot and drop the temperature to cook over medium or medium-low heat, shaking every 30 seconds to ensure the kernels pop evenly and the sugar does not burn on the bottom of the pot.

4. Once you can count a few seconds in between each pop, remove the popcorn from the heat and give the pot one final shake. Lift the lid so it remains ajar and let the popcorn cool slightly before transferring to a bowl.

5. Toss the popcorn with the chile flakes while still hot, then fish the lime leaves out and crush them between your fingers into the popcorn. Taste (careful—the sugar makes the popcorn very hot!) and season with more salt if you like.

MAKES GOOD LEFTOVERS: No.

MAKE AHEAD: No.

SEASON: Year-round.

OFF-PEAK HOURS
Breakfast, Late-Night, and Snack Time

If the thought of pulling together a dinner party makes your palms sweat, then take a pass on dinner altogether. The pressure associated with hosting the big-bang meal of the day intimidates even the most experienced of hosts. I, too, am haunted by Instagram images of endless farm tables, wildflowers, and mismatched tarnished-silver table settings.

This chapter is designed to free you from the formal constraints of sanctioned mealtimes and encourages you to claim the space between. What can you offer a friend who pops by last minute for an afternoon chat, or the collaborator who comes to you for a breakfast meeting?

Expand your repertoire—consider the interstitial social hours, and you'll find freedom in the empty spaces just waiting to be filled. It's intimate, casual, and unexpected.

AT HOME IN THE STUDIO Susan Cianciolo

Mixed-media artist Susan Cianciolo greets her guests, stylist Bunny Lampert and her four-year-old daughter Niagra, at the door of her Brooklyn home and studio by offering them each an apron. This is not to be misconstrued as a prompt to work. It is an invitation to step through the mirror into Susan's world, where scraps of fabric are sacred, and every object, tool, and tea leaf has a story to tell. The aprons are a couture hybrid of costume and work-wear, part of her project in life and art called RUN, which has spanned fashion, food, painting, film, and performance since the early nineties. The aprons are also "real" aprons. "I had a fancier one on before, but it wasn't practical for cooking. It didn't have a waist tie," Susan says as she stirs a bowl of muffin batter dotted with the last berries of the season. Lilac Sky, Susan's eleven-year-old daughter and frequent collaborator, rifles through the garment rack draped with vegetable-dyed fabric and tat-

Cianciolo holds an impromptu tarot reading for artist Sara Chow in her home/studio, 2019.

tered ribbon. She plays dress-up and docent at the same time, searching for just the right fit for Bunny and Niagra who have come for afternoon tea. Topics on the agenda: the best recipe for gluten-free banana bread, esoteric energy healers, and how cats see spirits over physical forms.

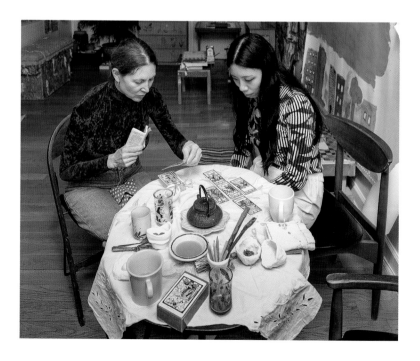

Table setting by Susan Cianciolo, with homemade ceramics, found objects, and a tea blend made by her daughter.

In Susan's domain, there is no distinction between the home and the studio. Even the dining table stands on high alert, ready to be folded and whisked away should a tapestry need mending. For the moment, the rickety card table is set with layers of tea-stained lace, sprigs of dried herbs sewn to the surface. Hand-built ceramic bowls are filled with cultured butter and jam, equally as important as the ones filled with twigs and seashells. Once baked, the blueberry muffins are perched in a pinewood box alongside hand-blended tea, a Christmas gift from Lilac to her mother. It's all so Susan—a little messy but perfectly particular, fantastical but rooted in the earth, refreshingly naive and unwaveringly avant-garde.

Susan made her mark in the space between art and fashion with a highbrow hippy aesthetic in the late nineties. It wasn't long before apparel became just one small component of her far more elaborate happenings. She staged thirty-person dinners in private homes and galleries, ambitious productions defined by her signature use of honest materials and her radical, collaborative spirit. She cooked healthy, unpretentious food informed by her Sicilian roots. She curated performances and lectures and sewed table linens and fantasy uniforms for the waitstaff that were hardly uniform at

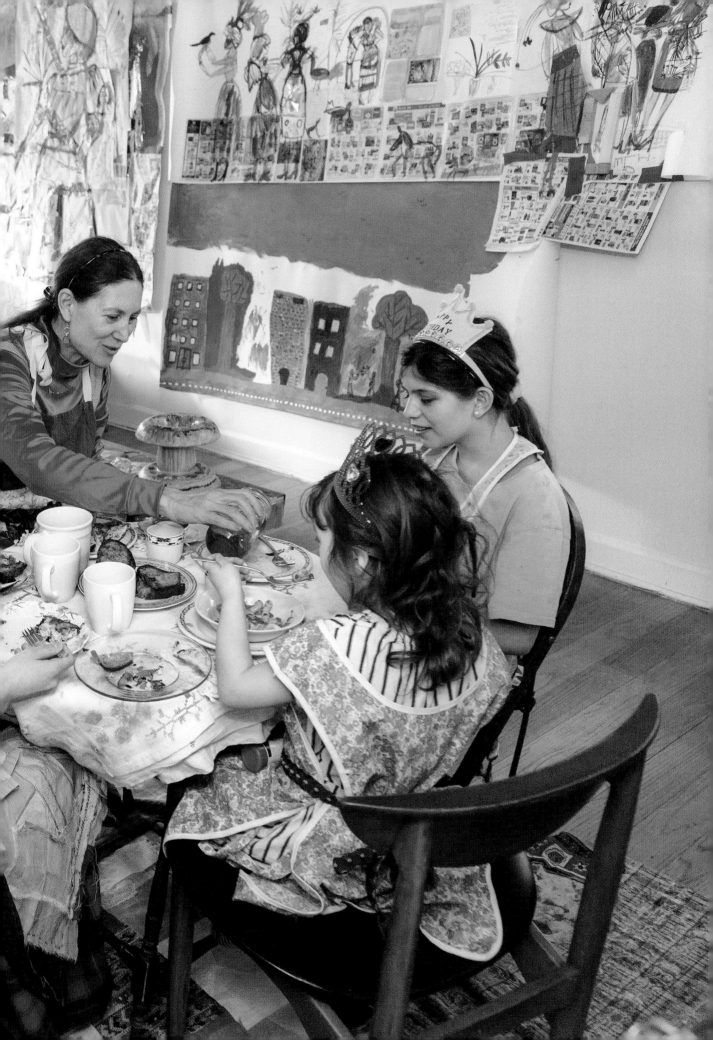

all. "I remember one dinner where we had every dish and bowl made by a ceramicist. An old friend and sommelier selected the wine, and the cheesemonger gave a presentation on her cheeses. My uncle had an oyster farm in Rhode Island, so he FedExed oysters. People wanted to buy tickets to the dinners way more than they ever wanted to buy my clothes, that's for sure. It seemed they would pay any price. And somehow, we always broke even. That was a big accomplishment."

Susan ran an underground "restaurant" as a work of art long before dinner clubs were part of the zeitgeist. Her string of private dinners culminated in her now-famous pop-up restaurant, also called RUN, that was staged at New York's Alleged Gallery in 2001. "I didn't know what I was doing. We were open every day and I charged ten dollars for lunch: soup, salad, and pasta. It was a new frontier for me." For an artist who finds inspiration in cottage industries and the handiwork of others, putting together a meal is an intellectual pursuit. "I look at it as research. There are so many people involved. It's a lot like building a textile; I have to collect all of the pieces." And now, almost twenty years later, food has made its way back into her work, and in high demand. "It's a calling. Every show I have this year has some aspect of a food performance, and I am not sure I am any more a professional than I was in 2001. It's still an experiment. I'm still wondering, 'What the hell am I really doing?' I am surging with raw excitement."

Cianciolo and her daughter, Lilac Sky, frost cupcakes for guests in their Fort Greene, Brooklyn, home.

OFF-PEAK HOURS

Preparing for a series of upcoming shows that all revolve around food, Susan began to associate cooking with work, to feel like every moment in her own home was a rehearsal or a performance. "When domestic life is the content of your work, it's hard to keep your home life sacred," she explains. As a result, she found herself hosting less frequently, and longing for a practice that once provided much needed counterbalance to long, quiet hours of isolation in the studio. In turn, Susan instituted a weekly teatime, inviting over a friend or an artist she admires for an intimate visit. Designed to balance out the rigor of her work schedule, she makes a concerted effort to not put pressure on the situation.

When artist Sara Chow stopped in, Susan read tarot over Lilac's thickly frosted experimental cupcakes. On another occasion, Susan served her famous frittata and portioned off bottles of Italian olive oil from an industrial cannister for her guests to take home, a gift from a patron's family farm in Sicily. There's no real agenda in place. "I just don't make a big deal out of it, for my own personal satisfaction. I don't have to call it anything." But at the same time, every detail of the table feels like a piece in Susan's larger oeuvre. Because, well, it is.

Savory Miso Oatmeal with Soft Egg and Asian Greens

Time: 30 minutes
Yield: Serves 2

Oats are thirsty for all the deep flavor of garlic, sesame, shallot, miso, and that homemade chicken broth I know you've been diligently making every week. This is the kind of stick-to-your-ribs (not to your love handles) hearty breakfast that makes it worth inviting someone over to your house before noon.

1 tablespoon plus 1 teaspoon neutral oil (see page 291)
2 small shallots, minced
2 teaspoons Microplaned fresh ginger
2 cloves garlic, Microplaned
5 cups (1.2 L) chicken, beef, or vegetable broth
2 tablespoons brown rice or white miso
1 teaspoon fish sauce
2 cups (310 g) steel-cut oats

For the toppings:

2 green onions, thinly sliced on a diagonal
Toasted sesame oil, for finishing
Sesame seeds, toasted (see page 293)
2 soft-boiled eggs
Handful flowering pea shoots or other Asian greens
9 ounces (25 g) steamed kabocha squash, cut into 1-inch (2.5 cm) cubes (1½ cups; optional)

1. Set a medium saucepan with the neutral oil over medium-high heat. When hot, add the shallot and sauté for 3 minutes, stirring constantly. Add the ginger and the garlic and sauté for 1 minute.

2. Add the broth, miso, and fish sauce. Bring to a boil, stir in the oats, and lower the heat to a simmer. Cook for 20 minutes, stirring occasionally.

3. To serve, ladle the oatmeal into small soup bowls. Top with the green onion, a few dots of toasted sesame oil, a sprinkle of sesame seeds, and any additional toppings.

MAKES GOOD LEFTOVERS: No.

MAKE AHEAD: No.

SEASON: Year-round.

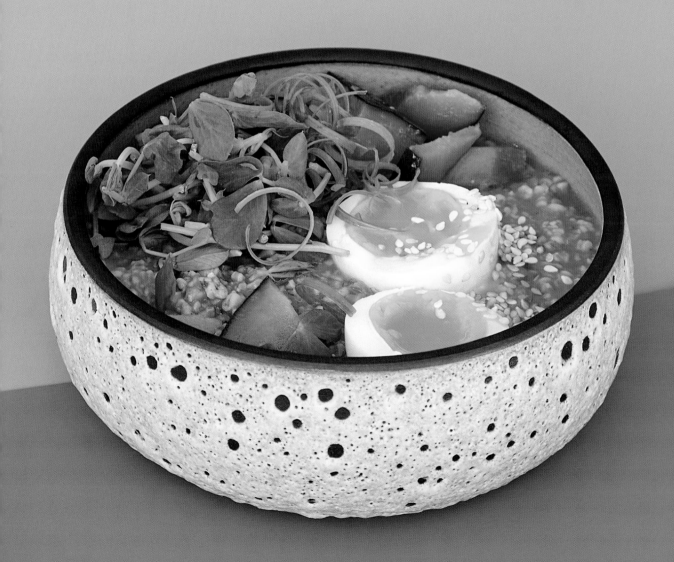

Squash Blossoms and Eggs

Time: 10 minutes
Yield: Serves 2

We all love the look of the fresh squash blossoms bundled together in showy bouquets, but how many of us know what to do with them short of the messy business of stuffing and deep-frying? When I heard a wise Italian lady at my local market squeal with joy at the sight of the first squash blossoms of the season, my ears perked up. Her specialty: Sauté the flowers with scrambled eggs. A brilliant, no mess recipe for a seasonal treat too pretty to submerge in a vat of bubbling oil.

10 squash blossoms

4 large organic eggs

½ teaspoon minced fresh oregano leaves

1 teaspoon minced fresh chives, plus more for serving

2 tablespoons ghee or unsalted butter

Fine sea salt

Flaky sea salt

Cracked black pepper

1. Prep the squash blossoms by rinsing and gently patting them dry.

2. Whisk the eggs with a fork, just enough to incorporate the yolk with the white, stopping before they are uniform in color. Add the oregano and chives.

3. Place a medium skillet over medium-high heat. When the skillet is hot, add 1 tablespoon of the ghee to the pan and swirl to coat. Add the squash blossoms and cook for about 2 minutes to sear. Flip and cook for an additional minute on the opposite side. Add 1 tablespoon of water to the pan and swirl to wilt the blossoms. Carefully remove them from the pan to a plate and season with a tiny pinch of fine sea salt.

4. Lower the heat to medium-low and add the remaining 1 tablespoon of ghee to the pan, followed by the eggs. (If using cast iron, let the pan cool for 5 minutes before making the eggs.) Trace gentle figure eights in the eggs with a rubber spatula until they are cooked halfway. Add the whole squash blossoms to the eggs and gently fold until the eggs are nearly set.

5. Transfer the cooked eggs to a plate. Season with a pinch of flaky sea salt and cracked black pepper to taste. Garnish with chives and serve immediately.

MAKES GOOD LEFTOVERS: No.

MAKE AHEAD: No.

SEASON: Summer.

Lemon Smashed Potatoes with a Pile of Herbs

Time: 1 hour
Yield: Serves 3 to 4

It's the little kitchen tricks that make a lasting impact. I used to resent potatoes—I craved them for breakfast, but I never had enough time in the morning to roast them to perfection. Then I changed my routine. Boil potatoes in salted water as soon as you get home from the market and hold them in the fridge fully cooked. When you are ready to serve, just smash, oil, and salt. After 10 minutes under the broiler, you'll have potatoes that are crispy, salty, and golden on the outside and pillowy soft inside.

2 pounds (910 g) large fingerling or small Yukon gold potatoes
2 tablespoons kosher salt
¼ cup plus 2 tablespoons (90 ml) extra-virgin olive oil
½ teaspoon red pepper flakes
½ teaspoon garlic powder
1 teaspoon fine sea salt
Zest and juice of **2 lemons**
1 cup (30 g) torn fresh dill sprigs
1 cup (30 g) torn fresh parsley leaves
Flaky sea salt

1. Place the potatoes in a medium pot with 4 quarts (about 4 L) of water and the kosher salt. Bring to a boil, then lower the heat to medium to keep an active simmer for 20 minutes, or until fully cooked through with skins still intact. Strain and move the potatoes to a cutting board.

2. Preheat the oven to broil with a large baking sheet set on a rack in the upper third of the oven. Use the palm of your hand against the broad side of a chef's knife to smash each potato in one fell swoop. They should become thick, flat potato patties. Transfer to a large bowl, drizzle with the olive oil, and season with the red pepper flakes, garlic powder, and fine sea salt and gently toss, allowing the potatoes to gently break apart.

3. Place the potatoes on the preheated baking sheet, reserving the bowl with the residual oil. Broil (on low setting if available) in the upper third of the oven for 8 to 15 minutes until golden brown and crispy. Watch them to make sure they don't burn. Remove to a serving platter and squeeze the juice of one lemon over the top.

4. While the potatoes are broiling, add the lemon zest, dill, and parsley to the bowl with the reserved residual oil. Toss and season with a pinch of flaky sea salt. Top the potatoes with the dressed herbs and serve.

MAKES GOOD LEFTOVERS: No.

MAKE AHEAD: Boil the potatoes ahead and refrigerate them. Broil right before serving.

SEASON: Year-round.

Healthy Strawberry Rhubarb and Rose Cobbler

Time: 1½ hours
Yield: Serves 6 to 8

Is a cobbler still "healthy" if you eat three-quarters of it yourself? A debate for the ages, and one I will table for now. (Especially since I just cleared another portion. Recipe testing takes its toll!) Gluten-free and with little added sugar, this cobbler can be made vegan by substituting coconut oil for the ghee in the topping. The filling relies on the naturally occurring sweetness of ripe, high-quality fruit and can really be made with the juicy fruit of your choice. Strawberries and rhubarb are my ultimate, but try it with ripe stone fruit and just double the coconut sugar (or even add a pinch of dried lemon verbena to the mix).

4½ cups (540 g) organic strawberries, quartered if large, halved if medium

2 cups (220 g) rhubarb, cut into ¾-inch chunks

1 tablespoon coconut sugar

1 teaspoon vanilla extract

¼ teaspoon rose water

2½ teaspoons tapioca starch

½ lemon

1 cup plus 2 tablespoons (135 g) almond meal

½ teaspoon ground cinnamon

⅛ teaspoon ground allspice

⅓ cup (30 g) sliced almonds

¼ teaspoon kosher salt

⅓ cup (350 g) rolled oats

⅓ cup (80 ml) maple syrup

2 tablespoons ghee or coconut oil

⅓ cup (45 g) flax meal

1. Preheat the oven to 350°F (175°C).

2. In a medium bowl, combine the strawberries and rhubarb with the coconut sugar, vanilla, rose water, and tapioca starch and stir to combine. Add the juice of the lemon half, toss, and set aside.

3. In another bowl, combine the almond meal, cinnamon, allspice, sliced almonds, kosher salt, and the oats. Stir to combine.

4. In a small saucepan, heat the maple syrup over medium-high heat. When the syrup starts to bubble, add the ghee and the flax meal. Continue to simmer, stirring constantly with a fork, until the mixture thickens to a caramel consistency, 3 to 5 minutes. It should be really gooey.

5. Pour the hot syrup over the spiced oats mixture and stir using a rubber spatula until you have a topping that is thick and tacky to the touch.

6. Pour the macerated fruit into a pie pan with all its runoff. Add the topping in blobs to cover the top (don't worry if the fruit pokes through in spots). Place the pie dish in the oven on the center rack with a baking sheet on the rack below. Bake for 30 minutes at 350°F (175°C), then lower the heat to 325°F (165°C) and bake for an additional 30 minutes. Let the cobbler cool to room temperature before serving.

MAKES GOOD LEFTOVERS: Yes; recrisp in the oven at 250°F (120°C) for 15 minutes before serving.

MAKE AHEAD: Prepare up to 3 hours ahead and let sit at room temperature until serving.

SEASON: Summer.

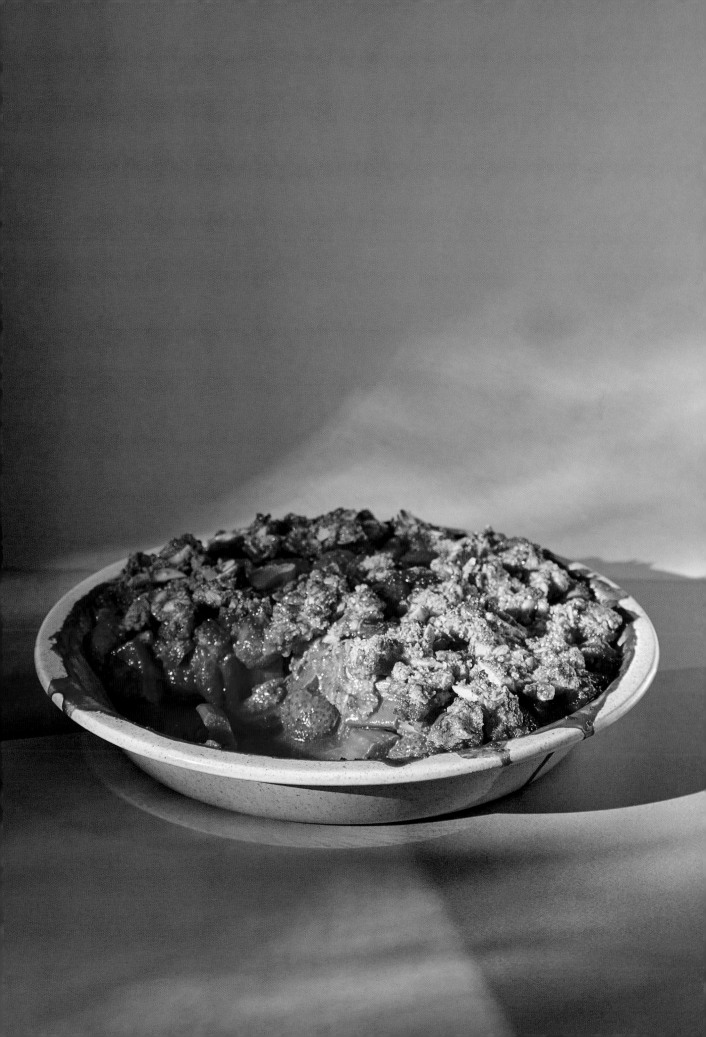

Gluten-Free Orange Blossom Citrus Cake

Time: 1 hour 45 minutes
Yield: One 8-inch (20 cm) cake; serves 8 to 12

There's nothing more satisfying than a recipe that uses a piece of produce in its entirety. A purée of boiled whole citrus is the base of this moist, flourless cake—just lightly sweet and the perfect match for tea or a daytime snack. It is inspired by an ancient Sicilian recipe, a version of which I first encountered via cookbook author Claudia Roden.

Make this recipe even easier (and less caloric) and skip the fruit topping. Cut a piece of parchment to line the bottom of your cake pan. Grease the pan, lay the parchment down into the base, and grease the parchment before adding the batter. Bake as instructed below. Serve the cake with powdered sugar and orange zest on top.

===============================

1. Scrub 2 Valencia oranges and 1 Meyer lemon and remove the stem ends of each. Boil in a medium pot of water for 30 to 45 minutes until easy to pierce with a fork. Add more water as the levels get low (the citrus will be bobbing in the water, not completely submerged). Preheat the oven to 400°F (204°C). Grease an 8-inch (20 cm) round cake pan.

2. Transfer the whole citrus to a blender with the vanilla and the orange blossom water. Purée until smooth (you should end up with about 1½ cups/375 g fruit purée). Allow to cool slightly, then add the eggs and granulated sugar and quickly blend on low speed until just combined.

3. In a separate bowl, combine the almond meal, baking powder, and salt. Whisk to incorporate. Slowly add the wet ingredients to the dry ingredients one-quarter at a time, folding to incorporate. Continue folding until the batter is smooth.

Make the topping
4. In a small bowl, mix together the brown sugar and the melted butter until fully incorporated into a paste.

2 medium Valencia oranges
1 large Meyer lemon
2 teaspoons orange blossom water
1 teaspoon vanilla extract
5 large organic eggs
¾ cup (150 g) granulated sugar
Nonstick cooking spray
2⅓ cups (268 g) finely ground almond meal
1 teaspoon baking powder
¼ teaspoon kosher salt

For the caramelized citrus upside-down topping:
¾ cup (165 g) firmly packed light brown sugar
3 tablespoons unsalted butter, melted
2 small pink or Meyer lemons, halved lengthwise and sliced into half-moons as thinly as possible
2 small tangerines or blood oranges, halved lengthwise and sliced into half-moons as thinly as possible

Scatter the mixture into the bottom of the prepared cake pan and press together using your fingers or a rubber spatula to form an even layer. Lay the sliced citrus in an overlapping fish-scale pattern on top of the sugar.

5. Pour the fruit batter over the top of the sugar and sliced citrus and settle it by tapping the side of the pan several times to eliminate air pockets.

6. Bake for 10 minutes on the center rack. Drop the temperature to 375°F (190°C) and continue to bake for an additional 45 minutes. The cake should be dark brown in color. While still warm, run a knife along the perimeter of the pan and place a serving plate on top of the cake. Invert the pan so the cake falls to the plate. Remove the pan. Allow the cake to cool for another 15 minutes before serving. If you have a baker's torch, you can use that to give the fruit topping some extra color in the center.

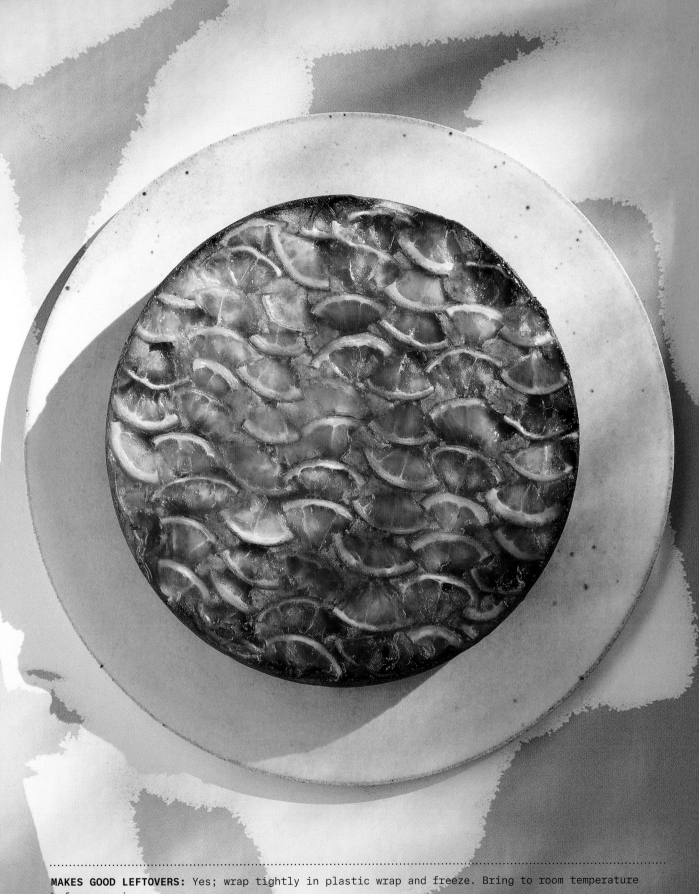

MAKES GOOD LEFTOVERS: Yes; wrap tightly in plastic wrap and freeze. Bring to room temperature before serving.

MAKE AHEAD: Yes.

SEASON: Winter.

Persimmon-Ginger Fruit-and-Nut Bread

Time: 1 hour, plus cooling
Yield: 1 loaf; serves 6

The Hachiya persimmon fascinates me, with its absolute refusal to be eaten even a moment before it is perfectly ripe. Unlike the crunchy Fuyu persimmon, this variety is the shape of a human heart, pointy at the bottom with a plump, crested top. If you've bitten into one before it was as squishy as a water balloon, you've experienced the repercussions firsthand—a cotton mouth to rival any stoner's late-night afflictions. High levels of tannins mellow once the fruit matures, rewarding patience with a flesh-like sweet jelly, ideal for baking.

This bread has the consistency and vibe of a carrot cake with a crispy crust. It shines with a slathering of ghee and a dark brown sear from a cast-iron skillet.

½ cup (120 ml) melted and cooled coconut oil, plus more for greasing the pan

1 tablespoon plus ½ teaspoon whole unhulled raw sesame seeds

⅓ cup (80 ml) plain full-fat yogurt

2 teaspoons Microplaned fresh ginger

1 large, extra-ripe Hachiya persimmon, pulp scooped out, skin and seeds discarded

2 large organic eggs, at room temperature

¼ cup (50 g) coconut sugar

1 cup (140 g) all-purpose flour

¾ cup (105 g) whole wheat flour

½ cup (435 g) unsweetened shredded coconut, toasted (see page 294)

Freshly cracked black pepper

½ teaspoon ground cinnamon

1 teaspoon baking soda

1 teaspoon kosher salt

½ cup (50 g) walnuts or pecans, toasted and roughly chopped (see page 293)

¼ cup (35 g) golden raisins

1. Preheat the oven to 350°F (175°C). Coat a loaf pan with coconut oil and scatter the sesame seeds inside, tapping the walls and the bottom of the pan to distribute them evenly. Set aside.

2. In a small bowl, whisk the yogurt, ginger, and persimmon pulp together until well combined (don't worry if it isn't perfectly smooth).

3. In a large bowl, whisk together the eggs and the coconut sugar until they are smooth and viscous. Add the coconut oil in a slow, steady stream, whisking continuously until uniform. Set aside.

4. In a medium bowl, combine the flours, shredded coconut, a few turns of freshly ground black pepper from the peppermill, cinnamon, baking soda, and salt and whisk to combine.

5. Add the dry ingredients and the persimmon-yogurt mixture in alternating thirds to the bowl with the eggs and stir well between each pour. When everything is combined, add the walnuts and the golden raisins and fold to incorporate. Your batter should be thick, similar to a muffin mix. Spoon into the loaf pan and level it out.

6. Bake for 45 to 60 minutes on the center rack, or until a knife comes out clean and the sides pull away from the baking tin. Let the bread cool for about 20 minutes before popping it out of the tin and onto a rack. Allow the bread to cool to room temperature before cutting and serving.

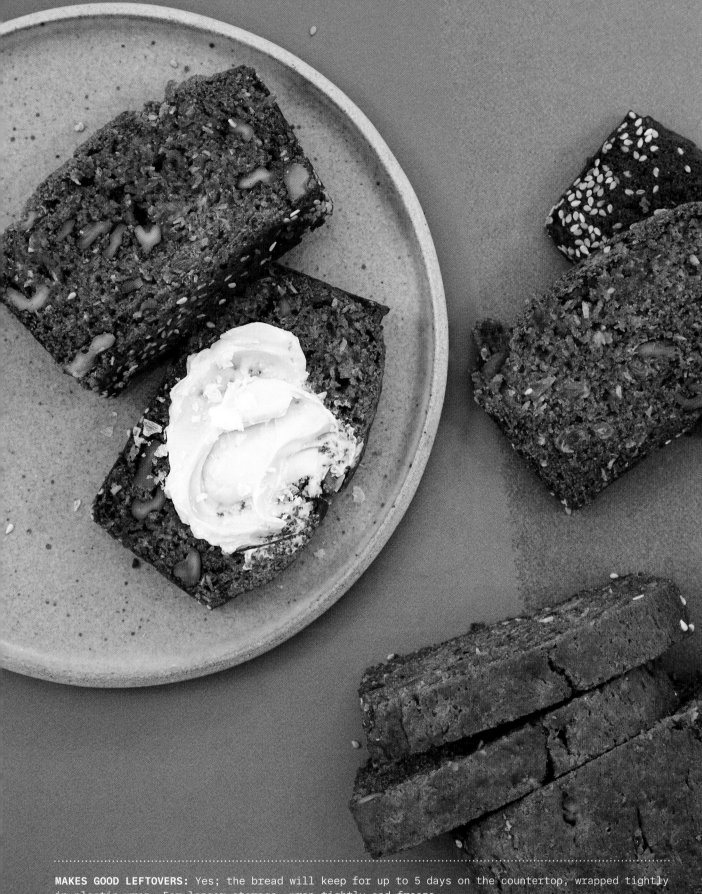

MAKES GOOD LEFTOVERS: Yes; the bread will keep for up to 5 days on the countertop, wrapped tightly in plastic wrap. For longer storage, wrap tightly and freeze.

MAKE AHEAD: Yes.

SEASON: Fall to early winter.

Gluten-Free Buckwheat Groat Pancakes

Time: 15 minutes, plus an overnight soak
Yield: Serves 5 to 7

Before this recipe, I considered pancakes junk food. Now I eat pancakes for breakfast most days of the week.

Buckwheat groats, the foundation of this pancake, are not to be confused with buckwheat flour. The groat is the whole seed of the buckwheat plant, most often sold "hulled" to remove its bitter outer layer. Buckwheat flour on the other hand, is ground with the bitter hull of the seed included, and while it has its place, I find it far too earthy to make crowd-pleasing pancakes. Besides being delicious, buckwheat groats are rich in protein, fiber, and a variety of antioxidants. They have a low gly-cemic index and they are gluten-free.

If you have a sourdough starter and you're looking for a place to use the discard, add a spoonful to the batter and blend before cooking.

1½ cups (270 g) hulled buckwheat groats
1 teaspoon apple cider vinegar
Dried or dehydrated blueberries (optional)
2 dates, pitted
½ cup (120 ml) plain full-fat yogurt
½ cup (120 ml) milk, buttermilk, or almond milk
4 whole large eggs
2 large egg whites
2 ripe bananas
1 teaspoon kosher salt
½ teaspoon almond extract
2 teaspoons baking powder
½ teaspoon baking soda
Ghee or coconut oil, for cooking

Do ahead
1. Add the buckwheat groats to a bowl with the apple cider vinegar and cover with 3 inches (7.5 cm) of water. Let stand for 8 hours or overnight. In the morning, drain and rinse until the water runs clear.

Make the pancakes
2. If using dried blueberries, soak them in warm water in a small dish to rehydrate for 10 minutes. Remove them from the water and squeeze them dry just before cooking.

3. Preheat the oven to 200°F (90°C) and place a baking sheet inside to keep your pancakes warm.

MAKES GOOD LEFTOVERS: Yes; the batter will be good for two days; a little less fluffy on day two, but still great.

MAKE AHEAD: Yes; freeze the pancakes in small stacks wrapped in plastic, with parchment in between each pancake. Defrost on the countertop and reheat in a hot cast-iron skillet.

SEASON: Year-round.

4. If your dates are leathery and tough, add them to a small dish and cover with hot water. Set aside for 5 minutes to soften and then discard the water (or add it to your iced tea as a natural sweetener). In a high-speed blender, combine the soaked and rinsed buckwheat, the yogurt, milk, eggs, egg whites, bananas, drained dates, salt, and almond extract and blend until smooth. Add the baking powder and the baking soda and pulse just to combine.

5. Place a 10-inch (25 cm) cast-iron skillet over medium heat. When the pan is hot, add the ghee or coconut oil and swirl to coat the pan. Pour a ladle full of batter into the pan and reduce the heat to medium. Cook for 2 to 3 minutes, until bubbles form on the surface of the pancake and the batter begins to dry out (if using blueberries, add them to the pancake now). Flip the pancake and cook on the second side until golden brown. Adjust the heat as necessary and use additional ghee as needed to keep your pancakes cooking evenly. Transfer the pancakes to the oven as you go to keep them warm.

6. Serve with Greek yogurt, whipped ricotta (see page 124), Macerated Meyer Lemon (page 207), Cacao Buckwheat Granola (page 276), or the labneh whipped cream filling from the banana cream pie (see page 80).

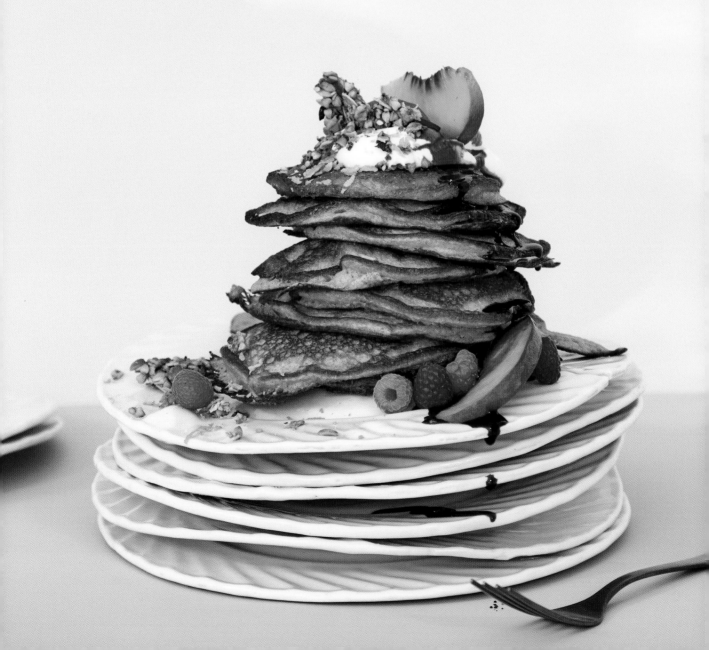

Pluot and Red Wine Tart with Hazelnut Crust

Time: 2 hours
Yield: One 9-inch (23 cm) tart

One day I couldn't figure out what to do with a leftover half-empty bottle of mediocre red wine, so I reduced it on the stovetop to make a syrup with an intoxicating aroma. All the flavor of the bottle of wine was concentrated down into a matter of tablespoons, and it was a triumph. For expediency on the crust, you can purchase skinned hazelnuts instead of the skin-on ones called for here, but skin-on hazelnuts are cheaper and more flavorful, and are arguably worth the effort.

For the syrup:
1½ cups (360 ml) red wine
2 tablespoons honey

For the crust:
1 large organic egg
Zest of ½ lemon
1 teaspoon vanilla extract
½ cup (1 stick/115 g) very cold unsalted butter, cut into ½-inch chunks
½ cup (68 g) skin-on hazelnuts
2 tablespoons sugar
1 cup plus 2 tablespoons (155 g) all-purpose flour
½ teaspoon kosher salt

To assemble:
1 tablespoon all-purpose flour
1 tablespoon sugar
1 pound (454 g) Pluots or plums, pitted and halved

Make the wine syrup

1. Pour the wine into a small saucepan over medium heat and bring to a boil.

2. Reduce the heat to medium-low, add the honey, and simmer to thicken, swirling the pot occasionally, about 30 minutes. Lower the temperature and cook for an additional 10 minutes, swirling more frequently. You should see large bubbles at this point, and it should have thickened to the consistency of thin maple syrup. Remove from the heat and set aside to cool and thicken to the consistency of loose honey.

Make the crust

3. Preheat the oven to 350°F (175°C) with a rack in the center of the oven.

4. Whisk the egg with the lemon zest and vanilla extract in a small bowl and refrigerate. Place the cubed butter in the freezer to chill.

5. Spread the hazelnuts on a baking sheet in a single layer. Toast in the preheated oven for 10 to 15 minutes, until the skins begin to flake off and the nuts are golden brown. Transfer the toasted nuts to a clean dish towel, bundle the edges of the towel together, and rub the nuts against one another to release the skins. Transfer the skinned nuts to a food processor with the sugar and process until they are the texture of coarse sand, scraping down the corners of the vessel if necessary. Add the flour and the salt and pulse to combine.

6. Add the butter to the food processor and pulse until the butter is the size of small pebbles. Add the egg mixture in a slow stream, pulsing as you go, until just incorporated.

7. Dump the dough directly onto a piece of parchment paper. Gather it together by hand into a ball, then flatten to a disk. Top with a second piece of parchment and roll the pastry out into a ¼-inch-thick disk (about 10 to 11

inches/25.5 to 28 cm wide). Transfer to a baking sheet and chill in the refrigerator for at least 30 minutes until solid and cold.

To assemble

8. Mix together the flour and the sugar in a small bowl. Remove the tart dough from the fridge and discard the top layer of parchment. Sprinkle the base of the tart with the flour and sugar mixture. Arrange the fruit on top, cut side down. Drizzle with 1 tablespoon of the reserved cooled wine syrup. Using the parchment paper underneath, fold the edges of the dough up and over the fruit, gently creasing, pinching, and repairing any cracks with your fingertips as you go. (Remember, it's rustic, so

don't worry about perfect pleats.) Chill the tart in the freezer until the dough is solid, 15 to 30 minutes.

9. Preheat the oven to 425°F (220°C). Slide the cold tart and its parchment paper onto a room temperature baking sheet. Lower the oven to 375°F (190°C) and bake for 45 to 50 minutes on a rack in the lower third of the oven, until the fruit is squishy to the touch but the skins are still intact. The syrup should be pooling and visibly bubbling.

10. Let the tart cool for at least 10 minutes. Drizzle with additional wine syrup and serve.

..

MAKES GOOD LEFTOVERS: Yes; after serving, refrigerate leftovers (not quite as good once they have been chilled, but still super tasty).

MAKE AHEAD: Yes; prepare a few hours ahead and leave covered on the counter.

SEASON: Summer.

..

Gluten-Free Tangy Banana Cream Pie with Date Nut Crust

Time: 25 minutes, plus time for the crust to chill and the bananas to cool
Yield: Serves 8

This no-bake dessert is inspired by the classic midwestern banoffee pie, an assemblage of store-bought crust, bananas, whipped cream, and dulce de leche. My healthier, raw, nut-based crust is sweetened with dates and is a treat for your gluten-free friends and family. Store the leftovers in the freezer and you'll get an ice cream-cake–like result, perfect for sneaking "just a sliver" as a late-night snack.

For the crust:

½ cup (70 g) raw almonds, toasted (see page 293)

1 cup (120 g) raw walnut pieces, toasted (see page 293)

¼ cup (25 g) cocoa powder, plus more for serving

½ teaspoon kosher salt

¾ cup (145 g) packed pitted Medjool or halawi dates, finely chopped

2 tablespoons unsalted almond or peanut butter

For the filling:

¾ cup (180 ml) heavy whipping cream

¾ cup (180 ml) labneh

½ teaspoon vanilla extract

Zest of ½ Meyer or Eureka lemon

2 tablespoons maple syrup

5 ripe but firm bananas

½ teaspoon unsalted butter

1 tablespoon coconut sugar

¾ teaspoon ground cinnamon

Make the crust

1. Place the nuts in a food processor or high-speed blender and pulse to the texture of coarse sand, stopping the blender periodically to scrape the nuts from the area around the blade and the edges of the bowl, careful to stop before you make nut butter. Transfer the nuts to a bowl with the cocoa powder, salt, dates, and almond butter. Combine using your fingers until well incorporated. Press into a 9½-inch (24 cm) tart pan with a removable bottom. Cover with plastic wrap and freeze for 1½ hours or overnight.

Make the filling

2. Place the whipping cream in a large ceramic, glass, or plastic bowl. Using a hand mixer on medium-high, whip the cream until light and fluffy. With the hand-mixer on low, add the labneh, vanilla, zest, and syrup and mix just to incorporate evenly. Cover and store in the fridge until ready to assemble and serve the pie.

MAKES GOOD LEFTOVERS: Yes; store in the freezer, wrapped tightly in plastic.

MAKE AHEAD: Make the crust ahead; wrap tightly with plastic and store in the freezer. Store the whipped topping in the fridge. Broil the bananas and assemble just before serving.

SEASON: Year-round.

To serve

3. When ready to serve, preheat the oven to broil with a rack in the upper third of the oven. Line a baking sheet with aluminum foil. Peel and slice the bananas in half lengthwise, and nestle the bananas together in a line, curving in the same direction on the center of the baking sheet. Dot with small blobs of butter, sprinkle with the sugar and cinnamon, and broil the bananas for 5 minutes. Rotate the pan and cook for another 4 to 5 minutes until the surface of the bananas is rich, brown, and bubbling. Allow to cool to room temperature.

4. Remove the pie crust from the freezer. Layer the bananas in a concentric circle on the base of the crust. Top with cream and dust with cocoa powder. Serve immediately.

Saffron, Cardamom, and Date Tea

Time: 40 minutes
Yield: About 7 cups (1.68 L)

A little pinch of saffron goes a long way, and the rich flavor of simmered dates carries throughout a big batch of this beverage. This is my secret to hydration! Caffeine-free and only lightly sweet, you can drink the whole pot yourself throughout the day, or serve it as a non-alcoholic beverage, hot or cold.

3 Medjool dates (4 if using a smaller variety)
2 whole cardamom pods, lightly smashed using a mortar and pestle
8 cups (**1.9 L**) filtered water
1 miserly pinch saffron threads

1. Place the dates and the cardamom pods in a pot with the water.

2. Bring to a boil, reduce the heat to a simmer, and cook for 30 to 40 minutes, until the dates fall apart. Remove from the heat and add a pinch of saffron, crushing it between your fingertips. Let the brew steep for 5 minutes.

3. Strain and serve hot or cold.

MAKES GOOD LEFTOVERS: Yes.

MAKE AHEAD: Yes.

SEASON: Year-round.

EFFICIENCY WITH SOUL

Tom Sachs

Tom Sachs is *always* working, and lunchtime is no exception. More method acting than entertaining, per se, the midday meal at his New York studio is just another scene in the integrated performance of Tom Sachs's existence. Once a week in his Chinatown space of twenty-eight years, an army of eager art school grads, uniformed in utility over-coats and Nike × Tom Sachs sneakers, pauses for "rice and slop." This is Tom's crude description of a proprietary food group that encompasses anything saucy, filling, and flavorful enough to carry a plate of performance-enhancing carbs. Today we are feast-ing on his very favorite iteration: Louis Armstrong's recipe for red beans and rice. Prized for its economy, acces-sibility, and cultural heft, he tells me, "It's the most efficient meal on earth, but it has soul." Efficiency with soul—Tom Sachs's oeuvre in a nutshell.

Walking through the obsessively cataloged racks of materials and supplies feels less like perusing an art studio and more like exploring the biodome, a place where one is expected to enter and never leave. On a Monday morning, a dozen hardworking employees pass through the bunker-like kitchen, grabbing coffee and snacks before they scatter to

Inspired by the International Space Station, the studio kitchenware is branded with the NASA logo.

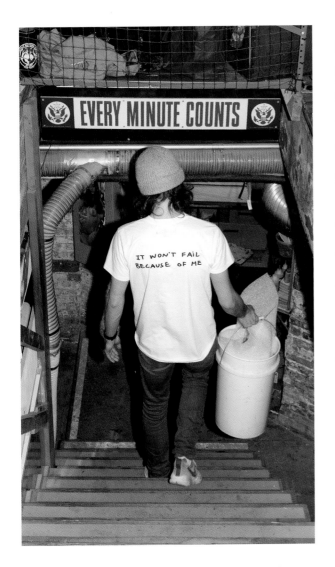

Assistants wear Tom Sachs apparel, including T-shirts with sayings such as, "It won't fail because of me."

solder, saw, and weld countless playful endeavors, from a scrappy Chanel manicure station to the trappings of a modern Japanese tea ceremony (think matcha whisk attached to the tip of a drill gun like an animated exquisite corpse). When the handmade collides with the industrial, hot glue, sharpies, and duct tape are the humble ingredients for ambitious works of art. It's the arte povera of our time. There is no limit to what can be made here, from beans and rice to a mock mission to Mars.

On this Monday morning, I sit with Claire, the designated Food Systems Manager, as she executes her assignment to make an affordable, streamlined meal for twelve hungry assistants and one very particular boss. (It is worth noting: Claire is not a professional cook by any stretch.) Per Sachs's request, she is decoding a type-written recipe for red beans and rice from Louis Armstrong's 1952 autobiography, *Satchmo: My Life in New Orleans*. Armstrong is Sachs's personal idol. "I've studied everything about [him]," he explains, "he represents the positive side of the darkest tragedy of American history, and the art of the African diaspora—the joy and love and the magic of it. Without Louis you wouldn't have rock 'n' roll, hip hop.... There are so many good things about his life, and this recipe is one of them. He even signed his letters 'red beans and ricely yours, Louis.'"

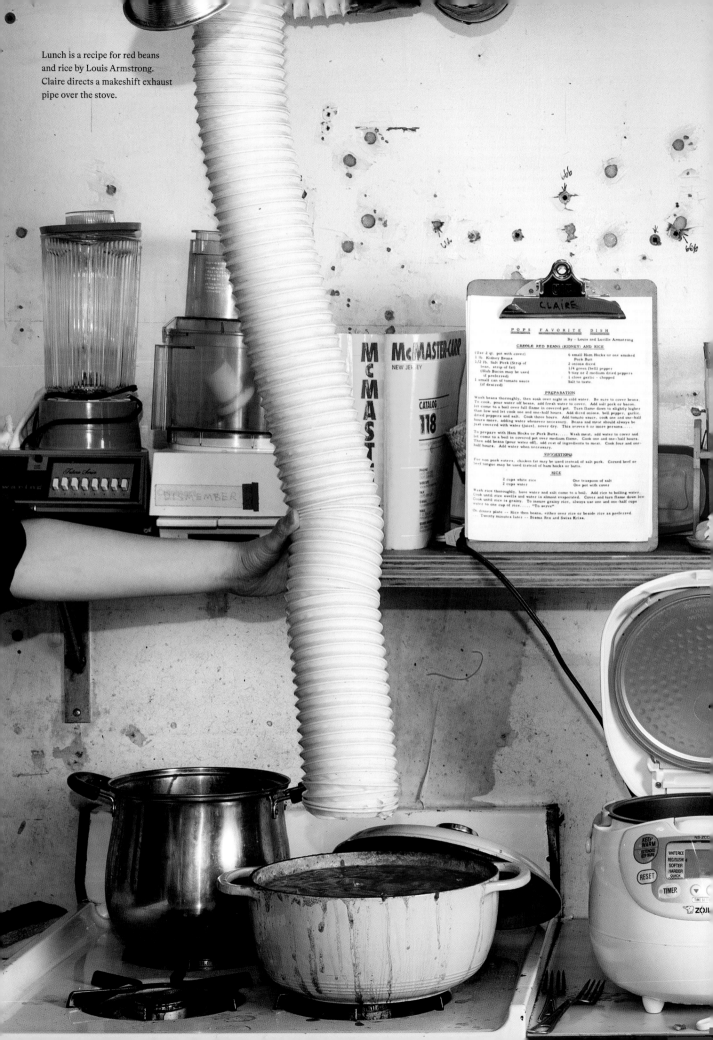

Lunch is a recipe for red beans
and rice by Louis Armstrong.
Claire directs a makeshift exhaust
pipe over the stove.

This is Claire's first time preparing this dish, but Armstrong's recipe has a longstanding legacy in the studio. Rice and beans were integrated into Tom's elaborate 2012 Park Avenue Armory show, a simulation of a space launch that reimagined every aspect of the Mars Rover in a four-week-long seamless endeavor. A cart serving Armstrong's recipe (beans selected and anointed by Martha Stewart herself) provided a meaningful meal for "astronauts" and the audience alike. Tom adds, "At NASA's headquarters in Florida, they all share red beans and rice after a successful launch." So, to get their collective head in the game, rice and beans were served for studio lunch on a weekly basis for the entire year leading up to the show.

Minutes before the clock strikes 1 P.M., Claire fills wonky pinch pots scribbled with the NASA logo with economy toppings—shredded cheese, tortilla chips, avocado, sour cream, and summer sausage. The beans sit on the stove next to the sacred rice cooker. (Tom assures me, one of the first steps to becoming a successful artist is to "get a good insulated rice cooker.") An assembly line of hungry assistants snakes through the galley kitchen. They serve themselves and gather snugly around the center table. Work is the topic of conversation—impending deadlines, product collaborations, shipping dates for an upcoming show in Tokyo. When the meal is finished, silence falls and the final choreography ensues—forks are dropped in unison into a center enamelware dish that is circulated counterclockwise to receive any last scraps of food, each plate stacked on top of the last. Tom looks at me and reiterates, "Feeding oneself can, of course, be an art, but sometimes we just have to get it out of the way."

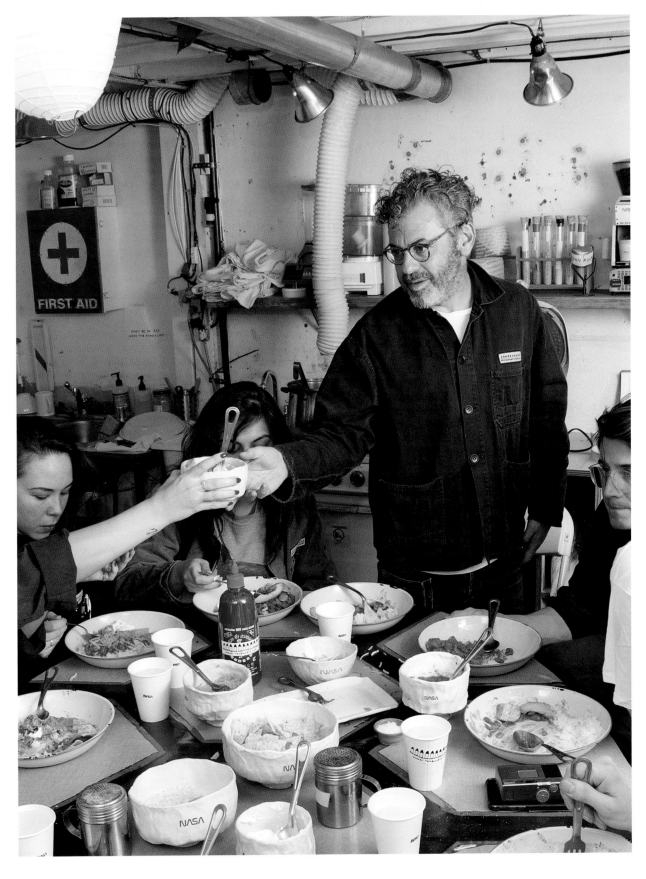

Artist Tom Sachs hosts daily staff lunch
breaks in his Chinatown, NY, studio.

BE THE AGGRESSIVE FRIEND-MAKER

Simple, Affordable Recipes to Feed a Crowd

On more than one occasion, my friends have recounted the tale of our first meeting and falling into friendship as a courtship spear-headed by me. While some people play hard to get and proceed with new relationships with caution, I've always opted for the straightfor-ward approach—if I like you, I will sing it from the rooftops!

I use my aggressive friending tactics when it comes to my own relationships, but I also foist it onto others—when the party is at my house, I expect you to invite your mom, your new colleague, and the childhood friend you haven't seen in twenty years. When entertaining for a large group, the threshold should be elastic enough to easily accommodate that surprise guest that just might turn out to be my new best friend.

This chapter is all about feeding a crowd without losing your mind and cursing those last-minute RSVPs. It's about finding infinite inspiration in a head of cabbage. These recipes make great leftovers and they are scalable, filling, and make for a stunning presentation.

PARISIAN OFFICE PARTY Onestar Press

On a recent trip to Paris, my hosts, artist book publishers and partners in life and work, Mélanie Scarciglia and Christophe Boutin, set out to prove that it is indeed possible to throw an easy, breezy, chic soirée in your place of work with delicious homemade food and great company. Cubed pepper jack, cheap chardonnay, and awkward conversation set against the hum of the copy machine—this is not that kind of office party.

I meet Mélanie at her neighborhood food co-op in the thirteenth arrondissement. We walk the snug aisles of the unbranded shop selecting seasonal produce with dirt still clinging to its roots. All of it was picked this morning and set on the shelf in no-frills farm utility baskets. This is a purist's grocery experience. We pluck cartoonishly plump dumpling squash and wooden baskets of fresh mushrooms. We handpick fuzzy mirabelle plums grasping at the tail end of their season, a much-

Scarciglia and Boutin review artists' projects in their Paris studio.

anticipated blip on the French calendar. Mélanie—better known as the co-founder of Onestar Press and Three Star Books— proves herself to be an expert shopper, zipping around Paris from classic boulangerie to crunchy health food store.

Tonight, we celebrate Mélanie and Christophe's twenty years of publishing visionary artists' books. For every publication they complete, they host a

BE THE AGGRESSIVE FRIEND-MAKER

Onestar's collection of artist-authored print-on-demand books.

fête, a coming out party for the artist-as-author. House party–meets–art world vernissage, these are generous affairs with homemade food and drink prepared by Mélanie herself in their apartment just across the road. "It's one day of hard work, but at the same time, it's a day of relaxation since I am not in front of the computer and I am not traveling."

In the kitchen, double-height windows flank rows of books as far as the eye can see. Trompe l'oeil photo collage sculptures of Greek urns and vases by artist Daniel Gordon (whose work appears throughout this book) are nestled amongst functional pottery from all over the world. The kitchen backsplash itself is a text piece by conceptual artist Lawrence Weiner, a longtime collaborator who made it just for them. The colorful French phrase that dances across the room translates to "burn the candle at both ends," a fitting backdrop for the activity that unfolds before me. Isolde, their twelve-year-old daughter, has just returned home from school, and is promptly put to work slicing mushrooms for a barley salad that will be served at room temperature. Mélanie's closest friend, illustrator Sophie Dufief, is conveniently dressed all in white, tossing puffs of pastry flour as she readies the surface of the wooden dining table for slab after slab of handmade tart dough for those seasonal plums.

Cooking for an amorphous crowd can be daunting. "Sometimes it's twenty people, other times it's one hundred. There's no way to know in advance," Mélanie tells me, unphased. It's not a

formal dinner, just a light but nourishing meal to encourage people to stay a while, to feel at home. The squash have been roasted and transformed into a simple soup now simmering on the stove (easily scalable and welcome as leftovers). The bread is abundant—this is Paris, after all. Baguettes are sliced and served with a ready-to-go accompaniment—fresh mounds of ricotta draped in a spicy tomato jam and garnished with a pinch of dried oregano, treasures brought back in a suitcase from Mélanie's hometown in Puglia. The tarts, well, there can never be too much mirabelle plum tart. The last one comes out of the oven and is set on a ceramic platter painted with the letters "L.H.O.O.Q.," the title of Dada artist Marcel Duchamp's 1919 readymade defacement of the sacred image of the Mona Lisa postcard. Scandalous at the time, when the abbreviation is said aloud in French, it translates to "she is hot in the ass," and still garners a chuckle, especially in the context of a sexy dessert.

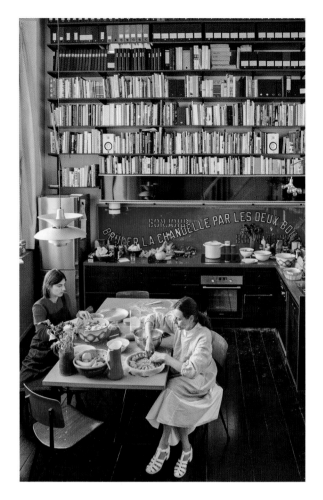

Scarciglia and her friend Sophie Dufief prepare a meal for thirty in Mélanie's apartment across the road from Onestar studio.

With the provisions complete, we walk all of the food across the street from the apartment to the studio where the first guests mingle under the studio work lights. Fluorescents, usually a party foul, are charming in this context, an unapologetic reminder that we are indeed in a place of creative work and play.

Guests serve themselves slices of seasonal pear tart, eating with their hands as they mingle.

BE THE AGGRESSIVE FRIEND-MAKER

The noise in the room works up to a fever pitch. Curators, architects, museum directors, and writers are pleased but not at all surprised to bump into each other in this familiar space. As I lift my hand for my first taste of soup, an arm glides over my shoulder and a pinch of salt rains down into my bowl. Christophe, the life of the party, is on a mission to ensure each and every one of his guests has the optimal experience, down to that very last dash of seasoning.

At some point, plates are cleared and an esoteric Dutch board game called *sjoelbak* is set out on the table. The wine keeps flowing and the competition turns cutthroat. You don't get this far in the art world by playing nice.

Guests enjoy simple food and drink in the studio.

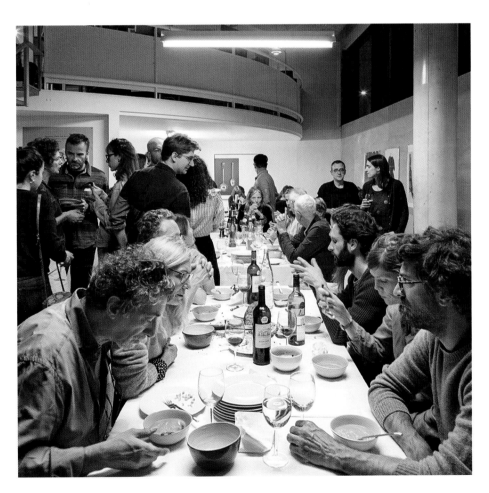

Chicken and Jeweled Rice

Time: 1 hour 15 minutes
Yield: Serves 3 to 4

This dish is inspired by all the beautiful Persian baked rice dishes, the most sophisticated version of a one-pot meal decorated with handfuls of fresh herbs and gems of sweet and tart dried fruit. And saffron—don't forget the saffron! I suggest you abandon chicken breasts forever in favor of bone-in chicken thighs, idiot proof and always moist and juicy.

8 pieces (about 2 pounds/910 g) bone-in skinless chicken thighs
¾ teaspoon kosher salt, plus more for seasoning the chicken
Cracked black pepper
⅓ cup (50 g) golden raisins
¼ cup (60 ml) red wine vinegar
1 generous pinch saffron
2 tablespoons ghee
1 large yellow onion, diced
2 cups (480 ml) chicken broth, plus more for deglazing
1½ cups (270 g) white basmati rice
6 green cardamom pods
¾ cinnamon stick
Pomegranate molasses (see page 42), for glazing

For serving:
¼ cup (35 g) pine nuts, lightly toasted (see page 293)
¾ cup (23 g) torn fresh dill, tough stems discarded
¾ cup (23 g) torn fresh mint leaves
Pinch ground Urfa chile (optional)

1. About 45 minutes before cooking, remove the chicken from the fridge and allow it to come to room temperature. Pat the chicken dry with a paper towel. Season generously on all sides with salt and black pepper.

2. In a small saucepan, combine the raisins and vinegar and place over low heat until warm, about 1 minute. (You can also do this by combining them in a microwave-safe bowl and blitzing in the microwave until warm.) Remove from the heat and allow the raisins to plump.

3. Crush the saffron between your fingertips into a small dish and cover with 1 tablespoon of hot water. Set aside to bloom.

4. Place 1 tablespoon of the ghee in a large cast-iron skillet with a tight-fitting lid or a large tagine over medium-high heat. When the oil is hot, add the chicken, 3 or 4 pieces at a time, and brown for 3 to 4 minutes on each side, pressing them down with a pair of tongs to sear. When ready to flip, the chicken should release easily from the pan (if you rush, the flesh will stick). Transfer the browned chicken to a plate.

5. Add a splash of chicken broth and the onions to the pan and deglaze, scraping the bottom of the pan. Add the remaining tablespoon of ghee and the salt and sauté the onion on medium-high heat for 5 minutes until golden brown.

6. Add the rice and sauté quickly to coat in the oil and mix with the onions. Add the broth, the saffron with its liquid, the cardamom pods, and the cinnamon stick. Strain the raisins from the vinegar, discarding the excess, and add them to the pan. Nestle the chicken in with the rice and brush the surface with a generous amount of pomegranate molasses to coat. Bring the rice and chicken mixture to a boil. Reduce to a simmer and cover with a tight-fitting lid or tagine top. Cook for 30 minutes. Remove from the heat and allow to sit for an additional 15 minutes before uncovering.

7. To serve, drizzle with more pomegranate molasses, top with pine nuts, a generous handful of herbs, and an optional pinch of Urfa chile.

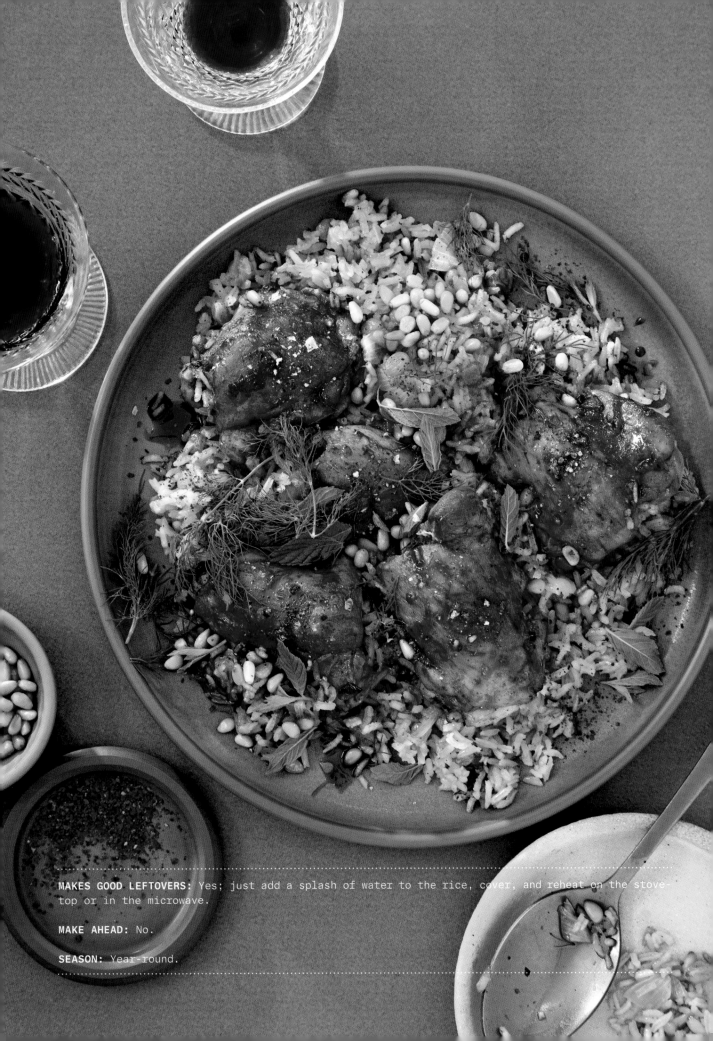

MAKES GOOD LEFTOVERS: Yes; just add a splash of water to the rice, cover, and reheat on the stove-
top or in the microwave.

MAKE AHEAD: No.

SEASON: Year-round.

Fig Leaf Chicken

Time: 1 hour 15 minutes, plus overnight dry brine and time to dry the fig leaves
Yield: Serves 4 to 6

Some say fig leaves taste like toasted coconut, but to me they sing of earthy green matcha with a hint of allspice. If you live in Southern California like I do, fig trees grow like weeds. But look closely and you will find them all over Queens and in Carroll Gardens, Brooklyn (Italian immigrants planted them), and, of course, anywhere in the Mediterranean or Middle East. Fig leaves dry really quickly. Look for tender, light green leaves (careful to avoid the milky white sap that oozes out when you snip them—it can irritate your skin). Rinse the leaves to remove any debris and lay them outside or on a windowsill in the sun. They should be crispy and dry in 24 hours or less, depending on your climate.

1 organic chicken (about 3 to 4 pounds/1.36 to 1.82 kg)

3 to 4 teaspoons kosher salt (1 teaspoon per pound of chicken)

8 to 10 medium fig leaves, stemmed, washed, and fully dried in the sun (see headnote)

¾ teaspoon ground cinnamon

1 teaspoon ground turmeric

½ teaspoon ground chile pepper (Piment d'Espelette, Aleppo, or Silk chile flakes)

1 tablespoon extra-virgin olive oil

½ lemon (sliced in half crosswise)

½ head garlic (top sliced off crosswise)

Baker's twine

¼ cup (60 ml) chicken broth or water

The night before

1. Pat the chicken really dry with a paper towel all over. Season all exposed skin and inside the cavity with kosher salt. Let the chicken rest in the refrigerator, uncovered, on a wire rack set over a rimmed baking sheet or on top of a trivet on a large plate for 12 to 24 hours (the idea is to raise the chicken off the surface of the plate so it can dry all over).

2. Remove the chicken from the fridge 1 hour before cooking and bring it to room temperature. Preheat the oven to 450°F (230°C) with a large cast-iron skillet inside.

3. To make the seasoning, place the dried fig leaves in a high-powered blender and blend to a fine powder. Measure out the powder—you should have approximately 3 tablespoons. Mix the fig powder with the cinnamon, turmeric, and chile.

4. Using a paper towel, blot the entire chicken dry of any excess moisture. Rub the chicken inside and out with the olive oil and sprinkle the spice mix all around, coating the skin evenly using your hands. Place the lemon half inside the chicken cavity. Truss the bird by tying together the ends of the drumsticks with baker's twine.

5. When the oven has come to temperature, remove the skillet and place the chicken in the pan, nestling the head of garlic alongside it. Roast for 45 to 55 minutes, or until a thermometer stuck in the thickest part of the thigh reads 160°F (70°C). Remove the lemon from the chicken cavity and reserve. Place the chicken on a cutting board to rest for 15 minutes.

6. Set the skillet on the stovetop over low heat (use caution, your pan is VERY hot). Using a pair of tongs, squeeze the juice from the roasted lemon half into the pan. Add the broth. Squish the garlic cloves out of their skins and mash them with the back of a fork. Whisk to make a sauce, scraping up any bits that are stuck to the pan.

7. Carve the bird and arrange on a plate, drizzle with the sauce, and serve.

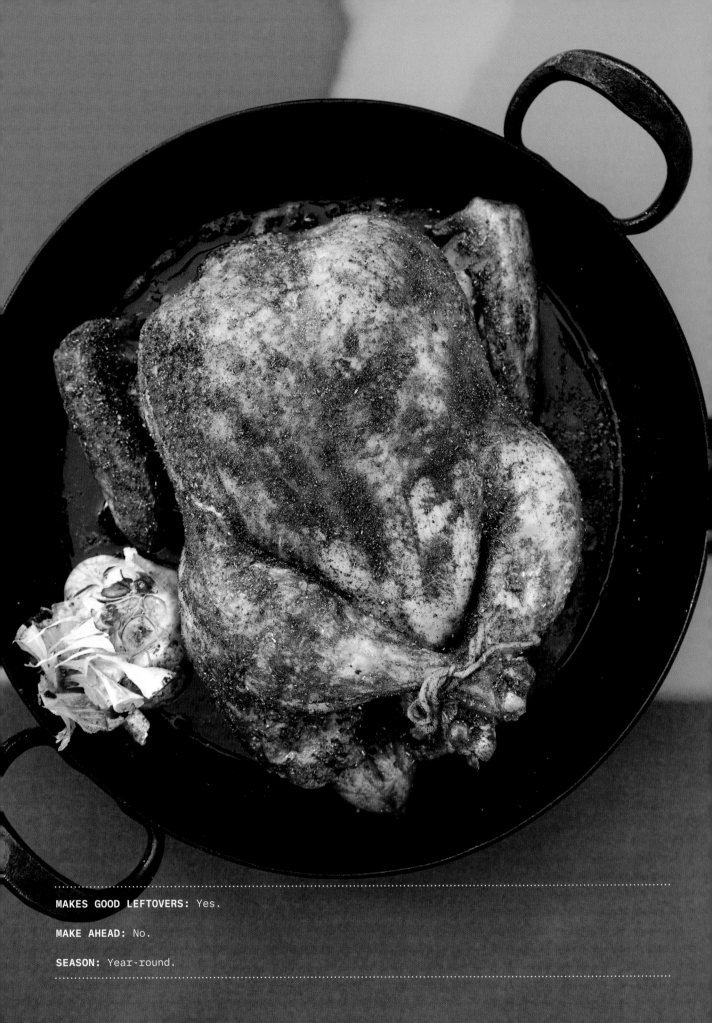

MAKES GOOD LEFTOVERS: Yes.

MAKE AHEAD: No.

SEASON: Year-round.

Penne with Sardines, Saffron, Currants, and Pine Nuts

Time: 40 minutes
Yield: Serves 2

I am passionate about tinned sardines—the fancier the better. They are low in mercury, a good source of protein and omega-3 fatty acids, and they are sustainably fished. This take on the Sicilian dish penne con le sarde is traditionally made with boneless fresh sardines (go ahead and use those if you can get them!), but if you embrace tinned fish, this is a dish you can make in a pinch with ninety-nine percent dry goods (assuming you always have pasta, a couple onions, and garlic on hand). It's unbelievably satisfying. Serve as a sauce for penne or bucatini, or skip the pasta and spoon over oven-roasted radicchio with a drizzle of syrupy balsamic vinegar.

½ **teaspoon** kosher salt, plus more for salting the water

1 pinch saffron threads

2 **tins (8.5 ounces/240 g)** oil-packed wild sardines

¼ **cup (60 ml)** extra-virgin olive oil

2 medium yellow onions, halved and sliced thin

¼ **teaspoon** red pepper flakes, plus more for serving

1 **to 2** cloves garlic

2 **tablespoons** dried currants

3 **tablespoons** pine nuts, lightly toasted (see page 293)

½ **cup (120 ml)** dry white wine

½ **pound (227 g)** dried penne pasta

¼ **cup (8 g)** roughly torn fresh parsley leaves

1. Bring a large pot of heavily salted water to a boil.

2. Place a pinch of saffron in a small ramekin, crushing the fronds between your fingertips. Add 3 tablespoons of hot water to cover. Set aside.

3. Drain the sardines, remove and discard the spines, and set them aside.

4. Place a large skillet with the olive oil over medium-high heat. Add the onions, salt, and red pepper flakes and sauté for 10 minutes, or until the onions are completely soft. Add the garlic and continue cooking for 5 minutes before adding the currants and pine nuts. Cook for an additional 2 minutes before adding the sardines. Toss to coat.

5. Add the white wine and the saffron with its water. Raise the heat and cook at an active simmer for 7 minutes. Turn the heat down as low as it can go.

6. Add the penne to the pot of boiling water. Bring the water back up to a boil and cook according to package instructions (taste the pasta; it should be al dente but there shouldn't be an uncooked white ring at its center when you bite into it). Add 2 tablespoons of the pasta water to the sauce and stir. Drain the pasta and return it to the pot. Add the sauce to the pasta and toss to combine. Finish with an extra pinch of red pepper flakes and the torn parsley and serve.

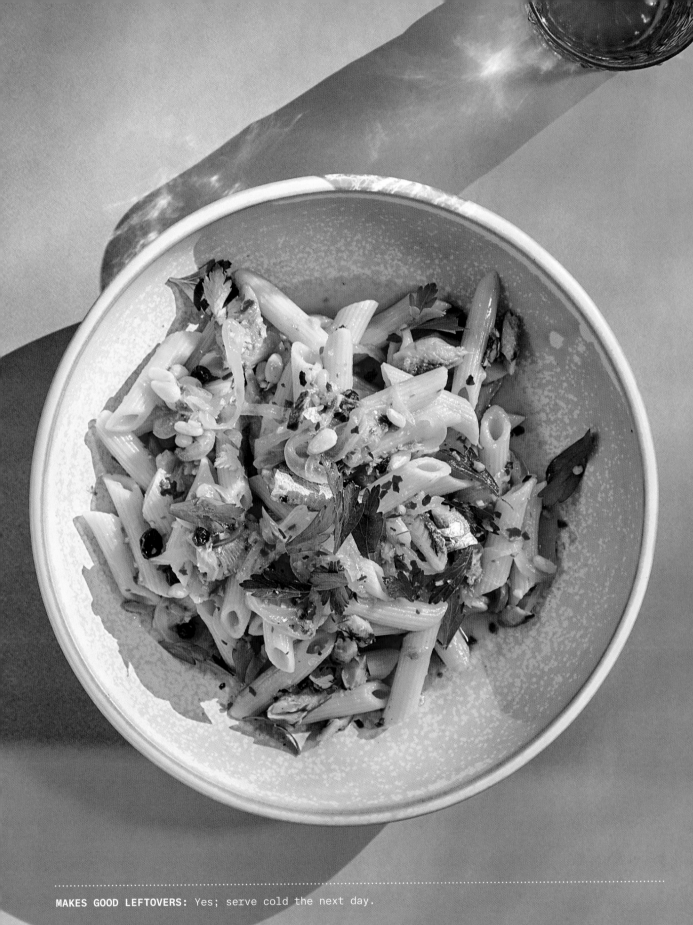

MAKES GOOD LEFTOVERS: Yes; serve cold the next day.

MAKE AHEAD: No.

SEASON: Year-round.

THE FUGUE-LIKE STATE OF EARTH PIZZA

On the face of it, Earth Pizza is a wood-fired pizza pop-up in East Los Angeles. But if you ask any of its well-fed attendees, their outsized adoration tells a larger story. "Earth pizza feels like some evangelical pamphlet of a utopian future: People sitting in circles in the grass with babies, dogs, weed, and extraordinarily delicious pizza," says David Kramer, owner of Los Angeles cult bookstore Family Books. There is a fugue-like pace to an event that revolves around a wood-fired oven. The food refuses to be rushed. It is set to its own internal clock, one that stretches a meal seamlessly from day to night without anyone taking note.

Ramunni (left) and Herman (right) in the Montecito Heights neighborhood of L.A.

What distinguishes Earth Pizza's legendary parties is their precise blend of insider caché with the deeply unpretentious nature of the hosts, mosaic artist James Herman and Jack Ramunni, the logistics person behind the wildly popular, ever sold-out Grateful Dead revival merch site, Online Ceramics. Invites, sent the day before, suggest you come for "pizza from 7 to 10 P.M. and party until dawn." The menu is a collection of woo-woo names like "Sunrise," "Sunset," "Ram Dass," and "Forest Garden." The caliber of the made-to-order pizza is matched only by the setting in which it is served—this is the last remaining undeveloped corner of Los Angeles's East Side, a sun-drenched verdant hilltop

BE THE AGGRESSIVE FRIEND-MAKER

Ramunni (left) and Herman (right), prepare ingredients for Earth Pizza in the home Herman built himself.

overlooking the aptly named Happy Valley.

I arrive early to assist with prep for the summer edition of Earth Pizza. Jack and James are standing on the edge of a precipice, scooping primordial blobs of leavened dough out of a bin and onto a piece of plywood, wobbly atop metal sawhorses. This is James's studio and makeshift prep kitchen, just one of the slapdash structures that dot this untamed landscape, deemed "unbuildable" by city building code. "They needed a groundskeeper," James explains, "Many a hippy before me promised to do something with this land, but they never followed through. I lived in my truck while I built my studio and home. Five years later, I'm still here." He gestures toward the 100-square-foot abode of his own making that he shares with his girlfriend, artist Jamie Felton. We walk through the terraced vegetable garden and suddenly James is reclining (fully clothed), in a claw-foot tub, its water source a dangling length of garden hose. He pops up to continue the house tour, leading me to the jewel box outdoor compost toilet, bedazzled inside with his signature mirror-and-tile mosaic. Never ever has modern plumbing seemed so expendable.

The pizzamaking developed organically. In 2017, Jack and James were both living on this magical hilltop. After months without an oven of any kind, they were inspired to build one from scratch. Their bible was a tattered 1970s DIY manual by Kiko Denzer titled, "Build Your Own Earth Oven." It

took two-and-a-half days to work through the instructions step-by-step, making use of available dirt, straw, and clay to form a resilient mud structure. (The method is called "cob.") They perfected their dough and used Jack's birthday as the occasion for the inaugural burn. From then on, the pizza parties just kept happening. Word spread, and so did the waitlist. When the headcount ballooned out of control, they sent the invites later and later, in the hopes that fewer people would be able to attend. An event with such a following deserved a name: Earth Pizza.

The Earth Pizza station.

My first Earth Pizza is James and Jack's seventeenth. The effort it takes to find this hideaway, a dusty drive up an unmarked winding dirt road followed by a harrowing trek down a steep woodland pathway, is a schlep with a sweet reward. The menu is seasonally inspired—we are collaborating on a salad-pizza with chicory lettuce, Parmesan, and anchovy (my "last meal" of choice). A pie is twelve dollars, while supplies last, but the pre-rolled home-grown joints and views of the city are always free. As the mingling parties swell, James and Jack scatter toppings onto pliant dough and wait for cheese to bubble, patiently nursing one perfect pie at a time. The pizzas are willingly passed around from group to group, nobody grumbles about the wait or keeps track of who came before or after them in line. No, this is not that kind of party. Instead, it's like that Jennifer Lopez music video, "Waiting for Tonight," from 1999 . . . but as the trees part, instead of stumbling upon a sexy jungle rave, you find Los

BE THE AGGRESSIVE FRIEND-MAKER

Angeles's creative intelligentsia clustered on a scenic hilltop, drinking homebrew and sharing something undeniably delicious.

James Herman cooking up pizzas in his homemade pizza oven built from mud and stone.

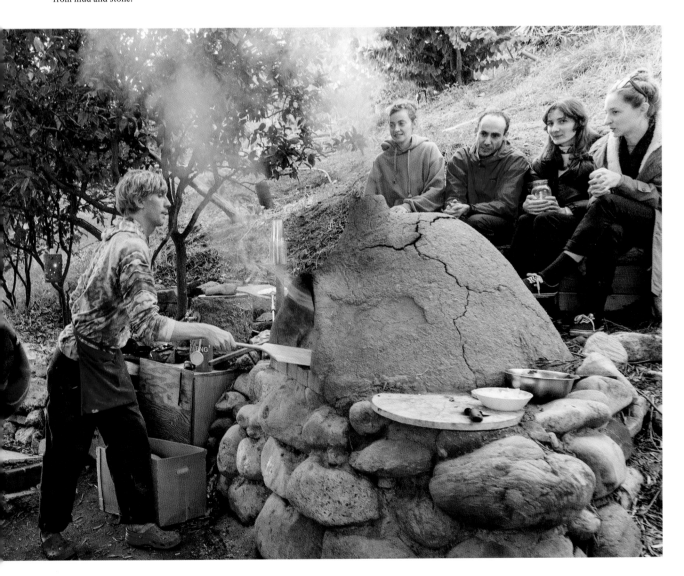

Rigatoni with Jammy Summer Squash and Tomato Sauce

(Variation: Make It Meat Sauce!)

Time: 1 hour 45 minutes
Yield: Serves 4

I learned this recipe from an Italian family friend who wowed us all with his wizardry with only four main ingredients. This is a stupid-simple sauce, but the extended cook time transforms the squash into a sweet, jammy delight. It can be served on its own as a vegetable side, over toast, or tossed with pasta as a main, with or without added ground beef. Make this in large batches at the end of the summer when tomatoes and squash abound and freeze for the darkest days of winter.

Use larger squash or some zucchini rather than baby squash—you'll want their water content for the longer cook time. Look for really juicy heirloom tomatoes—orange makes for a really nice color.

½ cup (120 ml) high-quality extra-virgin olive oil, plus more for the pasta

6 cloves garlic, thinly sliced

3 pounds (1.3 kg) medium or large heirloom summer squash (about 4), cut into 1- to 2-inch-thick (2.5 to 5 cm) chunks

2 teaspoons kosher salt, plus more for the pasta water

¼ teaspoon red pepper flakes, plus more for serving

½ pound (226 g) ripe heirloom tomatoes (about 4 or 5)

1½ cups (20 g) lightly packed, roughly torn fresh Genovese basil

1 pound (455 g) rigatoni

Freshly grated Parmesan cheese, for serving

1. Set a large Dutch oven over medium heat. When the pan is hot, add the olive oil and the garlic and sauté for 30 seconds until fragrant but not brown. Add the squash, salt, and red pepper flakes and cook for 12 minutes, until you start to see some color on the skin of the squash. Stir regularly to prevent the garlic from burning on the bottom of the pan.

2. While the squash cooks, slice and remove the butt end of each tomato. Using the large holes of a box grater, grate the flesh into a large bowl. Discard the skin when you get to the end. Add the grated tomato to the squash and cook for 1 minute on high, then reduce to medium-low, cover, and cook for 15 minutes. Remove the cover and cook at an active simmer for 1 to 1½ hours, or until the tomato juices have cooked down and thickened and the squash is soft and jammy. Stir every 15 minutes or so, scraping any caramelized bits from the bottom of the pan, stirring more frequently toward the end as the sauce reduces. Add 1 cup (13 g) of the basil and stir to combine. Cover and remove from the heat.

3. Fill a large pot with heavily salted water and bring it to a boil. Cook the pasta according to the package instructions, and just before draining, set aside about 1 cup (240 ml) of the pasta water. Drain the pasta, transfer to a serving bowl, and toss with a glug of olive oil. If the sauce feels too thick, add ¼ cup (60 ml) of the reserved pasta water to the sauce and stir to thin, adding more if needed. Spoon the sauce over the cooked pasta.

4. Garnish with the remaining ½ cup (7 g) fresh basil, a pinch of red pepper flakes, and a grate of Parmesan cheese.

Make it meat sauce!

If you want to add meat, season the beef with salt and a few cracks of freshly cracked black pepper. Heat a 10-inch (25 cm) cast-iron skillet over medium heat and coat with the olive oil. When the oil is hot but not smoking, break the meat up into small clumps across the surface of the pan. Cook without disturbing for 5 minutes until brown on one side, then stir and flip, breaking up any large clusters. Cook for an additional 2 to 3 minutes until just cooked through. Transfer the meat to a separate plate. Once you have added the pasta water to the tomato sauce and stirred well, add the cooked meat to the sauce and stir to combine.

For the sauce:

1¼ pounds (565 g) ground beef
1½ teaspoons kosher salt
Cracked black pepper
2 teaspoons extra-virgin olive oil

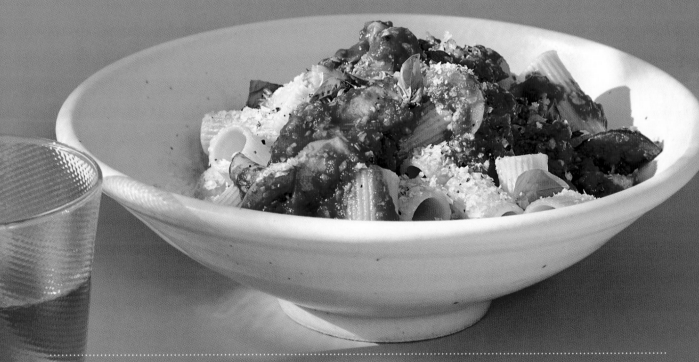

MAKES GOOD LEFTOVERS: Yes.

MAKE AHEAD: Make the sauce ahead and reheat in a saucepan with some pasta water. Add the basil and cook the pasta just before serving. Store the sauce in the freezer if not using within three days.

SEASON: Summer.

Halibut with Fennel and Green Olives

Time: 45 minutes
Yield: Serves 4

The most forgiving way to cook fish is to simmer it in broth and aromatics and go heavy with the olive oil. You can't mess it up. This recipe works beautifully with firm, thick halibut fillets, but you have a choice of fish as long as you go for something white and mild, and meaty enough that it won't fall to bits. Chilean sea bass is the butteriest of fish (much fattier than halibut) and makes for a luxurious variation.

Buyer beware: Chilean sea bass labeled "wild caught" is not necessarily sustainable. Look for "Best Choice" from the Prince Edward Islands, the Antarctic, or the Southern Indian Ocean. If it comes from Chile, stick with halibut or cod, and ask your fishmonger for a thick center piece in lieu of the thinner tail-end fillets.

1½ pounds (681 g) halibut or Chilean sea bass, thick center-cut fillet

Kosher salt

Cracked black pepper

⅔ cup (160 ml) extra-virgin olive oil

12 small cippolini onions, peeled and trimmed

3 medium fennel bulbs, sliced into ½-inch-thick wedges

3 cloves garlic, thinly sliced lengthwise

1 large Valencia orange, ends trimmed, sliced into ¼-inch-thick rounds, seeds removed

1 cup (170 g) pitted Castelvetrano olives, smashed

6 sprigs fresh thyme

5 cups (1.2 L) fish stock

1¼ cups (300 ml) dry white wine

1 lemon

1. Slice the fish filet into 4 equal pieces. Season on all sides with a generous pinch of kosher salt and freshly cracked black pepper. Set aside.

2. Set a large Dutch oven over medium-high heat. Place the olive oil in the pot and, when hot and glistening, add the onions and cook them on the first side for 2 minutes. Flip them and cook on the second side for 1 to 2 minutes, until golden brown. Remove to a plate.

3. Season the fennel with 1¼ teaspoons Kosher salt. Sear the fennel in three batches, cut side down, for 2 minutes on each side, and remove to the plate. Add the

citrus rounds and brown on the first side for 1 minute and then flip. Add the garlic to the pan with the citrus and cook for another minute.

4. Add the olives, thyme, fish stock, ¼ teaspoon salt, and the white wine to the Dutch oven. Bring to a boil and lower to a simmer for 10 minutes. Add all the vegetables back to the pot, distributing them evenly. Nestle the fish in the pot a single layer, tucking them in alongside the vegetables. Cover and simmer for 8 to 10 minutes, until the fish is just cooked through.

5. Garnish with fennel fronds and serve with lemon wedges on the side.

..

MAKES GOOD LEFTOVERS: Yes; gently reheat, covered in the microwave.

MAKE AHEAD: No.

SEASON: Year-round.

..

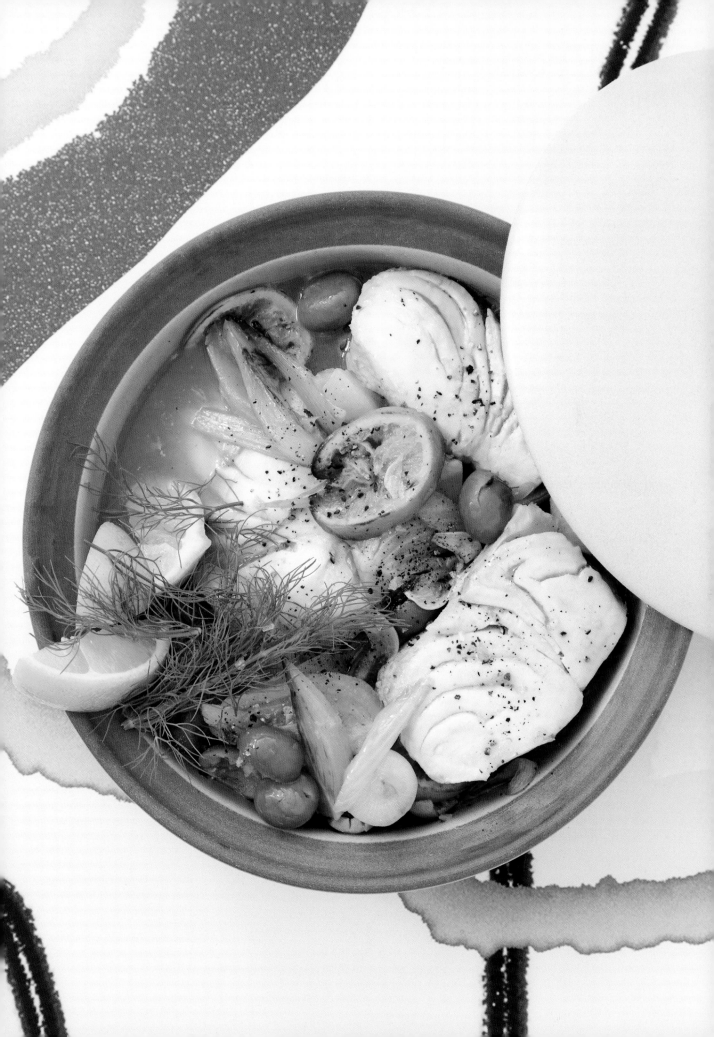

Baked Broccoli Polenta

(Variation: Make It a Main! Add Mushrooms)

Time: 1 hour
Yield: Serves 4 to 6

Behold, the marriage of two brilliantly simple but satisfying sides—crispy slices of pan-fried polenta and cheesy roasted broccoli, stems and all. An excellent choice if you are looking to front-load the work and still serve something piping hot and made to order. Note: Polenta is just coarse to medium ground yellow cornmeal. Avoid fine Italian or instant polentas—the coarse grind is what yields crispy edges. The cook time on your polenta will depend on the brand. Bob's Red Mill makes an accessible option.

¼ cup (60 ml) extra-virgin olive oil, plus more for broiling

1 small bunch broccoli, stems peeled, roughly chopped into ¾-inch (2 cm) chunks (to yield 2 cups/240 g)

Kosher salt

⅛ teaspoon red pepper flakes

2 cloves garlic, roughly chopped

3½ cups (840 ml) chicken, or vegetable broth or water

2 teaspoons unsalted butter

1 cup (140 g) medium-ground polenta (see Note)

½ cup (50 g) finely grated pecorino cheese

1. Preheat the oven to 375°F (190°C) with a baking sheet inside. Lightly oil and line a medium 9 by 5-inch (23 by 13 cm) loaf tin with a sheet of parchment paper overhanging the wide edge, long enough to fold over the top and cover the surface of the finished loaf. Set aside.

2. Combine the broccoli, olive oil, ½ teaspoon salt, the red pepper flakes, and garlic in a bowl and toss to combine. Spread the broccoli on the hot baking sheet in a single layer (do not overcrowd). Roast in the oven for 15 minutes. Remove and place the broccoli in a food processor. Pulse until it reaches a rough crumb texture, careful to stop before you reach a purée. (Alternately, hand chop the broccoli using a chef's knife.)

3. Add the broth, butter, and ½ teaspoon salt to a medium saucepan over high heat. When the liquid comes to a rolling boil, turn off the heat.

4. Place a large saucepan over medium-high heat. Add the polenta and stir to toast for 2 minutes. Add the hot broth and water mixture to the polenta approximately 1 cup at a time, whisking until smooth after each pour. When all the liquid has been added, bring the polenta to a boil and reduce the heat to medium to maintain a steady simmer. Cook the polenta for 15 to 25 minutes, whisking every 5 minutes, scraping the bottom and the sides, until it is no longer al dente and the water is absorbed. (The cook time will depend on the brand of polenta, but the granules should feel soft to the bite. It should take some elbow grease to whisk at the end.)

5. Using a wooden spoon, fold the broccoli and the pecorino into the polenta to fully incorporate. Spoon the mixture into the prepared loaf tin. Let the polenta cool, then fold the overhanging parchment flaps over the surface of the loaf. Cool completely in the refrigerator for at least 2 hours, or refrigerate for up to a week.

6. When ready to serve, preheat the oven to broil (convection broil, if available) with a large baking sheet on the center rack. Lift the polenta from the loaf pan and cut into ½-inch-thick slices crosswise. After 6 to 8 minutes, when the oven is hot, add 2 tablespoons olive oil to the baking sheet and use a pastry brush to coat the surface. Place the polenta slices on the hot baking sheet and brush the olive oil from the surface of the pan over the surface of the slices. Broil on the center rack for 15 to 20 minutes, or until golden brown.

Make it a main! Add mushrooms

If serving your polenta as a main dish with mushrooms, make the polenta first and let it rest on the hot sheet pan while the mushrooms cook.

Preheat the oven to 425°F (220°C) with a baking sheet inside. When the oven is hot, place the mushrooms on the baking sheet and drizzle with the olive oil. Season generously with fine sea salt and bake for 15 minutes, until crispy on the edges. Season with a pinch of flaky sea salt and freshly cracked black pepper. Serve over the polenta.

3 heads (1 pound/455 g) maitake
 mushrooms, gently torn in quarters
¼ cup (60 ml) extra-virgin olive oil
½ teaspoon fine sea salt
Flaky sea salt
Cracked black pepper

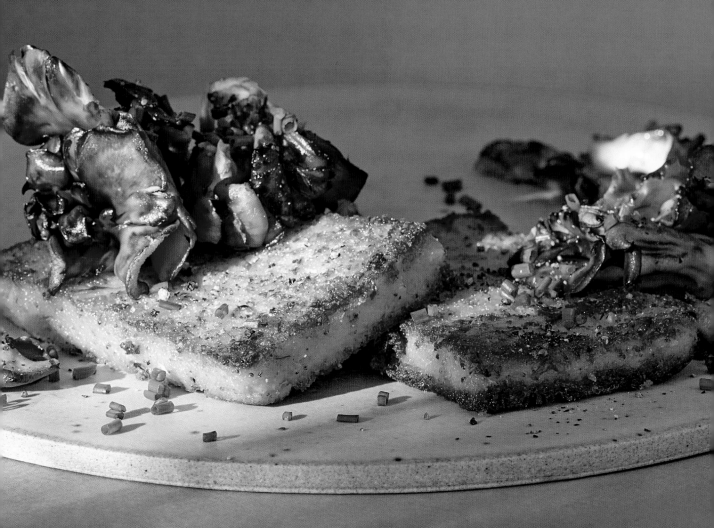

MAKES GOOD LEFTOVERS: The loaf, yes, but not once the polenta has been sliced and broiled.

MAKE AHEAD: Make the polenta loaf up to one week ahead. Slice and broil just before serving. Make the mushrooms just before serving.

SEASON: Year-round.

3 heads (1 pound/455 g) maitake

QUEER PERFORMANCE NIGHT AT LIL' DEB'S OASIS

As I pull up to Lil' Deb's Oasis in Hudson, New York, I am compelled to verify the address. I find myself in front of a Pepto-pink Caribbean shanty that appears to have washed up on the shore of the wrong coast. And while Hudson has been touted for its upscale antique stores and Brooklyn-y cheese shops, Lil' Debs stands a world apart. Inside, the place has the air of a nightclub exposed to the scrutiny of unforgiving daylight—hand-painted walls, campy oil cloth, and faux tropical foliage are best viewed at night in a wash of magenta, orange, and lime green lighting, with tables full of colorful characters and tropical cocktails exchanging hands.

Carla Perez-Gallardo and Hannah Black, the duo behind this art project–turned-restaurant, are

Perez-Gallardo (left) and Black (right), prepping Family Meal.

in the galley kitchen composing Family Meal, the preservice dinner that fuels restaurant workers through the wee hours of the morning on their feet. They are repurposing fish heads to make a spicy fish soup, cubing overripe fruit for *comé y bébé* (an Ecuadorian fruit salad served with ice), and stuffing plastic

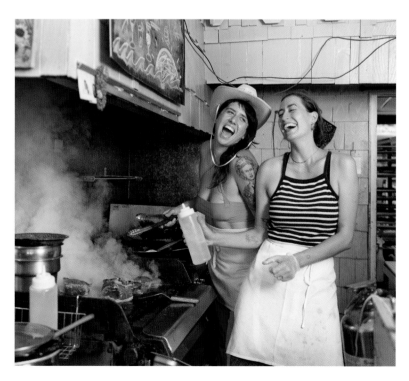

BE THE AGGRESSIVE FRIEND-MAKER

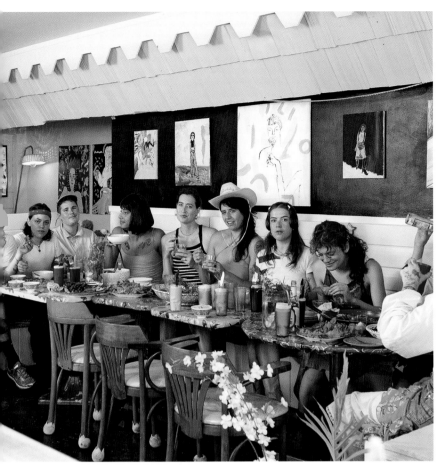

Family Meal at Lil' Deb's Oasis in Hudson, NY.

Fish-head soup, a delicious use of otherwise discarded kitchen ingredients.

diner pitchers with bouquets of herbs and flowers to make spa water on steroids. This meal far exceeds the slapdash assembly being served to staff in most restaurants at this time of day. This is more than leftovers; this is leftovers incarnate.

Tonight is their monthly Queer Performance Night, and with each jingle of the bell on the front door, another fabulous drag queen in half regalia presents themselves, peppered with wigs, fishnets, and false eyelashes. Hannah, a statuesque blond with aubergine lipstick, and Carla, head-to-toe in orange spandex, a velveteen cowboy hat the cherry on top, graciously ping-pong the role of grande dame. They welcome newcomers, fill glasses, and offer hot soup to friends and coworkers. Lil' Deb's Oasis was born in opposition to the hierarchy of the restaurant world. Carla addresses the dishwasher and the bus person equally as "chef," a habit that began as an awkward deflection of power, but quickly came to represent their horizontal pedagogy.

Dinner service trickles to an end and tables and chairs are briskly swept

aside. Hannah's sister balances precariously on a stepstool behind the bar with a floodlight in hand, and just like that—stage lighting is set. Restaurant staff disappear and reappear in tutus, corsets, and hot pink stilettos. Friends and neighbors consume every square inch of the floor and crowd the bar, sitting on any and all available surfaces. The performances are raw and heart-felt; the vibe is summer camp-meets-Rocky Horror with no distinction be-tween the audience and the stage. There's nothing precious about this place— the colors, the flavors, the characters, the camp. It's a celebration of how things could and should be. It's a restaurant of the future, or the past, or maybe just tonight.

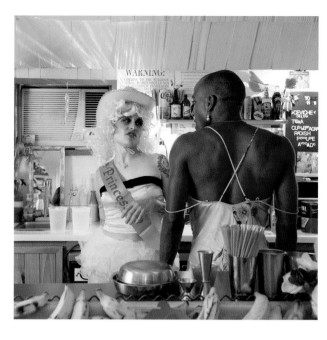

Wine director and business partner, Wheeler, behind the bar.

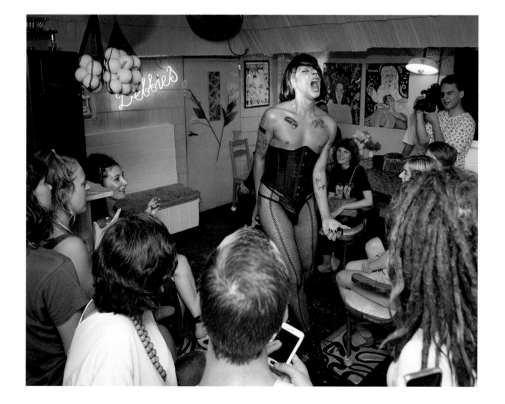

Left: Artist Àle Campos performs as Celeste for a crowd at Lil' Deb's Oasis.

Right: Performance artist Davon takes the stage at Queer Performance Night.

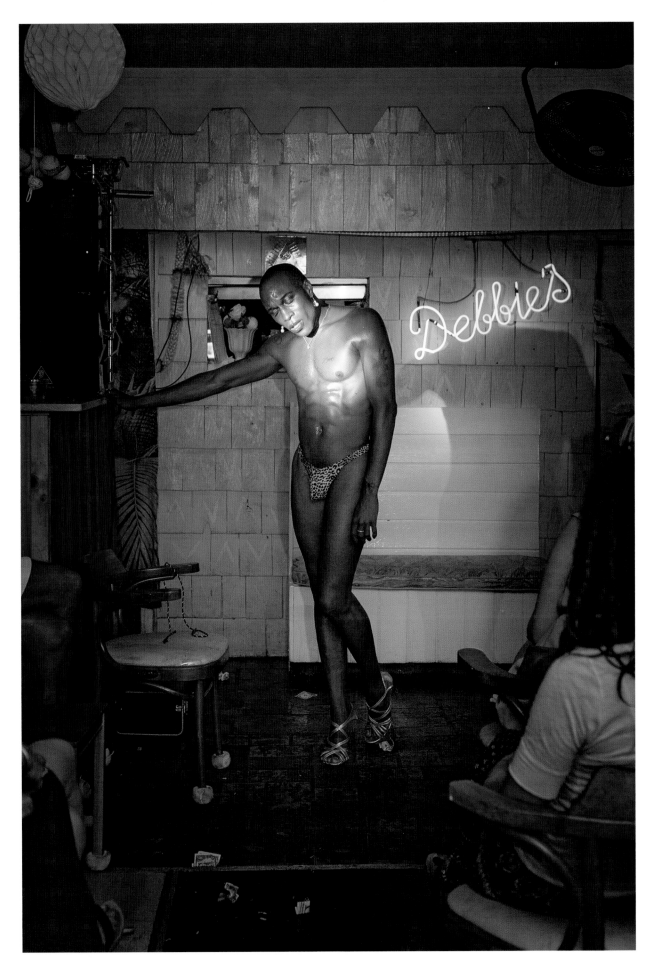

Warm Braised Celery Vinaigrette

Time: 30 minutes
Yield: Serves 2 as a main

Celery is CHEAP, like a few bucks a bunch. It lasts for a long time in your fridge and it's far more versatile than you think. Of course, you are used to eating it raw, but browned in olive oil and gently braised in stock, celery becomes a tender vehicle for a tangy, salty, lemony, warm Dijon vinaigrette. If your celery is on the tough side (often farmers' market celery can be especially rugged), run a vegetable peeler along the outer veins of any larger stalks to remove the fibrous strings. To make this a main dish, add soft-boiled eggs, boquerones, or sardines.

==============================

1. Pour ¼ cup (60 ml) of the olive oil into a large sauté pan set over medium-high heat. Place a dinner plate off to the side. When the oil is hot, add the celery in two batches, convex side down. Season with ¼ teaspoon kosher salt and brown on one side for approximately 7 to 10 minutes. If the stalks start to bow from the heat, press them down with a pair of tongs to maintain contact with the surface of the pan. When the celery is blistered and golden, remove to the plate and cook the second batch.

2. When all of the celery has been browned, lower the heat to medium. Add the lemon peel, red pepper flakes, capers, and garlic and sauté just until fragrant, less than 1 minute. Add the broth and all of the cooked celery back to the pan. Cover and braise for 10 minutes. Check once to make sure the liquid is at an active simmer but not boiling, then keep it covered for the remaining cook time. Transfer the celery to a serving platter and remove the pan from the heat.

¼ cup plus 2 tablespoons (90 ml) extra-virgin olive oil

6 hearty stalks celery, ends trimmed, cut in half crosswise

Kosher salt

Peel of **1** lemon, removed with a vegetable peeler and sliced as thinly as possible, plus juice of **½** lemon

⅛ teaspoon red pepper flakes, plus more for serving

1 tablespoon brined capers, squeezed dry

1 clove garlic, smashed

¼ cup (60 ml) chicken or vegetable broth

1 teaspoon Dijon mustard

For serving:

Flaky sea salt

1 tablespoon minced celery leaves

2 soft-boiled eggs, sliced in half (optional)

Boquerones or high-quality anchovies (optional)

3. To make the vinaigrette, add the Dijon and the lemon juice to the pan and whisk. Add the remaining 2 tablespoons olive oil in a slow stream and whisk to emulsify. Spoon the dressing over the celery.

4. Season with a pinch of flaky sea salt and a pinch of red pepper flakes. Garnish with celery leaves and serve with soft-boiled eggs and boquerones, if using.

...

MAKES GOOD LEFTOVERS: No.

MAKE AHEAD: No.

SEASON: Year-round.

...

BE THE AGGRESSIVE FRIEND-MAKER

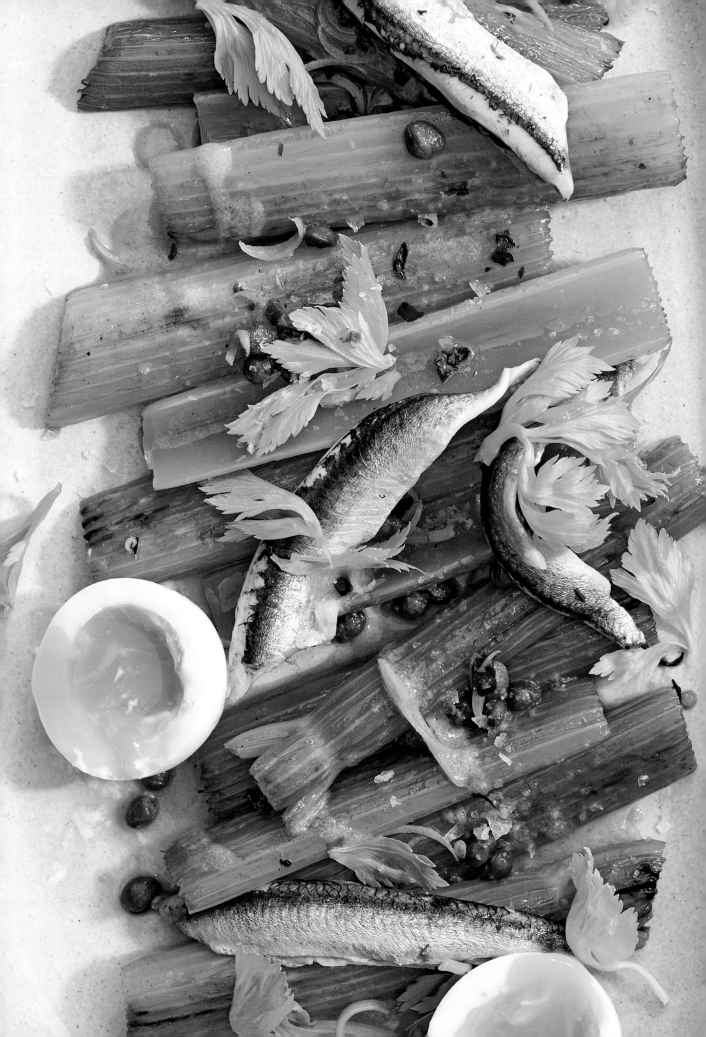

Crispy Napa Cabbage with Cilantro-Yogurt Sauce, Feta, and Pickled Red Onion

Time: 40 minutes
Yield: Serves 4

The crispy layered leaves of frilly Napa cabbage hold this spicy, tangy dressing with pride. This dressing also works well as a crudité dip, especially if you blend it with a few slices of avocado to thicken it up.

Note: If your oven has a broiler drawer, the final cook on the cabbage will go quickly, so keep a close eye on it.

================

1. Preheat the oven to broil with a large baking sheet on the center rack (see Note).

Make the sauce
2. While the oven is heating, place all the ingredients for the sauce in a blender and pulse until smooth in consistency but speckled with herbs. Transfer the sauce to the refrigerator.

Make the cabbage
3. Season the cubed avocado with lime juice and a pinch of salt; set aside. Slice the cabbage into 1½-inch (4 cm) wedges, leaving the root end and core intact to hold each wedge together. Drizzle with ⅓ cup (75 ml) of the olive oil and rub the cabbage all over to coat. Season with a generous pinch of kosher salt.

4. Lay the cabbage on the hot baking sheet in a single layer. Roast for 20 minutes. Flip the slices and broil for

For the sauce:
1 tablespoon plus 1 teaspoon roughly chopped, canned or jarred pickled jalapeño
1 cup (240 ml) plain full-fat Greek yogurt
½ cup (20 g) loosely packed fresh cilantro leaves and stems
2 green onions, root ends removed
1 clove garlic
¼ teaspoon kosher salt
1 tomatillo, husk removed
Juice of **½** lime

For the cabbage:
1 avocado, cut into ½-inch cubes
Juice of **½** lime
Kosher salt
1 small head (about **1½ pounds/700 g**) Napa cabbage
⅓ cup plus 1 tablespoon (95 ml) olive oil
½ cup (20 g) loosely packed cilantro leaves
¼ cup Pickled Red Onion (page 293)
⅓ cup (50 g) feta, preferably French, roughly crumbled
Flaky sea salt

an additional 10 minutes, checking every 3 minutes to remove the smaller bits that are fully browned to a serving platter.

5. Move the cabbage to a platter when golden brown on the surface and edges. Spoon the sauce over the top and finish with the avocado, cilantro, pickled onion, feta, and flaky sea salt and serve with extra sauce on the side.

........................

MAKES GOOD LEFTOVERS: Yes.

MAKE AHEAD: Yes; the cabbage can hold at room temperature for 2 hours and be dressed right before serving.

SEASON: Year-round.

........................

Cast-Iron Cabbage Tinga

Time: 3 hours 45 minutes
Yield: Serves 4

I love this spicy tinga made with everyday canned chipotle in adobo. Beyond cabbage, the tinga is great for braising chicken, or for use as a marinade for roasted carrots (shredded carrots tinga makes an excellent vegetarian taco filling). But if you want a more plug-n-play roasted cabbage recipe, use 3 cups (720 ml) of whatever tomato sauce you have in your pantry —just keep an eye on it as it cooks, since some will reduce faster than others and require the addition of a little extra broth.

Note: Save excess chipotle in adobo in single-serving portions in the freezer for later use.

For the tinga sauce:

7 cloves garlic, skin on
2 small red onions, peeled and quartered
¼ cup (60 ml) olive oil
2 teaspoons minced fresh ginger
1 teaspoon kosher salt
2 cups (480 ml) canned whole peeled tomatoes
¼ teaspoon ground allspice
1½ cups (360 ml) chicken or vegetable broth
2 tablespoons roughly chopped chipotle chiles in adobo (see Note)
2 whole cloves
½ teaspoon dried oregano

For the cabbage:

1 medium (2½ to 3 pounds/1.2 to 1.4 kg) green or red cabbage
¼ cup (60 ml) neutral oil (see page 291)
¾ teaspoon kosher salt
3 tablespoons extra-virgin olive oil
2 cups (230 g) thinly sliced red onion
¼ cup (60 ml) chicken or vegetable broth (optional; see page 292)
4 ounces (115 g) goat cheese (optional)

Make the tinga sauce

1. Heat a large cast-iron skillet over high heat. When the pan is hot, add the garlic and the onion, cut sides down. Cook the garlic until the skin starts to brown and it feels halfway softened, careful not to burn the flesh, about 5 to 10 minutes. Cook the onion for 15 minutes, until both sides are charred and the quarters are falling apart. Remove to a plate and peel the garlic.

2. Allow the pan to cool for 5 minutes. Return it to medium-low heat and add the olive oil. When the oil is hot, add the ginger, the peeled garlic, and the onion. Sauté for 3 minutes, until the ginger just starts to brown. Add the salt, tomatoes, allspice, broth, chiles, cloves, and oregano and stir. Raise the heat to high, bring to a boil, and then lower to a simmer for 30 minutes. Transfer the mixture to a blender and blend until smooth.

Make the cabbage

3. Preheat the oven to 375°F (190°C). Slice the cabbage in half from top to root end. Halve each piece to create four equal wedges, each held together by their core.

4. Place a large Dutch oven with the neutral oil over high heat. When the oil is hot, sear the cabbage for 3 minutes on each cut side until golden brown. Flip to sear

the outer surface of the cabbage for an additional 3 to 5 minutes before removing to a plate. Season the cooked wedges with ½ teaspoon of the salt.

5. Lower the heat to medium and add the olive oil to the pan. Sauté the red onion with the remaining ¼ teaspoon salt for 15 minutes until lightly browned and cooked through. Add the tinga sauce and raise the heat to high, stirring until it starts to bubble. Nestle the cabbage into the pan, cut side down, and spoon the sauce over the top.

6. Cook on the center rack, uncovered, for 30 minutes, then spoon more sauce over the cabbage. After another hour and a half, lower the heat to 300°F (150°C). If the sauce is looking dry at this point, stir the broth into the pan. Cook for an additional 30 minutes, until the cabbage is tender all the way through when you poke it with a paring knife. (Total cook time is 2½ hours).

7. Remove the pan from the oven and stud the surface of the dish with mounds of goat cheese, if using. Serve while warm.

...

MAKES GOOD LEFTOVERS: Yes, freezes well.

MAKE AHEAD: Make the sauce up to 5 days ahead. Prepare the cabbage just before serving.

SEASON: Year-round.

...

Whole-Roasted Cabbage with Whipped Ricotta, Croutons, and Smoky Persillade

Time: 6 hours
Yield: Serves 4 to 6

With aspirations of abolishing Thanksgiving Tofurkey for generations to come, I stole a few pages from the old bird's playbook for this whole-roasted cabbage. Instead of coaxing seasoned butter under the turkey skin, slide it under the outer leaves of a common cabbage and roast it whole for savory, parchment-thin outer layers and a steamy tender flesh. In the right hands, this dish is worthy of a Norman Rockwell moment.

Note: Flathead cabbage is a wonderful variety you can find at your late fall/winter farmer's market. The layers are not as dense as a common cabbage, with space between the leaves, which produces a really light and crispy result when roasted whole.

For the cabbage:
One 3-pound (1.4 kg) flathead or green cabbage
4 tablespoons (½ stick; 55 g) cold unsalted butter
1 teaspoon kosher salt
Cracked black pepper

For the whipped ricotta:
2 cups (490 g) whole-milk ricotta
½ teaspoon kosher salt
Zest of 1 lemon

For the smoky persillade:
Zest and juice of 1 lemon
½ teaspoon kosher salt
1⅓ cups (40 g) finely chopped fresh parsley leaves
4 green onions, tops and root ends trimmed and thinly sliced on a diagonal
1 clove garlic, Microplaned
¼ teaspoon red pepper flakes
¼ teaspoon smoked paprika
½ cup (120 ml) high-quality extra-virgin olive oil

For serving:
Flaky sea salt
3 cups (90 g) Croutons (page 294)
¼ cup (7 g) torn fresh parsley leaves

Make the cabbage

1. Wash and dry the whole head of cabbage, removing any leathery, loose outer leaves. Preheat the oven to 400°F (205°C). Prepare a 9-inch (23 cm) square metal or glass baking dish.

2. Using a mortar and pestle, smash 3 tablespoons of the butter with the salt and a few cracks of black pepper until combined. Stab X's into the cabbage, going as deeply as possible, wiggling the knife around a bit in each puncture to create some space. Using your fingers, slip 2 tablespoons of the seasoned butter in blobs underneath the edge of the top layer of leaves, trying not to rip them as you work. Once the butter is underneath, pin the edge of the leaf tight to the head using your thumb. Use your other thumb to press and spread the butter inward, under the leaf and across the surface of the cabbage. Repeat along all the revealed leaf edges. Smear the remaining tablespoon of seasoned butter onto the outer surface, paying extra attention to the holes in the flesh.

3. Roast the cabbage in the baking dish for 35 minutes. Reduce the heat to 250°F (120°C) and place the remaining tablespoon of reserved, unseasoned butter on top of the cabbage so it melts down its sides. Roast for 4½ to 5 hours. Baste the cabbage with the pan drippings every hour using a pastry brush. The cabbage is done when it is fork tender inside and dark brown and crispy on the exterior.

Make the whipped ricotta

4. While the cabbage is roasting, combine the ricotta, salt, and lemon zest in a food processor and blitz for 30 seconds to 1 minute until smooth, light, and fluffy, like whipped cream. Store covered in the fridge until ready to serve, or for up to 3 days.

Make the smoky persillade

5. Mix the lemon zest, salt, parsley, green onions, garlic, chile, and paprika together in a small bowl. Add olive oil and stir, then add the lemon juice and stir again.

To serve

6. Allow the cabbage to cool slightly and slice into 4 to 6 wedges. Brush the inner flesh with any remaining pan drippings, season with a pinch of flaky sea salt, and arrange on a platter. Spoon a generous amount of ricotta over the top and finish with the persillade. Scatter the platter with croutons and garnish with fresh parsley.

..

MAKES GOOD LEFTOVERS: No.

MAKE AHEAD: Prepare the toppings ahead (storage instructions in recipe). To make the cabbage ahead, roast and cool to room temperature, wrap the whole head in tinfoil, and refrigerate. When ready to reheat, preheat the oven to 300°F (149°C). Slice the cabbage in half, place cut side down on a baking sheet, and bake for 20 to 30 minutes until warm throughout.

SEASON: Year-round.
..

BE THE AGGRESSIVE FRIEND-MAKER

Tried-and-True Vegetarian Beans with Garlic Salsa Verde

Time: 1 hour 10 minutes
Serves: 6 to 8 as a main

This recipe is a silver bullet when you need to feed a lot of people and account for vegans and vegetarians, but you don't feel like making a mess or breaking the bank (ninety-nine percent of the time). One should always have a supply of dried beans in the pantry, and one should eat them often. Splurge: A pound of fancy beans will set you back eight to ten bucks, but that amount will feed eight people! Freshly dried beans will cook evenly and have a much less starchy texture than their petrified grocery store counterparts.

In parts of Mexico, mainly Oaxaca and Puebla, a toasted avocado leaf is added to beans to lend a nutty, mildly anise flavor, and it's said to reduce flatulence. To toast a fresh or dried avocado leaf, wave both sides of the leaf directly over a low flame until fragrant and just beginning to brown.

1 pound (454 g) dried white beans (borlotti or cranberry, Mayocoba, or cannellini)

8½ cups (generous 2 L) filtered water

Kosher salt

1 sprig oregano

5 sprigs parsley

2 sprigs tarragon

2 sprigs thyme

¼ cup (60 ml) extra-virgin olive oil

½ large yellow or white onion

1 head garlic, top sliced off crosswise

¾ teaspoon fennel seeds

⅛ teaspoon red pepper flakes

2 small carrots

2 stalks celery

2 bay leaves

1 toasted avocado leaf (optional; see Note)

⅛ teaspoon baking soda

2 tablespoons apple cider vinegar

For the Garlic Salsa Verde:

½ head roasted garlic from Tried-and-True Vegetarian Beans (above) or 1 small clove fresh garlic, Microplaned

1½ cups (45 g) mixed fresh herbs (fennel or carrot fronds, parsley, cilantro, tarragon, basil, and chives are nice), minced

½ teaspoon flaky sea salt

Zest of **1** lemon

2 fresh spicy chile peppers, seeded and minced (optional)

½ cup (120 ml) extra-virgin olive oil

For serving:

4 cups (60 g) fresh arugula

2 cups (400 g) diced tomato

½ cup (400 g) Pickled Red Onion (page 293)

⅔ cup (150 g) Garlic Salsa Verde (see above)

Do ahead

1. Soak the beans in the filtered water with 1 tablespoon kosher salt on the counter overnight.

2. Preheat the oven to 375°F (190°C). Tie the sprigs of oregano, parsley, tarragon, and thyme together with kitchen twine to make a bouquet.

3. Place the olive oil in a large Dutch oven over medium-high heat. When the oil is hot, add the onion and the head of garlic, cut sides down. Cook undisturbed for 3 to 5 minutes, just until the surfaces are browned. Add the fennel seeds and red pepper flakes and stir until fragrant, about 1 minute. Add the beans with their soaking liquid, the carrots, celery, bay leaves, avocado leaf (if using), the bouquet of herbs, and the baking soda. Bring to a boil, skimming the foam that forms at the surface with a slotted spoon.

4. Cover the pot, place it in the oven, and bake for 45 minutes. Lift the lid, add the cider vinegar, cover, and bake for an additional 15 minutes, or until you taste five beans in a row that are all silky and soft to the bite.

5. Remove the pot from the oven. Discard the carrots, onion, celery, avocado leaf, and herbs. Set the garlic aside for the salsa verde. Ladle the beans and their broth into individual bowls. If using, spoon about a tablespoon of the salsa verde over each serving of beans and top with fresh arugula, diced tomato, and pickled red onion.

Make the salsa

6. Squeeze the roasted garlic cloves from their peels onto a cutting board and smash them with the broad side of a chef's knife to make a paste. (You can use 1 clove of Microplaned fresh garlic if you're making salsa verde, but not the beans.) Put the paste in a small serving bowl or a container with a tight-fitting lid. Add the minced herbs, flaky sea salt, lemon zest, and chile peppers to the garlic and stir to combine. Pour the oil over the top. Store in the fridge (or a wine fridge if you have one) for up to 2 weeks, as long as the herbs are fully covered in the oil. Bring to room temperature before serving.

To serve

7. Ladle the beans and their broth into individual bowls. If using, spoon about a tablespoon of the salsa verde over each serving of beans and top with fresh arugula, diced tomato, and pickled red onion.

MAKES GOOD LEFTOVERS: Yes.

MAKE AHEAD: Yes.

SEASON: Year-round.

BE THE AGGRESSIVE FRIEND-MAKER

Beans with Ham Hock

Time: 2 hours 45 minutes, plus overnight soak
Yield: Serves 6

A ham hock is the carnivore's bouquet garni, used to season a dish without actually being eaten itself (although I do like to pick the lean bits off the hock before serving). The hock is a big knuckle made up of sinewy, collagen-rich tendons and ligaments. When salted, smoked, and simmered it unleashes a world of flavor from its porky depths and everyone leaves with the lingering impression of having partaken in a meaty feast when in reality, they didn't really consume much meat at all. Look for ham hocks at your high-end butcher. They keep well wrapped tightly in plastic wrap in the freezer.

1½ cups (270 g) dried yellow eye, pinto, or cranberry beans
2½ teaspoons kosher salt
¼ cup (60 ml) extra-virgin olive oil
1 small yellow onion, minced
1 poblano pepper, seeded and minced
2 cloves garlic, minced
1 small carrot, minced
2 stalks celery, minced
2 bay leaves
1 pound (455 g) piece smoked ham hock
5 sprigs thyme
1 tablespoon (15 ml) sherry vinegar
Minced celery leaves and heart, for garnish

Do ahead

1. Soak the beans overnight in 9 cups (2.1 L) of filtered water with 2 teaspoons of the salt.

2. Preheat the oven to 300°F (150°C).

3. Set a Dutch oven or a 4-quart (3.8 L) heavy-bottomed pot with a tight-fitting lid over medium heat. When hot, add the olive oil. When the oil is glossy and hot, add the minced onion, chile pepper, garlic, carrot, celery, and remaining ½ teaspoon of salt. Sauté for 30 minutes, stirring occasionally until the onions are translucent. Add the bay leaves, the ham hock, and the whole sprigs of thyme. Add the beans to the pot with their soaking liquid. Bring to a boil, cover, and place the pot in the hot oven. Cook, covered, for 1 to 1½ hours, until you taste five randomly selected beans and all of them are tender and creamy. Add the sherry vinegar and stir to combine.

4. To serve, top with the minced celery heart and tender leaves.

MAKES GOOD LEFTOVERS: Yes.

MAKE AHEAD: Yes.

SEASON: Year-round.

BE THE AGGRESSIVE FRIEND-MAKER

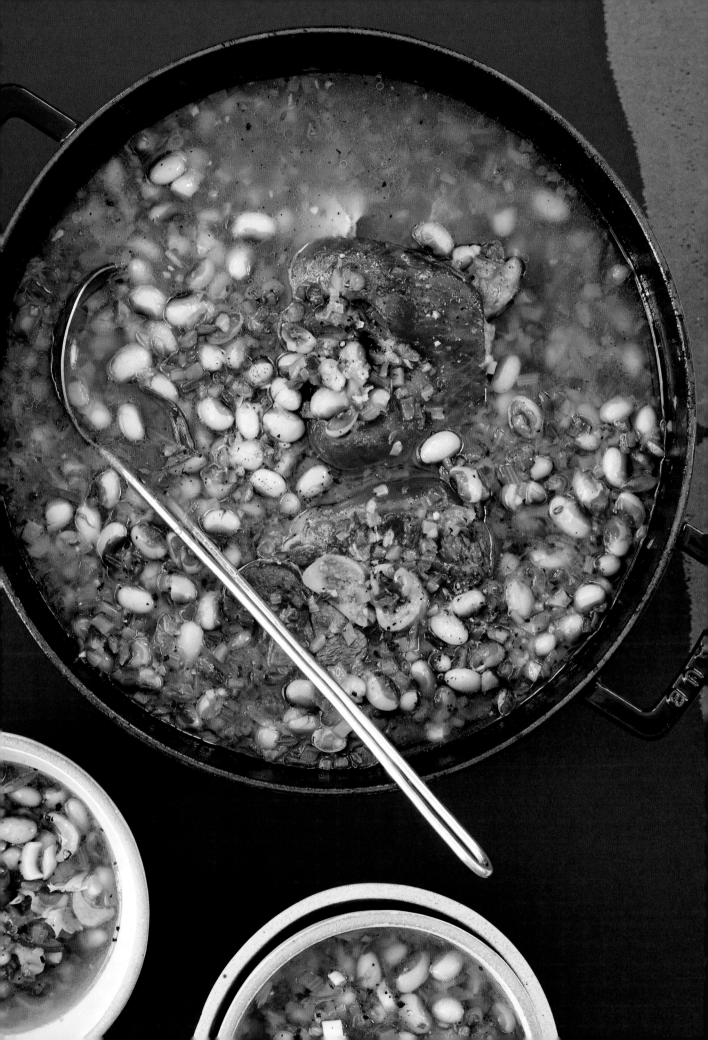

Elderberry Cooler with Apple Cider and Lime

Time: 5 minutes
Yield: Five 6-ounce cocktails

My friend, chef and cookbook author Mina Stone, does miraculous things with basic ingredients (it's a Greek thing). She threw together this almost-mocktail (the bitters do add a small amount of alcohol) one night at my house, and it quickly became part of my regular repertoire. (My husband likes to have his with a shot of vodka). Mina, I miss you, my culinary soul sister.

Note: Elderberry syrup is an immune-boosting supplement that you can find at most health food stores. Most people turn to it when they are getting sick, but I drink it regularly, mostly because it tastes so good.

1 tablespoon plus 2 teaspoons elderberry syrup, plus more to taste
Juice of **5** limes
1¼ cups (300 ml) high-quality pressed apple cider
Several dashes angostura bitters
Crushed ice, for serving
Club soda, **4 to 5 ounces (120 to 150 ml)** per drink

1. Fill a pitcher three-quarters of the way with ice. Add the elderberry syrup, lime juice, apple cider, and bitters and stir.

2. To serve, fill each glass with crushed ice. Fill each glass half full with the mixer and top off with club soda to taste.

MAKES GOOD LEFTOVERS: No.

MAKE AHEAD: Yes; just add ice before serving.

SEASON: Fall.

BE THE AGGRESSIVE FRIEND-MAKER

COOKING FOR A CAUSE
Put The Soup Back In "Soup Kitchen"

You don't have to be a professional cook to dedicate your kitchen to a good cause. A meal made with good intention is something people are willing to pay for, whether it's a coursed dinner, a cocktail party, or a pancake breakfast at the fire station. (I have always wanted to go to one of those.)

In 2017, I participated in a fundraiser called Potters in Protest. The event was organized by ceramicist Helen Levi in concert with a cadre of chefs. It went like this: Local ceramicists donated handmade bowls and guests purchased tickets. Upon arrival, each guest chose the bowl that spoke to them, and their meal was served to them in that vessel. At the end of the evening, they took their bowl home as a parting gift. With the ceramics as a framework, there is no need to outdo yourself with the menu—prepare one big pot of delicious soup and make a salad using standout seasonal produce. Ask your favorite bakery to donate bread or dessert and your work is done.

The best advice I can give to someone planning a modest fundraiser is to always ask for help—assume that everyone wants a chance to get involved. Grassroots events are a valuable opportunity for small businesses to market their products and connect with an engaged customer. Want to offer a pairing of natural wines? Just ask your local wine shop or your favorite winemaker for a discount to support your cause. If it's a thoughtful shop, ask them to select course pairings and prepare talking points on the wine. They might even want to come pour and speak to their selection themselves. In return, offer to make their business card available at the event, to

include their name on the invitation, or even to follow up with guests with a special one-time discount in the shop. You can take this give-get approach to all kinds of vendors, from florists to cheese shops to restaurants who might be willing to donate a free meal for a silent auction or a raffle.

Soups and stews are ideal fare for this type of event because they are affordable and easy to scale. For those of you who aren't used to cooking for large groups, just make extra and put your mind at ease! Soup is better the next day, and it's the most valuable thing to squirrel away in the freezer for a future lunch.

Dare I say people love soup as much as they love salad? People will be jockeying to attend your fundraiser, not because they feel guilty saying no, but because it's too delicious to miss.

IT'S POSSIBLE TO DO BETTER Lauren Halsey

When artist Lauren Halsey told her studio staff that their next project was to turn their warehouse in South Central Los Angeles into an oasis for free, high-caliber produce for more than 600 families per week, nobody batted an eye. "There are high-stress moments, deadlines, and unforeseen learning curves, but all in all, this is a space of joy and community action." Lauren says, describing the ethos of her 5,000 square-foot operation. From the ambitions of Summaeverythang, her community center turned food distribution hub, to the demands of a burgeoning art career, collaboration is the heart of Lauren's practice. As an artist and activist, she considers it her job to be the ultimate host.

Artist and activist Lauren Halsey.
Photograph by SLH STUDIO.

With a foundation in architecture that precedes her career as a fine artist, Lauren is fascinated by the way "fantasy meets brass tacks" in the signage, the buildings, and the vernacular of the urban landscape. She questions why things are built the way they are, she proposes ways to do it better, and she celebrates the "survival architecture" of her own community, where people find infinite creativity within bounds. "I learned to build by watching my father and his friends—free-form, intuitive, use what you got to make what you want, and make it work. If it fails, just keep

repairing, rebuilding, and remixing structures." It's an approach that permeates every aspect of this interdisciplinary studio. Lauren's installations are immersive, fantastical, hand-built environments that propose a world pieced together from Afrofuturist fantasy, and the castaway yet deeply symbolic ephemera from the streets of Los Angeles. Synthetic hair, concrete, old CDs, EBT signage, and wanted posters harmonize here.

Lauren's love of food runs deep. She grew up in South Central Los Angeles, but she commuted far afield for school. "I took one million migrations around LA to get home at the end of the day. Early on, I saw how the food that was available in other parts of the city compared to what we had where I lived." That insight stuck with her. "I have been an insider/outsider my whole life, and I have always known that our food supply chain was criminal." As far as she can remember, South Central Los Angeles has been a food desert, but when the pandemic hit, access to fresh produce became an impossibility.

So, Lauren mobilized her space, her resources, and the manpower of her studio to take action. With a crew of up to twenty-two, she spends a portion of each day tackling the complexities of local food distribution. It became her particular mission to see the bounty of Southern California farms made available in her neighborhood. For free.

She turned to Vinny Dotolo, the chef and co-owner of some of Los Angeles's most celebrated restaurants—Animal, Jon & Vinny's, and Son of a Gun—and a long-time collector of her work. He introduced her to his expert produce buyer, Samantha Rogers, who shared wholesale access to the premium purveyors at the Santa Monica

Farmer's Market. And just like that, Lauren was ordering hundreds of pounds of finger grapes, purple potatoes, kale, melons, and varieties of avocados that you could never buy in a grocery store, regardless of your zip code. She paid for the produce with donations from neighbors, art patrons, with the profits from her own art sales and commissions, and with help from friends, like Melody Eshani, who dropped a line of sweatsuits and donated five percent of the proceeds to the project. Farmers and chefs donated cardboard boxes, packing materials, and excess produce, the more unusual the variety, the better. This project emerged in a moment of global crisis, but Lauren assures me, "When the economy is built up and booming again, South Central and Watts will still be in a hunger crisis. I'm going to be doing this forever. It's possible to do better."

Word of Summaeverythang spread, and demand skyrocketed. When I spoke with Lauren, she had just completed her thirtieth week of food distribution. She emphasized the group effort, one that started as an improvisation, and evolved into fine-tuned choreography. The process takes up a greater portion of the week and begins on Tuesday with her childhood best friend, E-Man, driving three

Every week, volunteers enjoy an agua fresca made from seasonal fruit, just one of the celebratory moments in the process of preparing food for distribution. Photograph by SLH STUDIO.

hours to pick up cardboard produce boxes and clamshell containers. The next evening, they collect the refrigerated truck, an essential component to the process. At 7 A.M. they reconvene at the Santa Monica market, where Lauren, her girlfriend Monique, and a host of friends load hand trucks with everything from pluots to okra. They finish with a little personal shopping—seasonal flowers, stone crabs, fresh lemonade—and head back to the studio to build more than 600 cardboard boxes, set up tables, and prep for the next day.

On Thursday, a crew of studio assistants and paid volunteers assemble at 6 A.M. to pack each box with food for one household for the week. This is the big lift, and it's a party. Lauren's studio assistant's partner, Angel Xotlanihua, makes a celebratory agua fresca, using whatever fresh fruit they have on-hand. "There's always upbeat, feel good music. My little cousins are running around the trucks. One time my aunt brought a ton of kids from her friend's childcare." The boxes are palletized, plastic wrapped, and stored back on the cold truck until the morning, when, one by one, they will be loaded directly into recipients' cars and handcarts. Their work is done, until Monday.

Perennial Saffron Tomato Soup

Time: 20 minutes
Yield: Serves 4

The bread crumbs here are used to thicken the soup and lend it body. If it's late summer and you have a glut of fresh tomatoes, score them gently on one side and blanch them in boiling water until the skin begins to peel back. Remove the skins, roughly chop the tomatoes, and use them along with their juices in lieu of canned tomato.

3 small pinches saffron threads
¾ teaspoon crushed Aleppo pepper
3 tablespoons extra-virgin olive oil, plus more for drizzling
3 shallots, thinly sliced
½ teaspoon kosher salt
1 clove garlic, roughly chopped
2½ cups (600 ml) canned diced tomatoes
3 cups (720 ml) chicken or vegetable broth (see page 292)
¼ cup (25 g) Bread Crumbs (page 294) or stale bread
Crème fraîche, for serving
1 cup (57.5 g) Croutons (optional; page 294)

1. Crush the saffron between your fingertips and combine with the Aleppo pepper in a small bowl.

2. Place the olive oil in a medium stockpot over medium-high heat. When the oil is hot, add the shallots and the salt and sauté for 3 to 5 minutes until soft. Add the garlic and continue to sauté for an additional 2 minutes.

3. Add the saffron and its soaking water, the tomatoes, and the broth to the pot. Raise the heat and bring to a boil. Reduce the heat and simmer for 10 minutes. Transfer the soup to a blender with the bread crumbs, and purée until silky smooth (or use an immersion blender). Return the soup to the pot and simmer for another 5 minutes.

4. Ladle the soup into individual bowls. Drizzle with olive oil and finish with a dollop of crème fraîche. Garnish with croutons, if using.

MAKES GOOD LEFTOVERS: Yes.

MAKE AHEAD: Yes.

SEASON: Year-round (but especially summer if using fresh tomatoes).

Vegan Lima Bean Escarole Soup

Time: 1 hour 20 minutes
Yield: Serves 4

My husband lovingly dubbed this dish my "water soup." Far from a diss, the soup has such depth and character, he just couldn't believe the recipe wasn't built on the back of chicken stock. Even lima beans for dinner sounds somewhat puritanical, but slow cooked they are reborn as liquid velvet. Vegan, comforting, filling, and made with humble ingredients. Some of you have a spirit animal—this is my spirit soup.

Note: If you are not committed to the vegan angle on this dish, substitute the 6 cups of water for Parmesan broth (page 158).

2 cups (360 g) dried lima beans

1½ teaspoons kosher salt, plus more to taste

⅓ cup (80 ml) extra-virgin olive oil

1 large yellow onion, cut into 1-inch (2.5 cm) pieces

6 sprigs thyme

2 teaspoons minced lemon peel

2 bay leaves

2 large cloves garlic, thinly sliced

½ teaspoon dried oregano

¼ teaspoon red pepper flakes

1 small head escarole, roughly torn

Juice of **1** lemon

Do ahead

1. Cover the dried beans in 5 cups (1.1 L) cold water with ½ teaspoon salt in a large bowl and set on the counter to soak overnight.

Make the soup

2. Preheat the oven to 300°F (150°C) with the rack in the center.

3. Place a Dutch oven over high heat. When the pot is hot, pour in the olive oil. When the oil is hot, add the onion with 1 teaspoon salt, the thyme, lemon peel, and bay leaves. Sauté for 5 minutes, then add the garlic, oregano, and red pepper flakes and sauté for 2 minutes. Add the lima beans with their soaking liquid and an additional 6 cups (1.4 L) cold water. Bring the liquid to a boil, cover, and place in the oven on the center rack to simmer for 1 hour 15 minutes, or until the beans are smooth and creamy and their skins are no longer tough.

To serve

4. Just before serving, add the escarole and stir to combine. Add the lemon juice and season with additional salt to taste.

..

MAKES GOOD LEFTOVERS: Yes.

MAKE AHEAD: Make the lima bean base ahead. Warm on the stovetop and add the escarole just before serving.

SEASON: Year-round.

..

Beet Cauliflower Soup

Time: 45 minutes
Yield: Serves 4 to 6

The mellow sweetness of cauliflower, fennel, and beets gets a kick in the pants from floral cracked white pepper and a generous scoop of horseradish-spiked sour cream. This one is a hearty and healthy candidate for a vegetarian starter. Serve hot or at room temperature.

1 small bunch red beets, scrubbed clean

1 tablespoon plus 1 teaspoon kosher salt

3 tablespoons extra-virgin olive oil

1 bulb fennel, quartered, fronds and tough tops removed

1 small leek, thinly sliced and thoroughly washed

2 medium carrots, peeled, scrubbed, and diced

1 clove garlic, roughly chopped

⅛ teaspoon whole white peppercorns, crushed with a mortar and pestle

½ head cauliflower, finely chopped, tough part of the stem removed

4 cups (960 ml) chicken or vegetable broth (see page 292)

1½ teaspoons fresh lemon juice

¼ teaspoon celery salt

Zest of **1** lemon

¼ cup (60 ml) sour cream

Fresh horseradish root, peeled and Microplaned

1. In a large pot, cover the beets with 2 inches (5 cm) of water. Add a tablespoon of kosher salt and bring to a boil. Reduce the heat to a low boil and cook the beets for 10 to 15 minutes or until fork tender. Drain, transfer the beets to a blender, and set aside.

2. Place 2 tablespoons of the olive oil in a large sauté pan over medium heat and swirl to coat. Add the fennel cut side down and cook for 5 to 10 minutes, until golden brown. Repeat on the opposite side and remove the fennel to a plate. Add the remaining tablespoon olive oil to the pan along with the leek, carrots, garlic, 1 teaspoon kosher salt, and crushed white peppercorns and sauté until the vegetables are soft, about 10 minutes, adding a splash of water if the pan dries out. Add the cauliflower and cook until soft.

3. Add the cooked vegetables and the broth to the blender with the beets and purée until smooth and creamy. Season with lemon juice and additional salt to taste.

4. In a small bowl, combine the celery salt, the lemon zest, and the sour cream and stir to incorporate. To serve, ladle the hot or room-temperature soup into individual bowls and add a dollop of the seasoned sour cream to each serving. Top with freshly Microplaned horseradish root to taste.

MAKES GOOD LEFTOVERS: Yes.

MAKE AHEAD: Yes.

SEASON: Year-round.

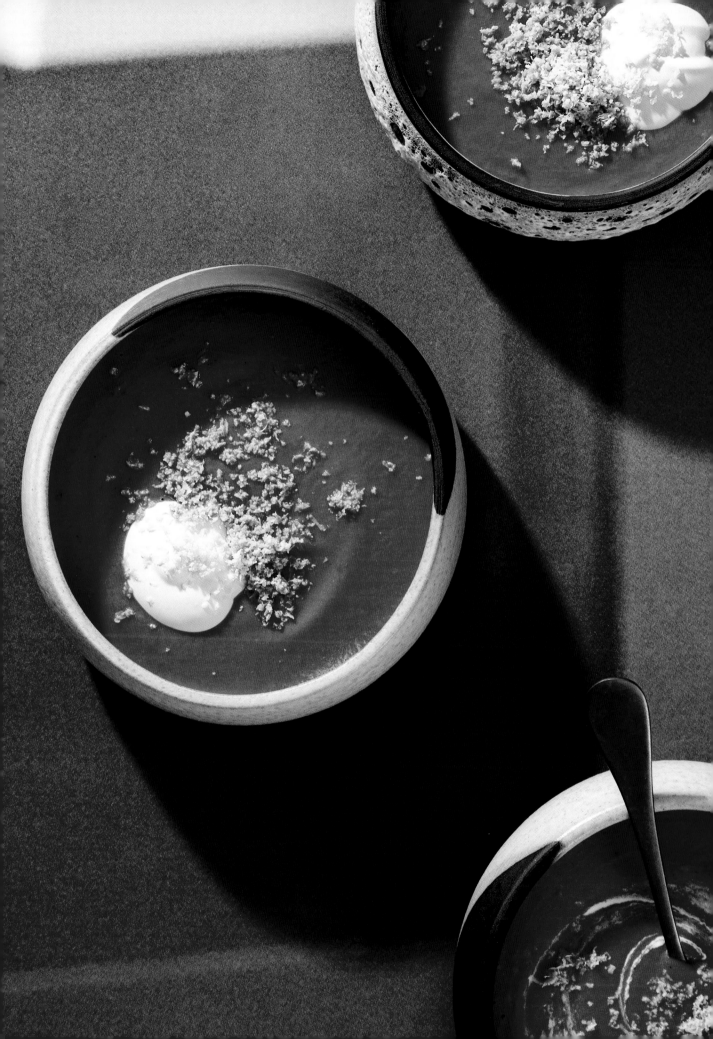

Carrot-Fennel Seed Soup

Time: 45 minutes
Yield: Serves 4 to 6

Fennel seeds, carrot, parsnip! Another simple, healthy, and colorful soup to prepare in large batches, freeze in individual portions, or keep simmering on the stovetop for people to serve themselves, at your next party. The fennel pollen is optional but highly encouraged. To harvest your own, see page 284.

1 tablespoon plus 1 teaspoon ghee

1½ teaspoons fennel seeds

1 large onion, thinly sliced

1 teaspoon kosher salt

2 cloves garlic, thinly sliced

2 pounds (910 g) carrots, peeled and cut into 1-inch (2.5 cm) pieces

2 medium parsnips, peeled and cut into 1-inch (2.5 cm) pieces

6 cups (1.4 L) beef broth (chicken or vegetable will do; see page 292)

2 tablespoons apple cider vinegar

⅓ cup (80 g) plain full-fat yogurt

½ teaspoon Urfa or similar chile flakes (see page 291)

½ teaspoon fennel pollen (optional; see headnote)

1. Place the ghee in a medium stockpot over medium heat. Add the fennel seeds and fry, stirring until fragrant, about 30 seconds. Add the onion and salt, reduce the heat to low, and sauté until translucent, about 10 minutes. Add the garlic and stir for 30 seconds.

2. Add the carrots and parsnips and stir to coat with the oil. Cook, stirring occasionally, for 8 to 10 minutes. Add the broth and cider vinegar, raise the heat to high, and bring it to a boil. Lower to medium-low heat and simmer for 20 minutes. Transfer the mixture to a blender (or use an immersion blender) and purée until smooth. Transfer the soup back to the pot and simmer for another 5 minutes. Taste and adjust seasoning.

3. Top each serving with a dollop of plain yogurt, a sprinkle of Urfa chile, and fennel pollen if using.

MAKES GOOD LEFTOVERS: Yes.

MAKE AHEAD: Yes.

SEASON: Year-round.

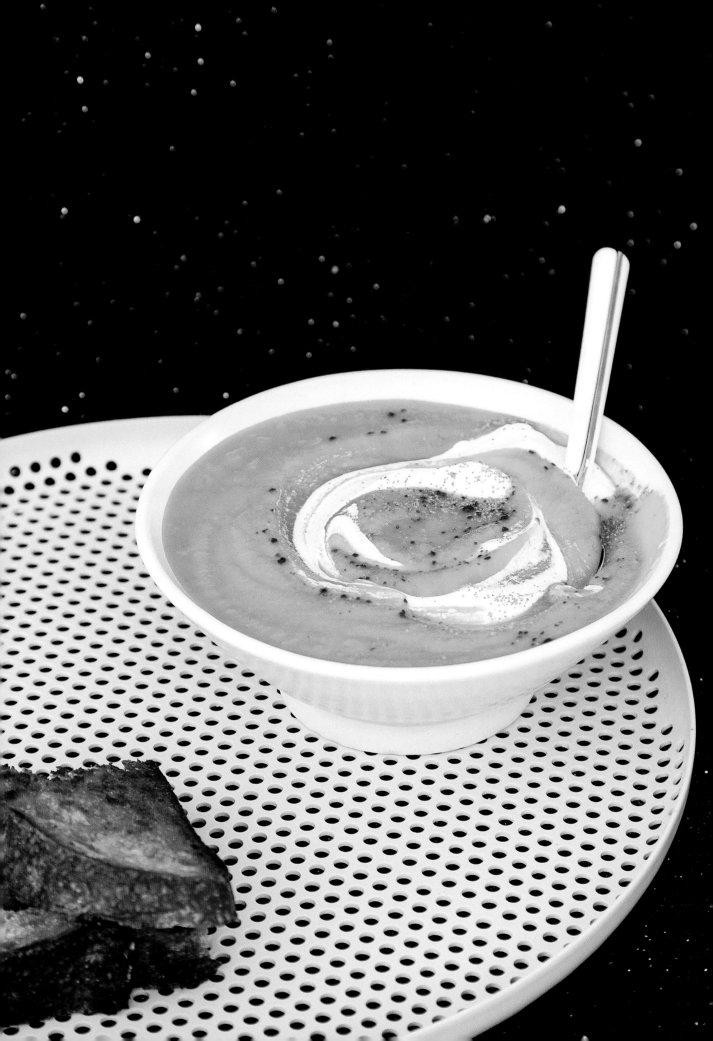

Mexican Chicken-and-Lime Soup

Time: 2 hours 15 minutes
Yield: Serves 4 to 6

I first tried a boiled masa dumpling while in Oaxaca City, where I was learning to make molé from an unbelievably talented local cook, Soledad Martinez. Soledad insisted that the preamble to the epic molé saga was to fortify oneself with delicate hand-rolled masa dumplings, called *chochoyotes*, set afloat in a light broth made with squash blossoms and squash vines.

This version of the *chochoyote* blends masa and sweet potato for color and sweetness, a brilliant suggestion from my friend and chef Norma Listman in Mexico City. *Chochoyotes* require some kind of fat as a binder. I suggest making the stock the day before serving and refrigerating overnight. This way, you can skim the layer of schmaltz that forms on the surface and use it for the dumplings.

Note: Masa harina is not the same thing as corn flour. It is ground corn that has been soaked in lime (calcium hydroxide) to initiate a chemical reaction called nix-tamalization, whereby the corn breaks down and its nutrients become digestible (masa harina is the key ingredient in tortillas and tamales).

For the chicken stock:

3 ears corn, husks and silks removed
1 dried ancho chile
1 yellow onion, peeled and quartered, root end intact
3 tablespoons extra-virgin olive oil
1 tablespoon plus 1 teaspoon cumin seeds
1 tablespoon plus 1 teaspoon coriander seeds
2 tablespoons whole black peppercorns
1 head garlic, top sliced off crosswise
1 carrot, roughly chopped
2 stalks celery, halved
2 tablespoons apple cider vinegar
¾ teaspoon dried Mexican or Greek oregano, or marjoram
2 whole star anise
2 bay leaves
1 tablespoon kosher salt, plus more to taste
¾ cup (15 g) parsley sprigs
One 3- to 4-pound (1.3 to 1.8 kg) organic chicken
2 tomatillos, husked and quartered (halved if small)

Make the stock

1. Slice the kernels from the cobs and set them aside. Save the cobs to simmer with the stock.

2. In a large dry stockpot over medium-high heat, toast the ancho chile on both sides until fragrant but not burned. Remove to a plate, seed, stem, and set aside. Place the onion in the pot cut side down. Char on all sides and remove to a plate. Remove the pot from the heat and let it cool for 5 minutes. Return the pot to medium heat and add the olive oil, cumin, coriander, and peppercorns and fry the spices for 30 seconds, stirring constantly. Add the onion, whole head of garlic, carrot, and celery and sauté for 5 minutes, until the vegetables begin to soften.

3. Add 1 gallon (3.8 L) of water and the cider vinegar to the pot along with the ancho chile, oregano, star anise, bay leaves, salt, parsley, the corn cobs, and the chicken. Bring to a boil, reduce the heat to a simmer, and cook partially covered for 20 minutes. Using a pair of tongs, transfer the chicken to a cutting board and allow to cool. Remove and discard the skin (if you plan to refrigerate overnight and use the chicken fat for your dumplings, you can add the skin to the stock to render). Using a fork and your fingers, remove all the meat from the carcass, roughly shred, and set aside. Add the chicken carcass, chicken bones, and 1 cup (240 ml) of water back to the pot. Bring to a boil, lower the heat to a simmer, and cook, partially covered for 1 hour. Strain and return the clear broth to the stockpot (don't worry if there are some stray spices floating in there still). Season with salt to taste. Cover and refrigerate if making the broth in advance.

Make the masa dumplings

4. Peel the sweet potato and cut into 1-inch (2.5 cm) cubes. Add to a medium pot of boiling water and cook for 15 minutes or until fork tender. Strain the potato and mash into a paste using a potato masher or the back of a fork.

5. If you refrigerated your broth in advance, skim the top layer of solidified chicken fat with a slotted spoon, and reserve 1 tablespoon for making the dumplings. Combine the masa, ½ cup (125 g) of the mashed sweet potato, cinnamon, salt, and fat in a medium bowl and mix well. Roll 1-inch (2.5 cm) balls of dough between your palms and press a finger gently into the center of each to make a dimple.

6. Bring the broth up to a simmer and drop 5 dumplings in at a time. Cook for 3 to 5 minutes, using a slotted spoon to transfer the dumplings to each individual bowl. Repeat the process with the rest of the dumplings, enough to serve 4 to 6 people. When you are finished cooking the dumplings, add the corn kernels and the diced tomatillo to the broth and simmer for 1 minute.

To serve

7. Add a handful of shredded chicken, a few slices of jalapeño, and the sliced scallions to each bowl. Add hot stock and the juice of half a lime to each portion and drizzle with olive oil. Add a slice of avocado and season with a pinch of dried Mexican oregano, crushing it between your fingers over each bowl. Finish with a dollop of crème fraîche, cilantro, a small handful of shaved cabbage, and some sliced radish. Serve with extra lime on the side.

For the masa–sweet potato dumplings:

1 medium sweet potato

1 tablespoon lard, schmaltz, bacon fat, duck fat, or vegetable shortening

½ cup plus 3 teaspoons masa harina (see Note)

¼ teaspoon ground cinnamon

¾ teaspoon kosher salt

For serving:

1 jalapeño, chile, thinly sliced

3 green onions, tops trimmed, thinly sliced, or Pickled Red Onion (page 293)

4 to 5 limes, quartered

Drizzle extra-virgin olive oil

2 avocados, cut into ³⁄₄-inch-thick (2 cm) slices

Pinch dried Mexican or Greek oregano, or marjoram

Crème fraîche or sour cream

1 bunch cilantro

½ cabbage, shaved paper-thin on a mandoline

½ cup thinly sliced radish

MAKES GOOD LEFTOVERS: Yes.

MAKE AHEAD: Yes; the dough keeps in the fridge for a week, so if you have leftover soup, roll and boil the dumplings fresh for each serving. To save the dumplings for later use, form the dumplings and freeze them in a single layer on a tray or plate for 1 hour before transferring them into a storage bag (so they won't stick together in a big mass o' masa).

SEASON: Year-round.

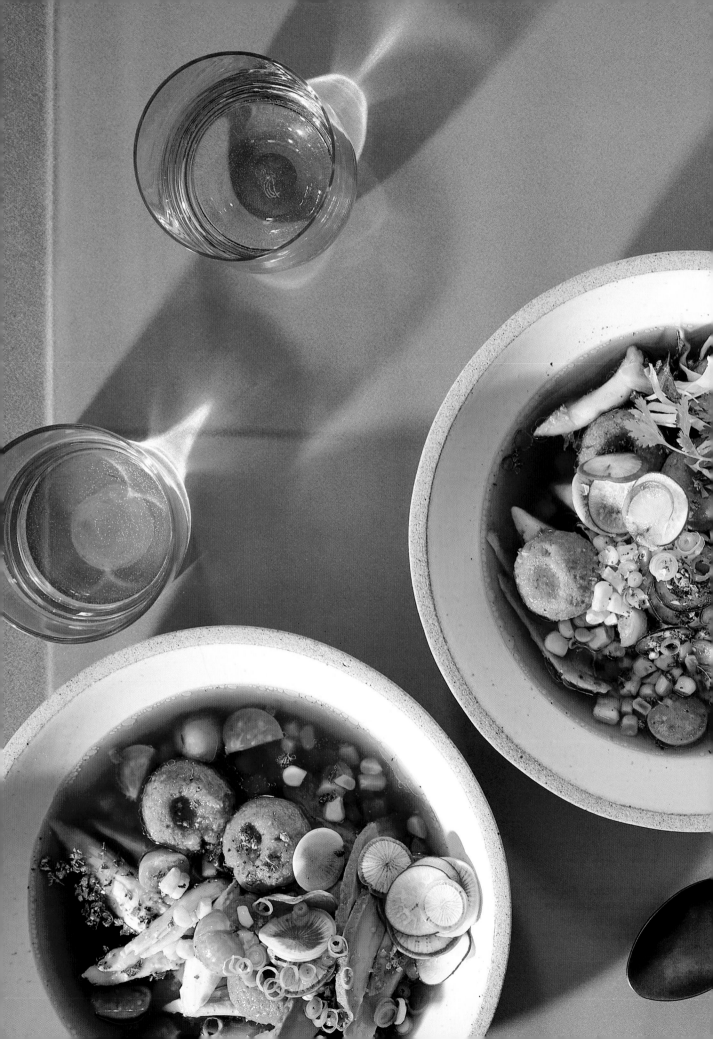

A CALL TO HARVEST The L.A. Fruit Share

Los Angeles's backyards are teeming with fruit. But as anyone with a fruit tree of their own can attest, it can be overwhelming to contend with even a single tree when the fruit comes to bear in one great flush. As a result, exceptional homegrown food too often goes to waste.

Walking the streets of L.A., I was taunted by neglected, fruit-laden trees just out of reach behind property lines. (Now I keep a retractable fruit picker in the undercarriage of my stroller.) I fantasized about organizing a public fruit swap, a massive gathering of fruit fanatics and urban growers, a space to trade, to gift, and to distribute an otherwise forsaken bounty. In 2020, to realize visions of delicious chaos, I joined forces with two like-minded partners: Food Forward, a nonprofit organization that has reclaimed and distributed 122 million pounds of otherwise unused backyard produce to date, and local fruit tree experts and backyard orchardists, the Fruitstitute. Just as our plans for the first ever city-wide Fruit Share were laid, the pandemic descended upon us and public gatherings became a thing of the past.

Photographer (and winner of our award for Most Artful Display) Alex Kacha's display of homegrown grapefruit on their Highland Park front porch.

The Fruit Share as we had envisioned it would be impossible, and yet, as a result of COVID-19, food insecurity was on the rise. So, we refined our mission and we pivoted. Instead of hosting a centralized event, the project became a city-wide call to action. We advertised on Nextdoor, on community forums, and on community garden email lists. We plastered fliers on telephone poles and

COOKING FOR A CAUSE

spread the word through social media. On July 12, 2020, participating households across the city added their locations to a public map. People woke up early, they picked their produce, and they set it out on the street in fanciful displays. We offered prizes for the most artful presentation, the most abundant harvest, and the most unusual variety of fruit. We saw a Greco-Roman front yard tableau made with Doric columns that teetered with lemons, all of it draped in gold lamé fabric. There was a reclaimed dollhouse newly inhabited by garden tomatoes and jalapeño peppers, and vegetables on display with social justice messaging in support of Black Lives Matter.

The morning of the Fruit Share, I sat on the curb with my collaborators, Joanna, Alison, and Alia. We greeted people as they stopped to gather the oroblanco grapefruits from boxes we had decorated with tissue paper fringe, piñata-style. They showed us what they had gathered so far, and they swapped intel with one another about which addresses offered the most coveted bounty. Just one day prior, it had felt impossible to hold a positive outlook on life. But that morning, people broke out of their quarantine echo chambers and went to great effort to nourish one another in body and soul. Those in need found relief from their neighbors, and others unexpectedly stumbled upon free fruit, walking home with the gift of pomelos, nectarines, and even the future promise of vegetable seedlings. The L.A. Fruit Share is now a seasonal event, one that continues to grow in scale. It's Halloween for fruit lovers. Come join us.

Participants in the L.A. Fruit Share collecting donated herbs and oro blanco grapefruit in Highland Park.

Khichdi-Inspired Lentil and Rice Stew

Time: 1 hour and 15 minutes
Yield: Serves 4 as a main

In Ayurvedic cooking, lentils and rice are stewed together to make a balancing dish called *khichdi*, and it's something every Indian person I know grew up eating at home. The classic dish is made with moong dal (dried, split, skinless mung beans, available at any Indian grocer), but if you can't find them, you can substitute split red lentils. I started with *khichdi* as inspiration, but true to form, I went off the rails, adding spices, sweet potato, and mustard greens. I serve this with a dollop of plain yogurt, or for a little more intrigue, top with cucumber-radish raita (page 174).

1 cup (200 g) moong dal or split red lentils

¼ cup plus 2 tablespoons (75 g) brown basmati rice

1 tablespoon plus 2 teaspoons ghee

2 teaspoons black mustard seeds

1 tablespoon plus 1½ teaspoons coriander seeds, lightly crushed

½ yellow onion, diced

1 teaspoon kosher salt

1 clove garlic, Microplaned

1-inch (2.5 cm) piece ginger, Microplaned

½ teaspoon ground turmeric

½ teaspoon ground cumin

½ teaspoon red pepper flakes

2 small sweet potatoes (about **8 ounces/455 g**), peeled and cut into ½-inch (12 mm) cubes

1 medium carrot, diced

5½ cups (1.3 L) vegetable broth or water (see page 293)

¾ cup (180 ml) diced canned tomato

1 tablespoon plus 1½ teaspoons lemon juice

1 small bunch mustard greens (**1¾ cups/80 g**), stems removed, leaves torn into bite-size pieces

¼ cup (15 g) minced fresh cilantro stems

⅓ cup (150 g) plain full-fat yogurt

¼ cup (5 g) roughly torn fresh cilantro leaves

1. Rinse the moong dal and the rice and set aside.

2. Place the ghee in a large stockpot over medium heat. When the ghee is melted, add the mustard and coriander seeds, stirring constantly until the mustard starts to jump out of the pot. Add the onion and the salt, raise the heat slightly, and sauté for 5 to 7 minutes to brown, adding a splash of water or broth if it starts to dry out or burn.

3. Lower the heat to medium and add the garlic and ginger. Stir to coat with ghee. Add the turmeric, cumin, red pepper flakes, sweet potatoes, and carrot and stir to coat with the spices. Add the broth, tomato, rice, and moong dal. Raise the heat to high and bring the mixture to a boil. Reduce to an active simmer and cook for 1 hour, or until the moong dal has fully broken down and the rice is soft.

4. Add the lemon juice, mustard greens, and cilantro stems. Stir to combine and remove from the heat. To serve, ladle stew into each bowl and top with a dollop of yogurt and a generous pinch of cilantro leaves.

MAKES GOOD LEFTOVERS: Yes.

MAKE AHEAD: Yes; make the soup ahead but add the mustard greens, lemon, and cilantro just before serving.

SEASON: Year-round.

Parmesan Broth

Time: 2¾ hours
Yield: About 9 cups (2.1 L)

This recipe makes important use of leftover Parmesan rinds—one woman's trash is another woman's liquid gold. Collect the rinds over time and store them wrapped in plastic in the freezer. Or, ask your cheese monger if they sell the rinds alone (if so, they will be very cheap). If refrigerating the broth for later use, break up the solidified fats with the back of a spoon or warm to redistribute before using. I use Parmesan broth in lieu of water or chicken stock to simmer beans, as the base for any Italian profile soups (see Papa a la Pomodoro on page 220), and for braising vegetables (see braised fennel on page 250).

3 tablespoons extra-virgin olive oil

1 large yellow onion, sliced in quarters, skin on and root end intact

1 head garlic, top sliced off crosswise

¾ pound (340 g) Parmesan rinds (about 5 large rinds)

15 sprigs parsley

8 sprigs thyme

2 teaspoons whole black peppercorns

2 dried bay leaves

1. In a large Dutch oven or heavy pot, heat the oil over medium heat. Add the onion quarters and the whole head of garlic and cook, cut sides down, until lightly brown, about 3 minutes. Add the Parmesan rinds, parsley, thyme, peppercorns, bay leaves, and 3 quarts (2.9 L) water. Bring to a boil and reduce the heat to a simmer. Partially cover and cook, stirring occasionally, to prevent the cheese from sticking to the bottom of the pot, until the broth is cloudy and tastes strongly like Parmesan, 2½ hours.

2. Strain the broth through a fine-mesh sieve, pressing the vegetables and cheese rinds against the walls of the sieve to extract all the liquid.

MAKES GOOD LEFTOVERS: Yes.

MAKE AHEAD: Yes; store the broth in the refrigerator for up to 1 week or in the freezer up to 4 months.

SEASON: Year-round.

Mushroom-Farro Soup with Parmesan Broth

Time: 1½ hours
Yield: Serves 4 to 6

This dish is layered with the earthiness and umami of farro, dried and fresh mushrooms, shallot, and Parmesan Broth (page 158). An optional pinch of fennel pollen (see page 284) at the end is a classy touch, though not required. It's a hearty vegetarian meal.

For the farro:

1 cup (180 g) pearled farro

1 ounce (28 g) dried mixed mushrooms or dried porcini mushrooms, roughly crumbled

1½ cups (360 ml) hot water

1 tablespoon unsalted butter

2 teaspoons extra-virgin olive oil

1 cup (140 g) minced shallots (from about 5 medium shallots)

Cracked black pepper

1 teaspoon kosher salt, plus more to taste

3 cloves garlic, minced

5 cups (1.2 L) Parmesan Broth (page 158)

5 sprigs thyme

⅓ cup (80 ml) dry white wine

1 ounce (28 g) freshly grated Parmesan cheese (⅔ cup), plus more for garnish

For the mushrooms:

3 tablespoons extra-virgin olive oil

1 pound (455 g) mixed fresh mushrooms (such as beech mushrooms, hen of the woods, or oyster mushrooms), roughly torn

½ teaspoon kosher salt, plus more to taste

2 teaspoons sherry vinegar

Cracked black pepper

Make the farro

1. Preheat the oven to 300°F (150°C). Spread the farro out on a baking sheet in a single layer and toast for 20 minutes, stirring once or twice to toast the grains evenly.

2. While the farro toasts, place the dried mushrooms in a small bowl and cover completely with the hot water. Cover the bowl with a salad plate and set aside to hydrate.

3. Place a large Dutch oven over medium-high heat. When the pot is hot, add the butter and the olive oil. Once the butter has melted, add the shallots, a few turns of cracked black pepper from the pepper mill, and ½ teaspoon of the salt and sauté until translucent, 3 to 5 minutes. Add the garlic and sauté for 2 minutes, adding a splash of water to prevent burning if necessary.

4. Stir in the farro. Add the dried mushrooms to the pot with their soaking liquid along with the Parmesan broth, thyme, and white wine. Bring to a boil over high heat, lower to a simmer, and cook, covered, for 25 minutes. Uncover the pot and continue to cook at an active simmer for an additional 25 minutes, until the farro is cooked through, swimming in a lightly creamy broth. Remove from the heat, discard the thyme stems, and stir in the grated Parmesan. Season with cracked black pepper to taste.

Cook the mushrooms

5. When the farro is almost done, heat 1½ tablespoons of the olive oil in a large (12-inch/30.5 cm) skillet over medium-high heat. When it's hot, add half the torn fresh mushrooms, stir to coat, then cook undisturbed for 2 minutes. Stir in ¼ teaspoon of the salt and cook until the mushrooms are golden and caramelized, 1 to 2 minutes. Transfer the mushrooms to a medium bowl. Repeat with the remaining 1½ tablespoons oil, the remaining mushrooms, and remaining ¼ teaspoon salt, transferring the mushrooms to a bowl as they're finished. Toss the mushrooms with the sherry vinegar and season to taste with salt and black pepper.

To serve

6. Ladle the soup into shallow bowls. Top with mushrooms and extra Parmesan cheese to taste.

...

MAKES GOOD LEFTOVERS: Yes.

MAKE AHEAD: Make the farro soup ahead, sauté the fresh mushrooms just before serving.

SEASON: Winter and fall.

...

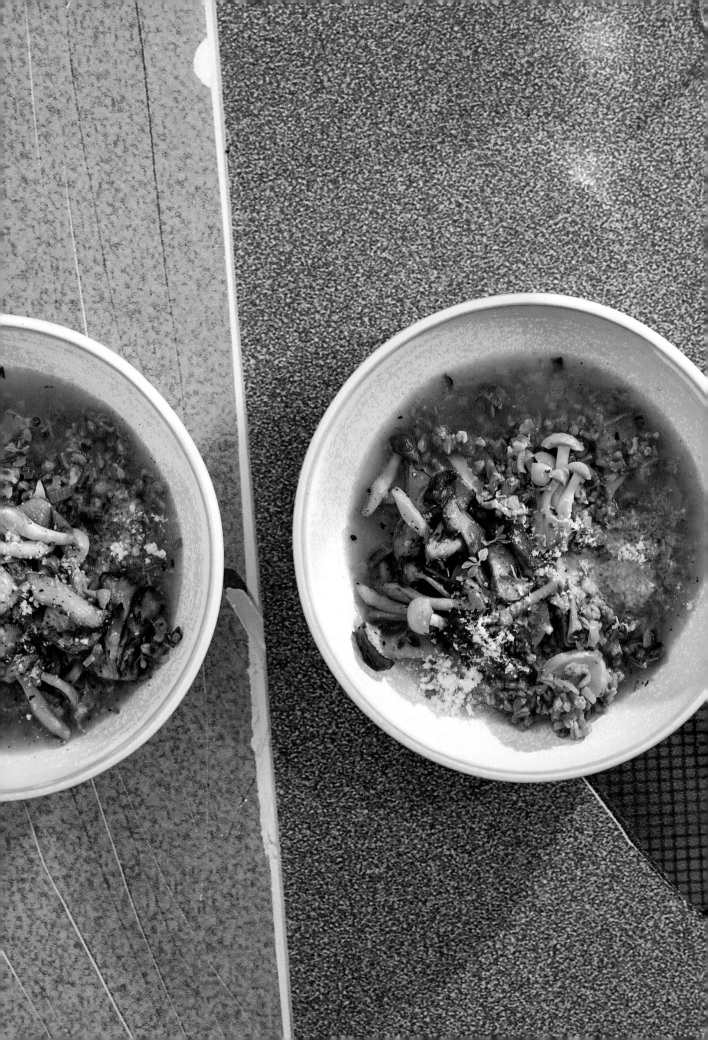

Fresh Tomato Michelada

Time: 2 minutes
Yield: Serves 1

On a Saturday morning in Mexico City, I watched Yola Jiminez, the woman behind the eponymous Yola Mezcal, crush a bursting ripe tomato through her fingers into a Collins glass, and top it off with ice cold beer and a squeeze of fresh lime to make the most refreshing michelada you've ever had. She swears by Oaxacan smoked worm salt, but you can use a pinch of worm-free smoked salt if you have it.

This drink is an interactive-yet-affordable option for a DIY fundraiser or a party where you don't have the manpower to dedicate to drinks made-to-order. Fill a beautiful bowl with fresh heirloom tomatoes and limes. Put a bunch of beer on ice and let your guests smash their tomatoes into their glasses to make their own. (If all this sounds too messy, grate the tomatoes on the largest holes of a box grater and discard the skins. Serve the fresh tomato pulp in a carafe so guests can pour it into their glasses and assemble the michelada themselves).

Ice
1 medium heirloom tomato
1 to 2 limes
1 pinch fine sea salt or smoked salt
1 can light beer (such as Modelo or Corona)
Cracked black pepper
Tabasco (optional)

1. Fill a large beer glass with ice. Using your hands, squeeze the juice and pulp from the tomato into the glass, discarding the peel. Add the juice of 1 or 2 limes, depending on your taste, and season with a pinch of salt.

2. Fill the glass the rest of the way with beer and stir. Crack black pepper on top, garnish with a few drops of Tabasco sauce (if using), and enjoy.

MAKES GOOD LEFTOVERS: No.

MAKE AHEAD: No.

SEASON: Summer.

CHAPTER 5

CHOOSE YOUR OWN ADVENTURE

Hands-On Dining for a Room Full of Fiercely Individual Individuals

My regular "Ladies' Night" brings together an ever-expanding group of women, all of them passionate about what they do, from within the realms of art to food to social work. Some are longtime friends and others might be entering my coven for the very first time. For this kind of gathering, I design the menu to be interactive, something that can be eaten standing up to facilitate mingling naturally. When the food is hands-on, you get people out of their seats, striking up conversation by sharing tips and tricks for how to customize that taco or pile high their crispy coconut rice cake. This way of eating appeals to the control freak in me—everyone gets to make their own, and it's social engineering at its tastiest.

This chapter offers ideas for do-it-yourself meals where the host tees it up and guests craft the final result. It's playful, and most of all, the food is damn good.

COLLAGE NIGHT

Shin Okuda and Kristin Dickson-Okuda

If you do it right, a craft party can really gain momentum once the kids go to sleep. When I arrive at the Los Angeles home of clothing designer Kristin Dickson-Okuda and furniture designer Shin Okuda of Waka Waka, a small group of old friends are huddled in deep focus around the kitchen table, taking glue sticks to paper to create original works of art. I am crashing their ritual collage night, where Japanese snacks, scissors, and old magazines are the trappings for a good time. "It's an unfussy, midweek gathering, a creative release over casual

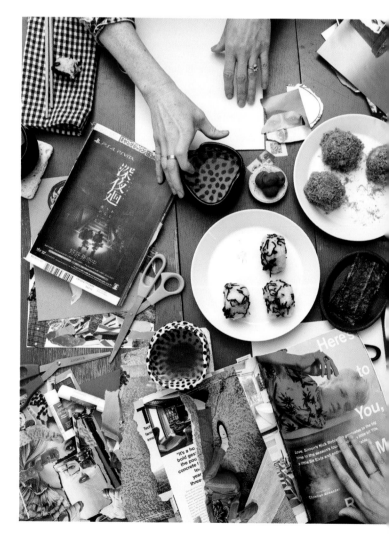

Collage Night with furniture designer Shin Okuda and clothing designer Kristin Dickson-Okuda.

food." Says Shin. When I asked if the kids were invited, Shin replied, "Oh, no kids allowed. You gotta smoke and drink."

For Shin, who spends his days meticulously designing sleek plywood and laminate furniture, collage night is a reprieve, an immediate low-stakes, expressive past-time. The artmaking is the main event, so the food is always simple and easy to share: Japanese curry as one-pot meal, onigiri as tidy finger food, or more often than not, tater tots as the silver bullet solution. "I introduced Shin to tater tots," says Kristin of her Japanese husband. He turns to me, eyes

CHOOSE YOUR OWN ADVENTURE

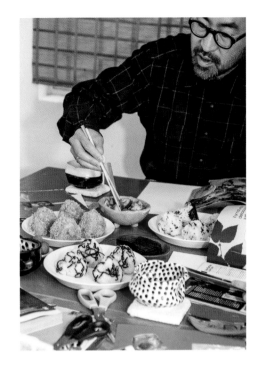

wide with wonder, "I didn't know. . . ."

Hundreds of collages have been made in this kitchen, each one archived in a box for some future show-and-tell or maybe even a coffee table book. As I thumb through their collection, they easily identify the makers of the unsigned works. The unmistakable personality and style of each of their friends—artists, designers, and creative directors—jumps off the page. Shin demonstrates, holding up a collage with a smattering of irregular shapes, hastily layered to create an infinite overlap of color. "My style is a dense, torn-edge, no scissors approach." By way of contrast, Shin pulls another gem from the coffer, a work by Case Simmons, an artist whose practice includes digital collage. "His compositions are elegant with fewer elements. Very impactful. Everyone's work has some lingering thread of their primary creative practice."

Basic Onigiri

Time: 40 minutes
Yield: Serves 4 to 6

Onigiri are freeform and improvisational hand-held rice balls stuffed with secret surprises. "Like tacos you can put anything inside," explains Shin. Given that collage is the main focus of Shin and Kristin's party, they prepared the rice and assembled their fillings ahead of time, forming the rice balls right when guests arrived. But onigiri making can also be the activity in and of itself. Just prepare the ingredients and set small bowls of warm water at each place setting. Guests will dip their fingers as they stuff and form the onigiri to taste.

3 cups (540 g) sushi rice
2 tablespoons seasoned rice wine vinegar
One .81-ounce (23 g) package toasted nori sheets (or four .17-ounce/5 g packages of seasoned seaweed snacks)
¼ cup white or black sesame seeds, toasted (see page 293)
Soy sauce

1. Cook the rice according to the package instructions. Add the seasoned rice wine vinegar and mix using a large wooden spoon or rice paddle. Cover and set aside. If using nori sheets, wave each piece 6 inches (15 cm) above the gas burner over medium heat, moving constantly back and forth, careful not to burn. The seaweed should crisp up without wrinkling or contracting out of shape. If using seaweed snacks, you can skip this step. Cover the surface of a 6-inch (15 cm) plate with sesame seeds.

2. Prepare one small bowl of water per person and set condiment dishes with soy sauce around the table. Wet your hands so the rice doesn't stick to your fingers. Take a small handful of rice and press it firmly together into a ball between the palms of your hands. Make a deep indent in the center of the ball and stuff the filling of your choice (see suggestions opposite) inside. Seal the hole by adding more rice and compressing and shaping the mound into a flat-sided triangle, a ball, or a log. Roll the finished onigiri on the plate with the sesame seeds to coat.

3. Serve the onigiri with the sheets of toasted nori or seaweed snacks so people can wrap their own like a taco and dip them in soy sauce.

Furikake rice seasoning

This is a packaged rice seasoning blend that comes in many varieties, from shiso to wasabi to smoked bonito flakes. Try them all to find the ones you like best.

After you season the rice with vinegar, add 1 tablespoon of furikake per cup of sushi rice and mix with a fork until evenly distributed. Simply form the balls without any filling inside, or with the filling of your choice.

Umeboshi plum

Fermented sweet and salty plums with intense flavor, a little goes a long way. Pit the plums and fill the rice balls with one each, pushing the plum toward the center, then plugging the holes and shaping according to the onigiri instructions above. Finish by rolling in sesame seeds or tororo seaweed (see below).

Tororo seaweed

Tororo kombu is a fine, flossy, shredded seaweed that looks like dryer lint (in a good way!). It's really fun to work with and available online or in your Japanese market. Roll the finished rice balls in this seaweed instead of sesame seeds. You can stuff the center of the rice ball with umeboshi or leave it plain inside.

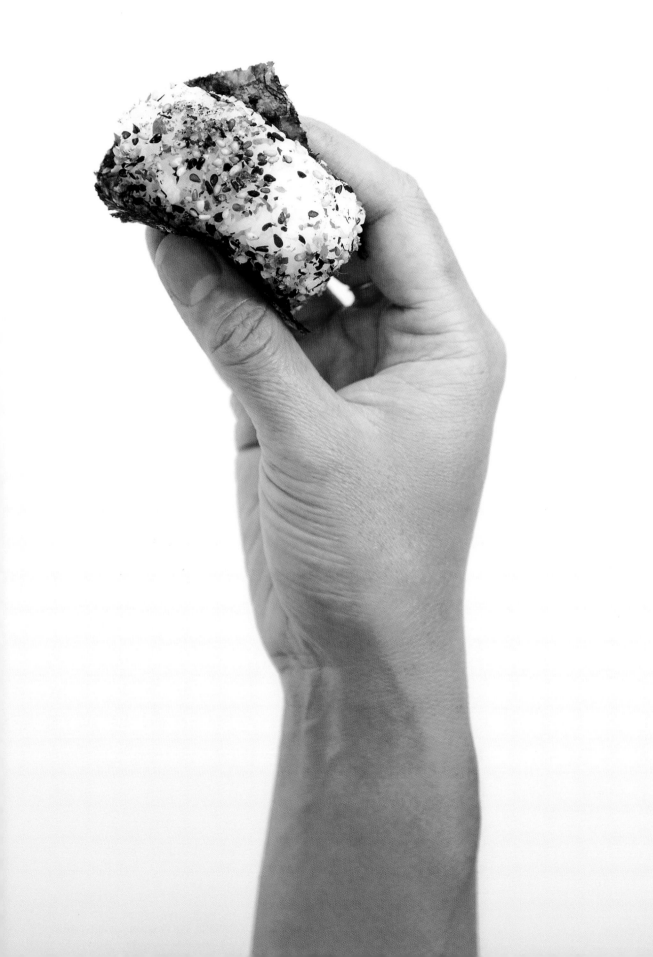

Spicy sardine filling

Remove and discard the spines from one 4½-ounce (120 g) tin of oil-packed sardines. Combine the fish with 1 tablespoon Kewpie (Japanese mayo) or mayonnaise, and 1 teaspoon Sriracha in a small dish. Use a fork to mix, flaking the fish to create a paste. Use 1 teaspoon filling per rice ball. Finish by rolling the balls in sesame seeds. (Don't care for sardines? Substitute canned oil-packed tuna, salmon, or mackerel).

Carrot miso filling

Combine 3 tablespoons white miso paste and 2 tablespoons hot water in a cup and mix to form a smooth, loose paste. Set aside. Place 2 teaspoons of neutral oil, like untoasted sesame or grapeseed, in a medium saucepan over high heat. When the oil is hot, Microplane 1 small garlic clove into the pan and sauté for 1 minute, stirring constantly until fragrant but not brown. Add 1 cup (110 g) finely grated orange or red carrot and sauté for 2 minutes, spreading them out evenly on the surface of the pan, then stirring with a wooden spoon. Add the miso paste and water mixture to the pan, turn off the heat, and mix to combine. Fill each rice ball with 1 teaspoon of the miso carrot mixture. Roll the balls in sesame seeds to finish.

...

MAKES GOOD LEFTOVERS: No.

MAKE AHEAD: Make the fillings ahead, prepare the rice just before serving.

SEASON: Year-round.

...

CHOOSE YOUR OWN ADVENTURE

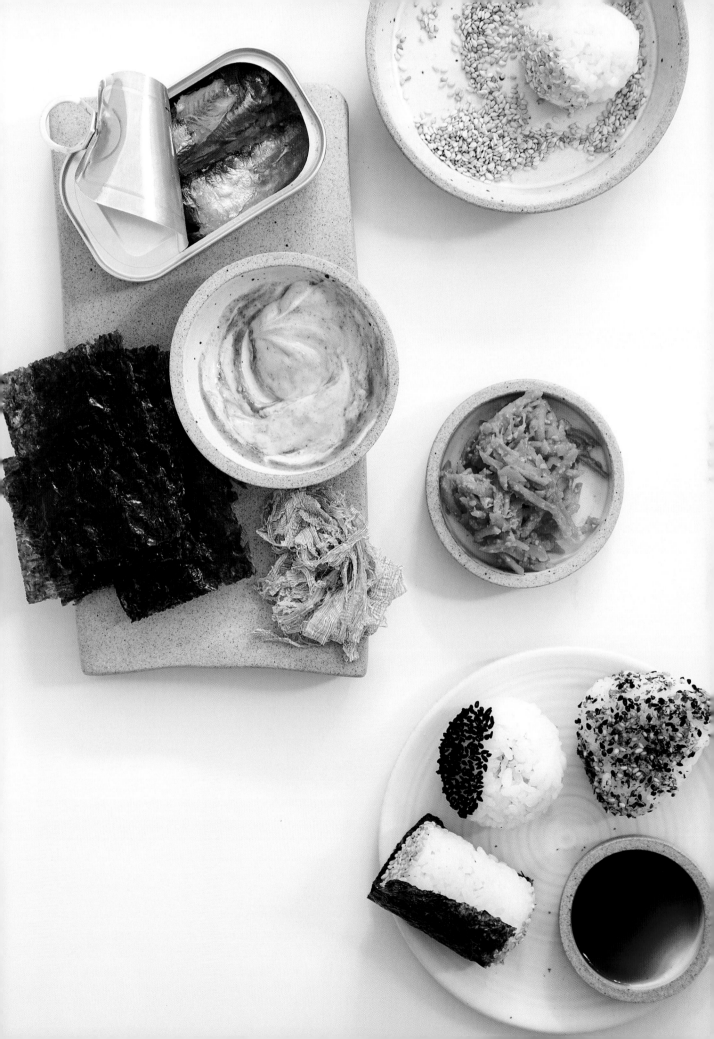

Salmon Lettuce Wraps with Cucumber-Radish Raita and Fried Lentils

Time: 50 minutes
Yield: Serves 4 to 6

Fresh and light, this is a great option for a summery outdoor meal. French lentils (or Puy lentils) are my variety of choice here, as they hold their shape remarkably well and won't get mushy with cooking. Everything can be served at room temperature, except the raita, which should be on the colder side if possible.

For the lentils:

1 cup (210 g) green French lentils, rinsed and picked through

1¼ teaspoons kosher salt

1 tablespoon plus 1 teaspoon sherry vinegar

2 tablespoons extra-virgin olive oil

¼ clove garlic

For the raita:

½ cup (120 ml) plain full-fat yogurt

1 tablespoon extra-virgin olive oil

Juice of **½** lemon

¾ teaspoon kosher salt

¼ teaspoon ground coriander

¼ teaspoon ground sumac

3 Persian cucumbers, peeled, seeded, cut into ¼-inch cubes

1 small grape or watermelon radish, cut into ¼-inch cubes

2 teaspoons minced shallot

½ cup (10 g) roughly chopped fresh cilantro leaves

¼ cup (10 g) thinly sliced fresh mint leaves

Make the lentils

1. In a medium saucepan, combine the lentils with 2½ cups (600 ml) of water and 1 teaspoon of the kosher salt, bring to a boil, reduce to a simmer, and cook for 15 minutes, until they are cooked through but still firm. Strain, rinse, and spread them along the surface of the colander to cool and dry. Reserve ¾ cup (115 g) of the cooked lentils for frying and transfer the rest to a medium serving bowl. Dress with the sherry vinegar, olive oil, and the remaining ¼ teaspoon kosher salt. Microplane (or mince) the garlic into the dressed lentils, toss, and set aside at room temperature.

Make the raita

2. Combine the yogurt, olive oil, lemon juice, kosher salt, coriander, and sumac in a medium bowl and stir thoroughly. Add the cucumbers, radish, and shallot and toss with the dressing. Transfer to a serving bowl and mix in the herbs. Refrigerate until serving.

Make the salmon

3. Preheat the oven to 425°F (220°C). Position a rack in the middle of the oven. Remove the fish from the fridge, pat dry with paper towels, and rub with neutral oil all over. Season generously with kosher salt and

black pepper on both sides. Cut into two equal-sized fillets. Set fish, skin side down, on a cooling rack set on a baking sheet so the fillets are elevated. Bake for 7 to 10 minutes, until the flesh flakes easily. Remove from the oven to cool slightly. Using a fish spatula, carefully separate the flesh from the skin (it's OK if it flakes out a little bit). Set the oven to broil. Flip the skin on the rack so the silver side is facing up and broil until crispy, 4 to 6 minutes, rotating the pan to ensure it doesn't burn. Remove to a plate to stop the cooking.

For serving

4. Place a sheet of newspaper or a paper towel on a baking sheet next to the range. Heat the neutral oil in a 10-inch (25 cm) shallow frying pan over high heat. When the oil is hot, add the ¾ cup (115 g) of the reserved cooked lentils, spreading them in an even layer using a slotted spoon. Cook for 3 minutes, stirring occasionally as they start to brown around the perimeter of the pan. Add the shallots and cook for 4 to 5 minutes, stirring constantly until the shallots begin to brown. Add the cumin seeds and cook for another minute, stirring until fragrant. Using a large slotted spoon or straining the lentils through a fine-mesh sieve (catching the oil in a heat-safe container), transfer the mixture to newspaper, spread in a single layer, and season with a generous pinch of fine sea salt while still hot. Spoon the fried lentils over the boiled lentils.

5. Arrange the lettuce and herbs on a platter along with the salmon and their skins. Serve alongside the bowl of lentils and the raita, letting guests assemble their own lettuce wraps.

For the salmon:
1½ pounds (685 g) salmon, steelhead trout, or sustainable arctic char
1 tablespoon neutral oil (see page 291)
Kosher salt and cracked black pepper

For serving:
¼ cup plus 1 tablespoon (75 ml) neutral oil
½ cup (85 g) minced shallot
1 teaspoon cumin seeds
Fine sea salt
12 to 16 large red oak or butter lettuce leaves, washed and dried
2 cups (60 g) fresh mixed herbs (mint, cilantro, basil, fennel fronds, etc.), for serving

...

MAKES GOOD LEFTOVERS: Yes.

MAKE AHEAD: Yes; make the raita ahead and refrigerate. Make the rest just before serving.

SEASON: Year-round.

...

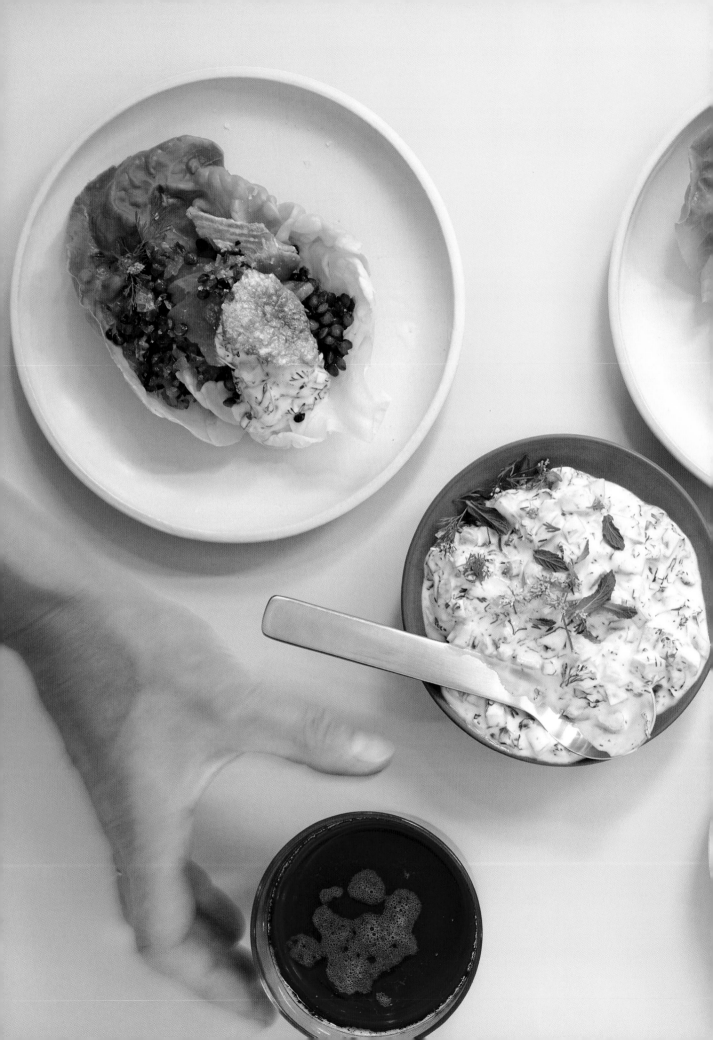

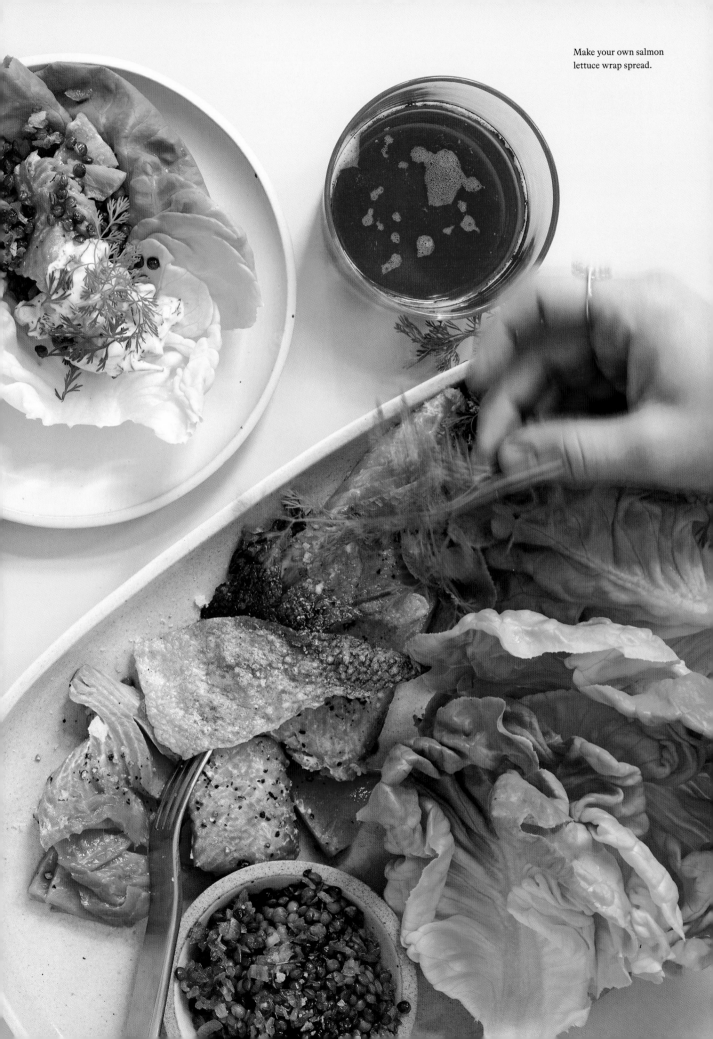

Make your own salmon
lettuce wrap spread.

Coconut Rice Cakes with Pineapple Chutney, Smashed Avocado and Soy-Marinated Eggs

Time: 95 minutes, plus time to refrigerate rice and marinate eggs

Yield: 10 cakes; serves 5

Crispy rice cakes are a solid base for all kinds of toppings and condiments. These are just a few fun ideas, but I encourage you to get creative. Instead of a soy-marinated egg, try a beet-pickled egg. A simple cabbage slaw would be a crunchy complement, or cucumbers tossed with mirin and sesame seeds works, too.

This recipe makes more chutney than you will likely use for the rice cakes, but it's a useful condiment to have in the fridge (it lasts for up to 2 weeks). Serve it with fish tacos or a seared pork chop, flank steak, or the lamb tacos on page 188.

For the rice cakes:

¾ cup (65 g) unsweetened shredded coconut

1 cup (180 g) sushi rice, washed and drained

¾ cup plus 2 tablespoons (210 ml) full-fat coconut milk

½ teaspoon kosher salt

⅓ cup (80 ml) coconut oil, for frying

Fine sea salt

For the cilantro and peanut garnish:

¼ cup (38 g) roasted salted peanuts, crushed

1 cup (20 g) fresh cilantro leaves

For the smashed avocado:

2 ripe avocados, pitted and peeled

1 lime

Flaky sea salt

1 pinch red pepper flakes

Make the rice cakes

1. Preheat the oven to 350°F (175°C). Spread the shredded coconut on a baking sheet in a single, even layer. Toast in the oven for 10 minutes, or until golden brown.

2. Place the rice, coconut milk, ⅔ cup (160 ml) water, and the kosher salt in a medium saucepan over high heat and bring to a boil. Stir, reduce to a simmer, cover with a tight-fitting lid, and cook for 12 minutes. Remove the saucepan from the heat, fluff the rice with a fork, replace the lid, and steam the rice for 5 minutes more.

3. Add the toasted coconut to the rice and mix to combine. Wipe the baking sheet free of any remaining coconut flakes and line with parchment paper.

4. Spoon the rice onto the parchment-lined pan and flatten it using a spatula or spoon, creating one even

layer about ½ inch (12 mm) thick, compressing it together as much as you can. When the rice is cool to the touch, wrap the baking sheet with plastic wrap completely and refrigerate overnight. (Be sure to wrap it well. If the rice dries out, it won't stick together when it fries and you're screwed).

5. When ready to cook, remove the plastic wrap and carefully cut circles out of the rice using a round cookie cutter or the metal ring top of a wide-mouthed (3⅜ inches/8.5 cm) Ball jar.

6. Line a baking sheet with newspaper and place it within arm's reach of the stovetop. Heat 3 tablespoons of coconut oil in a large sauté pan over high heat until sizzling hot (it should coat the bottom of the pan in a thin layer). Add the rice cakes three at a time and cook for 4 to 5 minutes, or until golden brown on the first side. Flip and cook for an additional 2 to 3 minutes. Remove to the newspaper, season with a pinch of fine sea salt, and continue to fry the remaining cakes, adding additional coconut oil as needed in between rounds. Wipe the pan out with a paper towel if the stray bits begin to burn.

Make the cilantro and peanut garnish
7. Combine crushed peanuts and the cilantro leaves in a small serving bowl and set aside.

Make the smashed avocados
8. Scoop the avocados into a small bowl and squeeze the lime over the top. Season with flaky sea salt to taste and smash with a spoon until roughly chunky. Finish with a pinch of red pepper flake.

Make the pineapple chutney
9. Place the oil in a medium cast-iron skillet over medium heat. Once hot and glistening, add the mustard seeds, fennel seeds, bay leaf, red pepper flakes, cumin seeds, clove, cinnamon, and cardamom and fry for 30 seconds, until the mustard seeds begin to pop out of the pan.

10. Add the onion, garlic, ginger, jalapeño, turmeric, and kosher salt and sauté over medium heat for 10 to 12 minutes, stirring constantly, until the onions are soft and slightly browned.

11. Add the pineapple, the brown sugar, and the vinegar to the pan and stir. Reduce the heat to medium, cover and simmer for 10 minutes.

For the pineapple chutney:
1 tablespoon neutral oil (see page 291)
½ teaspoon brown mustard seeds
½ teaspoon fennel seeds
1 bay leaf
¼ teaspoon red pepper flakes
¼ teaspoon cumin seeds
1 whole clove
1 cinnamon stick
1 green cardamom pod
1 small yellow onion, diced
1 clove garlic, Microplaned
½-inch (12 mm) piece fresh ginger, Microplaned
½ serrano or jalapeño pepper, seeded and minced
¾ teaspoon ground turmeric
¼ teaspoon kosher salt
2 cups (330 g) ripe pineapple, cut into ½-inch (12 mm) cubes
2 teaspoons brown sugar
2 tablespoons apple cider vinegar

For the soy-marinated eggs:
5 large organic eggs
2 teaspoons sugar
3 tablespoons rice vinegar
½ cup (120 ml) soy sauce

12. Uncover and continue to cook until all of the liquid has evaporated and the pineapple starts to caramelize and is sticking slightly to the pan. Add ½ cup (120 ml) of water, stirring and scraping the bottom of the pan to deglaze. Simmer uncovered for 30 minutes, or until all of the liquid has reduced. Before serving, remove the cinnamon stick, the clove, and the cardamom pod and discard.

Make the soy-marinated eggs

13. Prepare soft-boiled eggs and peel.

14. Combine the sugar, rice vinegar, ¼ cup (60 ml) of water, and the soy sauce in a small food storage container with a tight-fitting lid (choose a container in which 5 eggs will fit snugly.) Whisk until the sugar is dissolved. Add the eggs to the marinade and refrigerate for 1 hour. Quarter them carefully, wiping the knife blade between each slice, and transfer to a small serving plate (save the marinade in the fridge to make more eggs later). If preparing the eggs a day ahead, marinate them for 1 hour then remove them from the liquid and store them whole in a dry, sealed container. Quarter just before serving.

To serve

15. To assemble the rice cakes, top each cake with a generous scoop of avocado, a spoonful of the chutney, a showering of the cilantro garnish, a squeeze of lime, and a wedge of egg.

MAKES GOOD LEFTOVERS: No.

MAKE AHEAD: Yes; prepare the chutney and the soy-marinated eggs ahead. Make the rice the night before, but no more than 1 day in advance.

SEASON: Year-round.

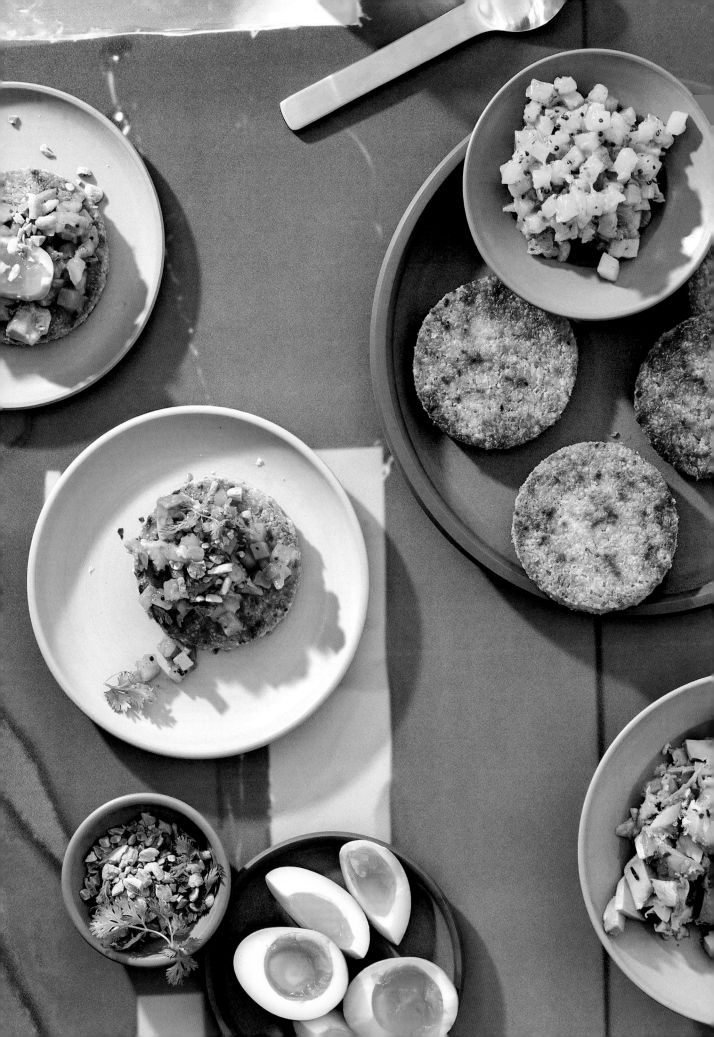

Coconut Rice Cakes with Mango and Coconut Lime Drizzle

Time: 45 minutes, plus time to chill
Yield: Serves 6 to 8 (15 cakes)

A take on the classic Thai dessert, sticky coconut rice and mango, the crispy rice cakes here add textural intrigue to that beloved flavor pairing. The brand of coconut milk you use makes a difference: My preferred brands for this recipe are Chaokoh and Native Forest, which are more widely available. (The Thai Kitchen brand doesn't cook down well, so look for alternatives.)

1 cup (240 mL) full-fat coconut milk
1 tablespoon coconut sugar
Pinch of fine sea salt
½ lime, juiced
2 or 3 ripe ataulfo mangos, peeled and sliced as thin as possible
Toasted sesame seeds

1. Prepare the rice as in the savory coconut rice cake recipe (see page 178), using a small, 2¾-inch (7 cm) wide Ball jar lid or circular cookie cutter to cut the cakes into rounds.

2. Add the coconut milk to a small saucepan with coconut sugar and salt. Bring to a low boil and reduce to a simmer. Cook until reduced by half, about 35 minutes. The sauce should be thick enough to coat the back of a spoon.

3. Remove from the heat and stir in the lime juice. Cool to room temperature and use immediately, or refrigerate in a sealed container until serving.

4. Top the rice cake with mango and drizzle the coconut cream over top. Garnish with sesame seeds and serve.

MAKES GOOD LEFTOVERS: No.

MAKE AHEAD: Prepare the rice the day before and fry just before serving.

SEASON: Year-round, or summer if you live somewhere where mangoes are grown.

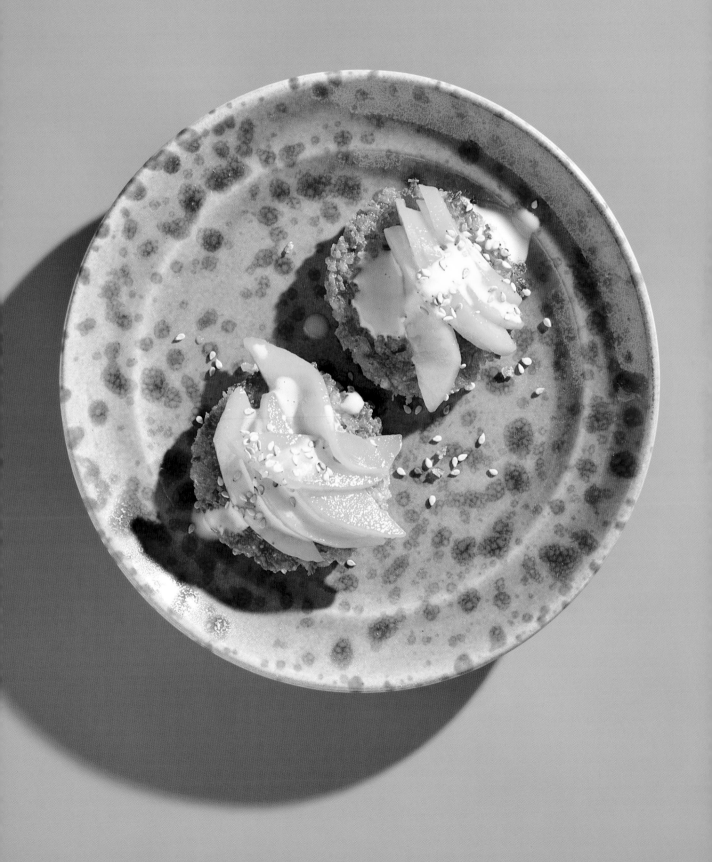

Winter Taco Night

Tacos are the original interactive meal—casual, infinitely customizable, and guaranteed to please. Fillings are designed to be made ahead and assembled to order, so as the host you can do your share of the work in advance, encouraging your guests to express themselves freely in the kitchen, scooping and garnishing to their own tune.

With high-quality tortillas (a must) and homemade toppings, you can satisfy your vegetarian and carnivorous friends all at once—there's more than enough flavor to go around. (The Charred Sweet Potatoes on page 194 make for an excellent vegetarian taco filling as well.)

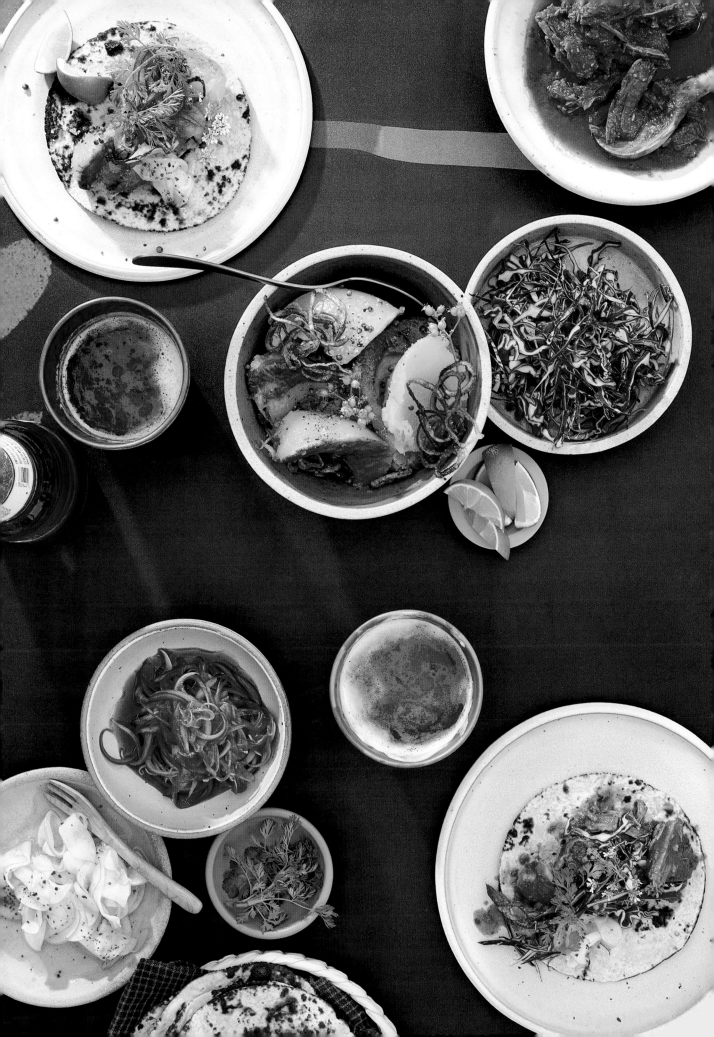

Roasted Smashed Winter Squash with Fried Coriander and Shallots

Time: 45 minutes
Serves: 6

This simple squash preparation can be the "meat" for a vegetarian taco, or serve it with the slow-braised lamb on page 188. Carnival squash is a colorful winter option similar to acorn. Winter squash is widely available, but try to source them from your farmer's market or CSA—I find them to be infinitely sweeter.

For the squash:
2 medium (1½- to 1¾-pound/680 to 800 g) carnival or acorn squash, cut in half and seeds removed
1 tablespoon plus 1 teaspoon ghee
Kosher salt
¼ to ½ cup (60 to 120 ml) neutral oil
3 large shallots, thinly sliced
¾ teaspoon flaky sea salt
¾ teaspoon whole coriander seed
½ lime

For serving:
½ cup (68 g) Pickled Red Onion (page 293)
¼ cup (30 g) cotija cheese
½ cup (10 g) fresh cilantro leaves
12 high-quality corn tortillas

Make the squash
1. Preheat the oven to 425°F (220°C).

2. Generously coat the inside of the squash halves with 1 tablespoon of the ghee and season with a pinch of kosher salt. Set the squash halves face down on a baking sheet. Bake until the meat is soft and scoopable, 25 to 35 minutes. Allow to cool slightly.

Fry the shallots
3. While the squash cools, heat a medium cast-iron skillet or sauté pan over high heat with enough oil to coat the bottom completely. Line a plate with paper towels or newspaper and place it next to the cooktop. When the oil is hot, add the shallots in one even layer and fry until golden brown, stirring every 30 seconds to promote even browning. When they start to appear golden brown, 15 to 20 minutes, transfer the shallots to the plate and season with a pinch of flaky sea salt, crushing the flakes between your fingers. Remove all the remaining shallot bits from the pan with a slotted spoon.

Leaving the oil in the pan, set the pan over medium heat. Add the coriander seeds and fry for 30 seconds, until fragrant. Transfer the coriander to a mortar and pestle, roughly crush, and transfer to a serving bowl.

To serve
4. Scoop the flesh of the cooked squash into the serving bowl with the coriander seeds. Add the juice of half a lime and the remaining 1 teaspoon ghee. Season with flaky sea salt and mix to combine. Top with shallots and serve with the optional toppings: pickled red onion, cotija cheese, and cilantro. To prepare the tortillas, wrap them in a damp paper towel and microwave for 10 seconds to warm and soften. Heat a dry, large cast-iron skillet over medium heat and toast the tortillas in the skillet until they start to brown on the bottom side, removing them before they begin to toughen up. Wrap in a dry napkin and serve immediately alongside the squash.

. .

MAKES GOOD LEFTOVERS: Yes.

MAKE AHEAD: Yes; the squash can be made ahead, but top with the fried shallots just before serving.

SEASON: Winter.

. .

Asian Pear Chipotle Pickle

Time: 5 minutes
Yield: 1½ cup (200 g)

A winning complement to any taco, this sweet and smoky pickle can also be made with thinly sliced Fuyu persimmons in the wintertime.

1 medium Asian pear or **2** Fuyu persimmons, cored and halved
Fine sea salt
Sugar
Squeeze of lime
Chipotle chile flakes

1. Using a mandoline, slice the Asian pear crosswise to create half-moons.

2. In a shallow bowl place one layer of the sliced pear and sprinkle with small pinches of salt and sugar. Repeat, layering and seasoning the fruit, until you have used all the pear. Squeeze the juice of half a lime over the top and finish with a small pinch of chipotle chile flakes. Set aside to pickle for at least 5 minutes and serve with the tacos.

MAKES GOOD LEFTOVERS: Yes.

MAKE AHEAD: Yes; store in an airtight container for up to 3 days.

SEASON: Year-round.

Slow-Braised Leg of Lamb Tacos

Time: 4 hours
Yield: Serves 12

For this recipe, I use an 8-quart (7.5 L) Dutch oven, but if you don't have one that large you can use two 4-quart (3.8 L) ovens. This dish is deal for entertaining, and it's best to make it ahead—refrigerating the sauce overnight will make it easier to skim the rendered fat before blending. Serve the lamb swimming in the intensely flavorful sauce, then use the excess as the base for a knock-out posole the following day (see page 190); you don't even need the meat.

Note: Precut roasts tend to be very lean. Have your butcher cut the leg of lamb to order and ask them to leave some fat on there. Oh, and spend money on the tortillas. The fancier ones really are worth the extra few bucks.

6½ **pounds (3 kg)** boneless leg of lamb, cut into 6 pieces

Kosher salt and cracked black pepper

1 **teaspoon** fennel seeds

2 **teaspoons** coriander seeds

2 **teaspoons** cumin seeds

4 whole star anise

4 dried mulato, ancho, or California chiles

2 dried chipotle chiles, seeds of one removed

4 bay leaves

Neutral cooking oil, as needed (see page 291)

2 medium red onions, roughly chopped

2 large yellow onions, roughly chopped

6 cloves garlic, crushed with the side of a knife

2 **teaspoons** dried Mexican oregano (sub Greek oregano)

3 **cups (720 ml)** canned whole peeled tomatoes in their juices

1 **tablespoon plus 1 teaspoon** brown sugar

4 **cups (960 ml)** chicken or beef broth (see page 292)

¼ **cup (60 ml)** apple cider vinegar

For serving:

18 **to 20** high-quality corn tortillas

3 limes

1 **cup (20 g)** fresh cilantro leaves

2 **cups** thinly shaved cabbage

Pickled Red Onion (page 293)

Asian Pear Chipotle Pickle (page 187)

Roasted Smashed Winter Squash with Fried Coriander and Shallots (page 186)

1. Preheat the oven to 300°F (150°C).

2. Season the lamb generously with salt and black pepper on all sides. If possible, do this the day before and leave the lamb on a rack over a baking sheet in the fridge to air-dry overnight.

3. Bring the lamb to room temperature about 45 minutes before cooking. Heat a large Dutch oven (at least 8 quarts) on the stovetop over high heat. When the pan is smoking hot, sear the lamb leg on all sides. Once the lamb has a deep brown color all around, transfer it to a plate and set aside. Reduce the heat to medium.

4. Add the fennel seeds, coriander seeds, cumin seeds, star anise, chiles, and bay leaves to the Dutch oven. (If there isn't enough rendered fat to lightly coat the bottom of the pot, add a few tablespoons of neutral cooking oil.) Fry the spices for 30 seconds, stirring constantly to prevent burning. Add the red and yellow onions, the garlic, and oregano, and sauté until the onions are caramelized and soft.

5. Add the tomatoes and their juices, the brown sugar, broth, 1 cup (240 ml) water, and the apple cider vinegar. Increase the heat to high and bring to a boil. Lower to medium heat and simmer for 5 minutes. Add the lamb to the braising liquid and cover. Braise the lamb in the oven for 3 to 3½ hours, until the meat is tender and falls off the bone.

6. If you are doing this the day before, cover and transfer the Dutch oven to the fridge to chill overnight. Skim any excess fat from the surface of the sauce and discard. (If refrigerated overnight, the fat will form a solid layer and will be easy to remove. If skimming just after cooking, the fat will be in its liquid state at the surface of the sauce.) When the fat is removed, use a slotted spoon or skimmer to fish out the bay leaves and star anise, pour the braising liquid into a blender, and purée until smooth (or purée directly in the pot with an immersion blender). Season the sauce with salt to taste. Return the sauce to the Dutch oven and continue to simmer the lamb for an additional 30 minutes.

7. When ready to serve, pull the meat into shreds using two forks, put it in a serving dish, and cover with a generous amount of the sauce. Serve with corn tortillas (see preparation notes on page 186), wedged lime, cilantro, shaved cabbage, pickled red onion, asian pear pickle, and roasted winter squash.

..

MAKES GOOD LEFTOVERS: Yes. Store the meat submerged in the sauce.

MAKE AHEAD: Yes.

SEASON: Fall and winter.

..

Leftover Lamb Posole

Time: 40 minutes
Yield: Serves 6 to 8

A soup made from the leftover sauce from the slow-braised lamb tacos recipe (see page 188), this is like a cheater's Lent after a meaty feast. If you don't plan to make posole the day after you make the lamb tacos, freeze the sauce for later.

Note: This recipe calls for cooked hominy, but you can also work with dried hominy, soaked and boiled. Rancho Gordo makes a great option.

1 kabocha or Blue Hubbard squash, sliced into 1-inch (2.5 cm) thick half-moons
2 tablespoons extra-virgin olive oil
4 medium carrots, peeled sliced on the diagonal into 1-inch (2.5 cm) pieces
3 large parsnips, peeled and sliced on the diagonal into 1-inch (2.5 cm) pieces
3 cups (720 ml) reserved chile purée from Slow-Braised Leg of Lamb Tacos (see page 188)
7 cups (1.6 L) beef or chicken stock
3 cups cooked hominy (or **one 30-ounce/885 ml can**)
Salt
Cilantro
3 limes, quartered

For serving:
½ small green cabbage, thinly sliced on a mandoline
Pickled Red Onion (page 293)

1. Preheat the oven to 425°F (220°C).

2. Toss the squash in a bowl with the olive oil and place it in a single layer on a baking sheet. Toss the carrots and parsnips in the same bowl using the residual oil to coat, and lay them in a single layer on a separate baking sheet. Roast the root vegetables for 25 minutes, flipping halfway through to ensure even color. Roast the squash for 30 minutes without flipping.

3. While the vegetables are roasting, add the lamb taco chile sauce and the broth to a large pot over medium heat and stir. Add the cooked hominy and bring to a simmer, taste, and adjust for seasoning.

4. Remove the vegetables from the oven and add the carrots and the parsnips to the broth.

5. Serve the posole in individual bowls with a few half-moons of cooked squash. Top with a handful of finely shredded cabbage, a squeeze of lime to taste, and Pickled Red Onions.

..

MAKES GOOD LEFTOVERS: Yes.

MAKE AHEAD: Yes, garnish just before serving.

SEASON: Fall.

..

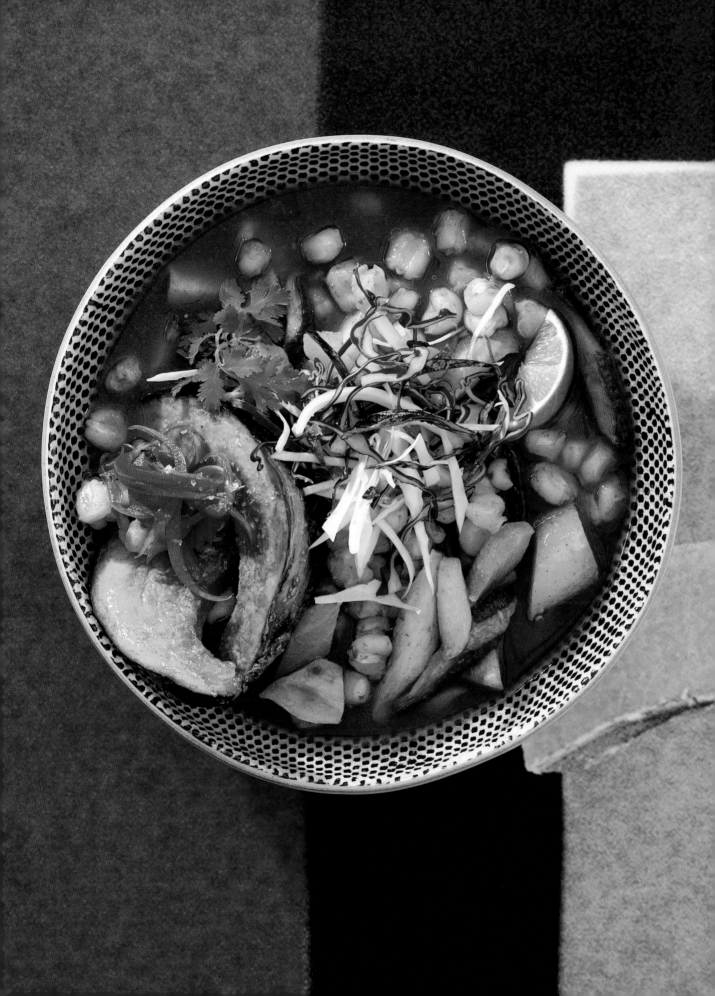

Make Your Own Charred Sweet Potato Night

There is so much more to sweet potatoes than meets the eye. Shop for them at your farmers market instead of the grocery store, and you will unlock a world of tuberous wonder, from the magenta-fleshed Okinawan to the Garnet with its hidden world of pumpkin pie-like custardy interior. Buy them all, the more variety, the more fun (little did you know, sweet potatoes in all their stripes and spots can be an excellent ice breaker).

Ideal for entertaining, precook the potatoes ahead, and char their skins just as people arrive (or leave them sitting on the hot coals of the BBQ). Set out a selection of toppings and let people pile them high.

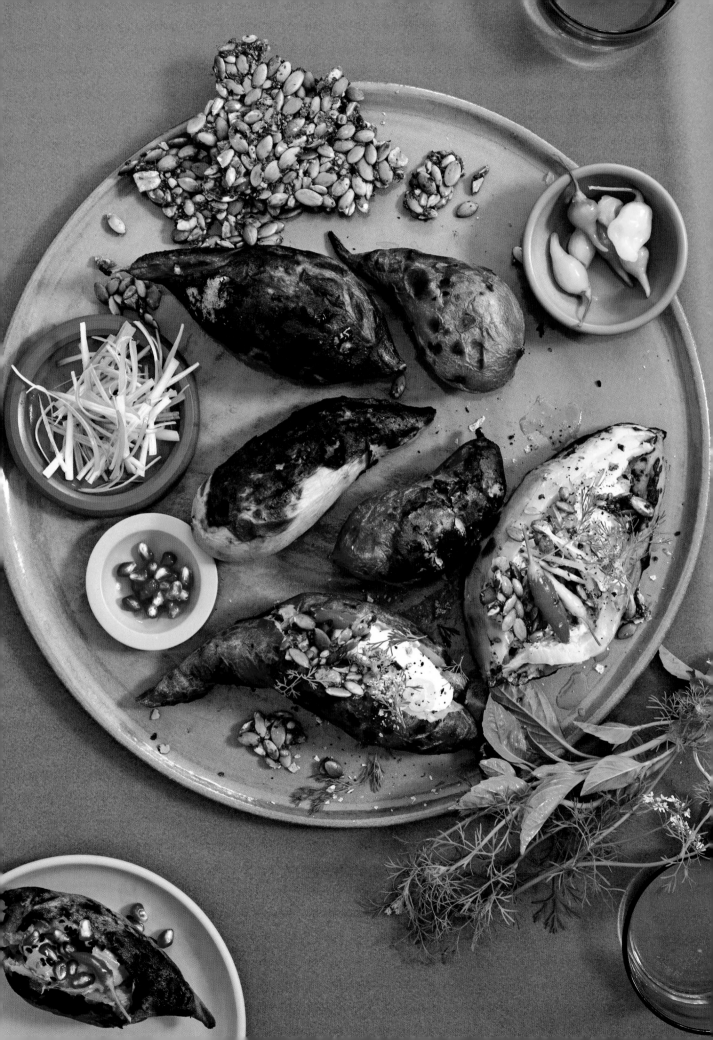

Charred Sweet Potatoes

Time: 1 hour
Yield: Serves 4

I keep roasted sweet potatoes in my fridge at all times. When I am ready to eat, all I have to do is heat them up in a hot dry cast-iron skillet or blacken the skins over the open flame of my gas stovetop burner. It's a filling meal for me (and a nutritious handheld baby snack on the go).

4 small sweet potatoes or purple Japanese yams
Olive oil
Kosher salt

For serving:
Flaky sea salt
Pepita Sauce (see page 240)
Roasted Beet and Goat Cheese Dip (page 45)
Cilantro-Yogurt Sauce (see page 120)
Grilled Lemon–and-Almond Salsa (see page 30)
Cucumber-Radish Raita (see page 175)
Garlic Salsa Verde (see page 127)
Fermented Chiles and Kombu Seaweed (page 268)
Whipped Ricotta (see page 124)
Dukkah (see page 222)

1. Preheat the oven to 425°F (220°C). Prick the potatoes all over with a fork. Line a baking sheet with parchment or aluminum foil and place the potatoes on the sheet. Drizzle with olive oil and rub to coat the skins completely. Sprinkle generously with kosher salt on all sides. Bake for 45 minutes to 1 hour or until the potatoes are supple and cooked through.

2. If using a charcoal BBQ, prepare your grill by lighting a charcoal fire and letting it burn until the coals turn white. When you're ready to party, it's time to char. Place the potatoes directly on top of the white-hot coals. Turn them every few minutes until the skins are semi blistered. When the potatoes feel squishy to the touch, clear a section of the barbecue basin of any hot coals and store the potatoes there until guests are ready to dress their own.

3. If you don't have a charcoal grill, or if you're preparing the potatoes on the stovetop, simply set your gas burner to a medium flame. Place the cooked potatoes directly on the burner, using a pair of heat-safe metal tongs. Rotate each potato as the skins start to show signs of color, moving them frequently until they are evenly blistered and hot to the touch. Remove them to a serving platter or hold them in the oven at 200°F (95°C).

MAKES GOOD LEFTOVERS: Yes.

MAKE AHEAD: Yes.

SEASON: Year-round.

CHOOSE YOUR OWN ADVENTURE

Sweet Potatoes with Tahini, Nigella, and Green Onion

Time: 5 minutes (not including time to cook the potato)
Yield: Serves 4

Nigella seeds look just like black sesame seeds, but they offer a subtle bitterness and a warm toasted-onion flavor. They are mostly grown in Egypt and India (and are even rumored to have been found in King Tut's tomb!). Keep them around to finish soups and garnish dips, as an addition to cucumber salads, or as a seasoning for rice.

2 green onions

4 small sweet potatoes or purple Japanese yams, pre-roasted and charred (see page 194)

Flaky sea salt

¼ cup (60 ml) high-quality tahini (see page 292)

Extra-virgin olive oil

¾ teaspoon nigella seeds (black onion seed)

1. Prepare a small bowl or quart container with ice water. Remove the root end and any floppy tops of the green onions (save them for your chicken stock). Cut the onions lengthwise into 2-inch (5 cm) pieces and julienne as thinly as possible. Plunge the sliced onion into the ice water and set them in the fridge to curl onto themselves, about 10 minutes.

2. Slice the charred potatoes in half lengthwise and season each one with a generous pinch of flaky sea salt. Drizzle the insides generously with tahini. If your tahini is thick and gloppy, add it to a small bowl and thin it by adding 1 tablespoon of warm water at a time, whisking until it's spoonable (at first it will get pastier, but keep stirring and adding water until it loosens). Finish with a modest drizzle of olive oil and a sprinkle of nigella seeds. Drain the green onions and spin them dry, or pat dry well using a clean kitchen towel. Garnish the potatoes with green onion ribbons and serve while hot.

MAKES GOOD LEFTOVERS: No.

MAKE AHEAD: No.

SEASON: Year-round.

Crunchy Seed Crackers

Time: 1 hour 15 minutes
Yield: Two slabs 7 by 12-inches (17 by 30 cm)

This dense slab of nuts, seeds, and spices is magic when crumbled on potatoes, but it's also a lifesaver for uninspired grain salads and plain old roasted vegetables. Keep it around as a high-protein snack, or as an upgrade to the lifeless cracker on your cheese plate. These pair well on a potato with something creamy—like the Roasted Beet and Goat Cheese Dip (page 45), crème fraîche, or labneh.

1 tablespoon plus 2 teaspoons flaxseed meal

1 tablespoon plus 1 teaspoon chia seeds

1 tablespoon white miso

2 tablespoons plus 1 teaspoon maple syrup

1 teaspoon kosher salt

¼ teaspoon garlic powder

1 tablespoon plus 1 teaspoon sumac

1½ cups (195 g) raw pepita seeds, toasted (see page 293)

1 cup (140 g) raw sunflower seeds, toasted (see page 293)

⅓ cup (50 g) roasted salted peanuts, roughly chopped

1. Preheat the oven to 300°F (150°C).

2. Combine the flax meal, chia seeds, and ⅓ cup (80 ml) water in a large bowl. Stir to combine and set aside to hydrate, 10 minutes.

3. Once the chia and flax have hydrated, add the miso, maple syrup, salt, garlic powder, and sumac to the bowl and smear together with a rubber spatula until smooth. Add the pepitas, the sunflower seeds, and the chopped peanuts and stir until well combined.

4. Cover a half sheet pan with parchment paper and add the nut mixture in 2 mounds at opposite ends of the long side of the baking sheet. Spread each mound using a rubber spatula to create 2 cohesive ¼-inch-thick slabs that fill the short end of the baking sheet completely, with a 2-inch (5 cm) gap in between.

5. Bake for 15 minutes in the preheated oven, then lower the heat to 275°F (135°C) and bake for an additional 50 minutes to 1 hour, until the slabs are evenly dark brown and no longer squishy when you press a fingertip into their centers. Allow to cool completely before breaking into large chunks.

MAKES GOOD LEFTOVERS: Yes; freeze what you won't use in the next few days. Crisp in the oven at 250°F (120°C) for 10 to 15 minutes to refresh.

MAKE AHEAD: Yes.

SEASON: Year-round.

CHOOSE YOUR OWN ADVENTURE

Make Your Own Dumpling Night

The dumpling potluck is a throwback to my college days in Providence, Rhode Island, where every night was an occasion to cook all day and share a meal with friends. (We had a lot of time on our hands back then.) It seemed there was always a potluck to anticipate, the more elaborate the better. One of my favorite parties was a BYO-dumpling night, where our hosts provided the dumpling skins and every guest brought a filling or a sauce for dipping. There was a station for rolling your dough, another for filling and pinching, and the eating happened anywhere and everywhere. The steamer baskets were piping on the stove all night, and while everyone got their hands in it, it really wasn't too much work for any one individual.

When making dumplings at home, there's no shame in buying premade dumpling wrappers, available frozen in most large grocery stores and Asian markets. I never used to make my own until COVID-19, when I had an insatiable hankering for dumplings and nowhere to turn. Making them yourself requires nothing more than flour, water, and a little elbow grease. These dumplings can be steamed or served pan-fried, gyoza style.

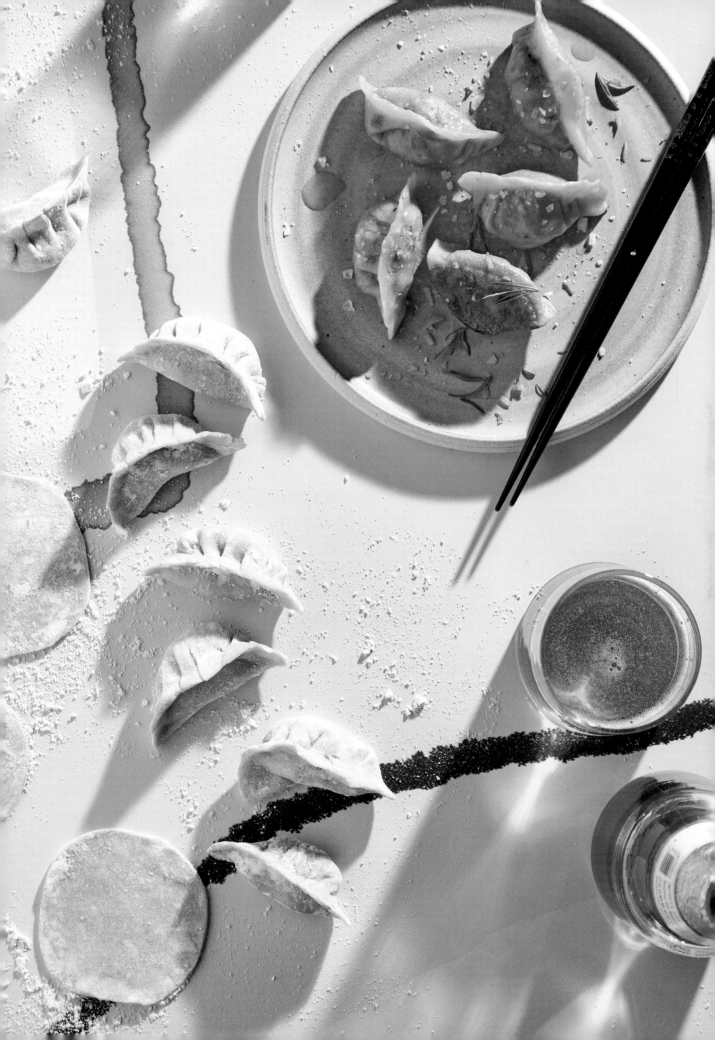

Dumpling Skins

Time: 1 hour
Yield: 16 skins

Note: Homemade wrappers tend to be larger than packaged ones. I use 1 tablespoon of filling for my homemade wrappers, but for store-bought I use less, around 1½ teaspoons.

1 cup (140 g) all-purpose flour, plus more for rolling

⅛ teaspoon kosher salt

2 tablespoons neutral oil (see page 291), plus more if pan-frying

2½ cups fillings (pages 201, 202, and 203)

1. Using a fork, whisk together the flour and the salt in a medium bowl.

2. Add ¼ cup plus 1 tablespoon (75 ml) of boiling water to the flour, whisking constantly with a fork to make a shaggy dough. Form the dough into a ball, adding more water, 1 teaspoon at a time as needed, to bring it all together (stop adding water before it feels tacky).

3. Flour a clean work surface. Using the palm of your hands, knead the dough for a few minutes until you form a mostly smooth, elastic ball (there will be some folds). It should be pliable but firm. Wrap the dough tightly in plastic wrap and let it rest at room temperature for 30 to 45 minutes.

4. When you are ready to roll out the dough, flour the countertop generously. Make 1-inch (2.5 cm) balls of dough by rolling small pieces of the dough between your palms. Squash the balls between your thumb and forefinger and roll them as thinly as you can using a rolling pin, flipping and flouring to prevent the dough from sticking to the counter. Try to roll into a circular shape, but don't fret if you end up with something more irregular. Cover the skins with a damp paper towel to keep them moist while you work.

Make the dumplings

5. Fill a small bowl with water. Place a scant 1 tablespoon of filling (see pages 201, 202, and 203 for options) in the center of one skin. Dip your forefinger in the water and trace the edges of the dough to wet all around. Fold the dumpling in half over the filling and press your finger along the edge to seal. If your edges don't perfectly align or there's excess, trim into a half-moon with a pairing knife. "Pleat" the seam by folding the wrapper over onto itself and pinching the sides of the dough together until you have about 5 or 6 pleats. As you work, cover the finished dumplings with a damp paper towel until you're ready to steam or fry them.

To steam the dumplings

6. Place a steamer insert inside a medium stockpot. Fill with water to reach just below the base of the insert. Brush the surface of the insert with oil and add a batch of the dumplings, leaving space so they aren't touching. Cover with a tight-fitting lid and steam for 6 minutes. Serve immediately. Repeat with the remaining dumplings.

To pan-fry the dumplings

7. Heat a large skillet with a tight-fitting lid over medium-high heat. When the pan is hot, add enough oil to completely coat the surface of the pan. Add a batch of dumplings and cook for about 1 to 2 minutes, until the bottoms are golden brown. Carefully add a scant ¼ cup (60 ml) of water and immediately cover. Lower the heat to medium-low to cook through. Transfer to a serving plate and eat while still warm. Repeat with the remaining dumplings.

MAKES GOOD LEFTOVERS: No.

MAKE AHEAD: Yes; you can keep the ball of dough tightly wrapped in plastic for up to 24 hours. Do not roll out the wrappers ahead of time.

SEASON: Year-round.

CHOOSE YOUR OWN ADVENTURE

Nettle and Chive Filling

Time: 5 minutes
Yield: Makes 12 to 16 dumplings

Nettles are the first sign of spring. You will see them pop up all over—in parks, the woods, your backyard. They are often available in CSAs and at farmers' markets where they are dirt cheap. They require some patience (and a pair of gloves) to process, but in my opinion, the payoff is worth it. Nettles are really nutrient dense, and I adore the deep verdant flavor. I trim, blanch, and squeeze them into 2-inch (5 cm) balls and keep them in my freezer when I need a pop of green for pasta sauce, a stew, or even a dip. Or, I simmer them fresh or dried in a big pot of water to make nettle tea.

The goat cheese in the filling acts as a binder to bring the greens together and lend it silkiness, but the result is light as air, not gloppy at all.

1 large bunch stinging nettles (about 5 ounces/140 g)

2 tablespoons extra-virgin olive oil, plus more for serving

3 cups (130 g) minced raw chard leaves

Cracked black pepper

¼ teaspoon fine sea salt

3 tablespoons plus 1 teaspoon chèvre

1½ teaspoons minced fresh tarragon, plus more for serving

1 tablespoon minced fresh chives

Flaky sea salt

Zest of **1** lemon

1. Set a small pot of water over high heat to boil. Prepare a medium bowl with ice water. Be extra careful when handling fresh nettles—they do sting! Wearing gloves, snip off the leaves using kitchen shears (it's OK to leave small stems attached). Drop the nettle leaves into the boiling water and blanch for 30 seconds until they wilt completely. Transfer to the ice bath then strain the water. Squeeze the nettles between your hands to remove any excess water (OK to remove gloves here). Give them a good wringing. Set them on a cutting board and mince. Transfer to a small bowl. This should yield ⅓ cup (85 g) cooked, minced nettle leaves.

2. Set a medium sauté pan over medium heat. Add the 2 tablespoons olive oil with the chard to cook. Season with a few grinds of freshly cracked black pepper and a pinch of salt and sauté for 2 minutes, or until soft. Transfer the cooked chard to the small bowl with the nettles. Add the goat cheese, tarragon, and chives and stir to combine. Fill, seal, and steam or fry your dumplings (see page 200).

3. Season with a pinch of flaky sea salt and a drizzle of olive oil. Garnish with torn tarragon and lemon zest and serve while hot.

MAKES GOOD LEFTOVERS: Yes; save extra filling to make more dumplings the next day or use for an omelet.

MAKE AHEAD: Yes; prepare the filling up to 2 days ahead, but fill the dumplings and cook just before serving.

SEASON: Spring.

Gingery Squash and Shallot Filling

Time: 15 minutes
Yield: Makes 12 to 16 dumplings

1 tablespoon plus 2 teaspoons neutral oil (see page 291)

2 small summer squash (**8 ounces/230 g**) sliced into ½-inch (12 mm) thick medallions

Fine sea salt

½ cup (85 g) minced shallot (from about 4 medium shallots)

1 clove garlic, Microplaned

½ teaspoon Microplaned fresh ginger

½ teaspoon Korean chile flakes

½ teaspoon brown rice vinegar

¼ teaspoon kosher salt

1. Set a large sauté pan over medium-high heat. Add 1 tablespoon of oil to the pan. When it is glistening hot, cover the pan with a single layer of squash and cook until golden brown, about 7 minutes. Flip and cook on the opposite side for 30 seconds. Using tongs, transfer the medallions to a cutting board and season with a pinch of the fine sea salt. Mince the cooked squash and set aside. This should yield 1 cup (about 450 g) of cooked, minced squash.

2. Add the remaining 2 teaspoons oil to the hot pan. Follow with the shallot and cook for 3 minutes, stirring occasionally to promote even browning. Add the garlic, ginger, and chile flakes and sauté for an additional minute before adding the cooked squash back to the pan along with the brown rice vinegar. Give it a quick stir and sauté until any residual liquid from the squash is gone. Remove from the heat.

3. Fill, seal, and steam or fry your dumplings (see page 200). Serve with soy sauce, brown rice vinegar, or black vinegar for dipping.

MAKES GOOD LEFTOVERS: Yes; save extra filling to make more dumplings the next day.

MAKE AHEAD: Yes; prepare the filling up to 2 days ahead, but fill the dumplings and cook just before serving.

SEASON: Summer.

Beef and Kimchi Filling

Time: 5 minutes
Yield: Makes 12 to 16 dumplings

The simplest filling possible, the kimchi does the heavy-lifting to season the beef.

6 ounces (170 g) ground beef

1 teaspoon gochujang paste

2 tablespoons plus 2 teaspoons finely minced kimchi

½ teaspoon kimchi brine

1 tablespoon thinly sliced green onions

¼ teaspoon kosher salt

Add all the ingredients to a small bowl and mix until well combined. Fill, seal, and steam or fry your dumplings (see page 200).

MAKES GOOD LEFTOVERS: Yes; save extra filling to make more dumplings the next day.

MAKE AHEAD: Yes; prepare the filling up to 24 hours ahead, but fill the dumplings and cook just before serving.

SEASON: Year-round.

Make-Your-Own Sundae Bar

As a host, I love to pawn the procurement of ice cream off on my friends—it's the right price point and easy to find, but you can also lend your guest some agency in choosing the flavor and the brand. People have strong opinions on this topic! Better yet, ask a few guests to bring a pint, then you can focus on the fun stuff—TOPPINGS.

Pavlova

Time: 2½ hours, up to overnight
Yield: Serves 6

Pavlova are light and airy, with a delicate, crispy shell that shatters to reveal a chewy, marshmallowy center. Usually baked in individual servings, I prefer to make a big amorphous blob so everyone can tear off a piece and add it to their ice cream sundae.

Note: This recipe works best with superfine baker's sugar. If you only have regular white sugar, put it in the blender and break it down before using it.

4 large organic egg whites
¼ teaspoon fine sea salt
⅛ teaspoon cream of tartar
1 cup (195 g) superfine sugar (see Note)
½ vanilla bean, seeds scraped out, or **½ teaspoon** vanilla extract

1. Preheat the oven to 275°F (135°C). Line a baking sheet with parchment paper.

2. Using a hand mixer or a stand mixer on medium-high, whip the egg whites, salt, and cream of tartar until consistently foamy and white. Add the sugar, sprinkling in 1 tablespoon at a time and whipping until it forms stiff peaks, about 10 minutes. Add the vanilla seeds and whip for an additional minute to incorporate.

3. Using an angled rubber spatula, spread the egg whites in a blob approximately 1 inch (2.5 cm) thick on the prepared baking sheet, allowing the top to have peaks and valleys. Bake for 10 minutes, then reduce the temperature to 250°F (120°C) and bake for 1 hour 15 minutes. Turn the oven off and leave the pavlova in the oven for at least 1 hour or overnight.

MAKES GOOD LEFTOVERS: Yes; the Pavlova will keep for 1 week in an airtight container at room temperature.

MAKE AHEAD: Yes.

SEASON: Year-round.

Macerated Meyer Lemon

1 Meyer lemon

Orange blossom water

Sugar

Fine sea salt

Time: 5 minutes

Yield: ¼ cup

Meyer lemons are naturally sweet, almost mild enough to eat on their own. Macerated with a pinch of sugar and a splash of heady orange blossom water, available at any Middle Eastern grocer or online, this makes for flowery, tart sundae topping, or a complement to full-fat Greek yogurt with nuts and honey.

1. Slice the stem end off of the Meyer lemon, removing just enough to expose the flesh. Using a mandoline or a very sharp knife, slice the lemon into paper-thin rounds, as thin as you can (don't worry if you tear the slice). Remove the seeds along the way.

2. Place the smallest dash of orange blossom water in a small bowl. Layer the sliced lemon in the bowl and sprinkle with a pinch of sugar and a tiny pinch of salt. Gently toss using your fingers. Set aside to macerate for 5 to 10 minutes before serving.

MAKES GOOD LEFTOVERS: Yes; use to top pancakes the next morning.

MAKE AHEAD: Yes; store in the fridge.

SEASON: Winter.

Pears Poached in Cinnamon Hibiscus Syrup

Yield: Serves 4
Time: 30 minutes

Hibiscus, called Jamaica flower in Mexican cooking, is a beautiful thing. The dried flowers are primarily used for tea but are also a potent natural dye in food and in textiles. The flavor is tart and bright, with notes of red currant.

1 **cup (220 g)** packed brown sugar
½ **cup (30 g)** dried hibiscus flowers
½ cinnamon stick
2 firm Anjou pears, peeled, halved, and cored

1. Trace the perimeter of a large saucepan onto a sheet of parchment paper. Cut out the circle and snip a small hole in the center.

2. In the same large saucepan, bring 2½ cups (600 ml) water, the sugar, hibiscus, and cinnamon stick to a boil, lower the heat to a simmer, and swirl the pan to dissolve the sugar. Simmer the syrup for 15 minutes. Slide the pears into the liquid and cover with the parchment paper circle. Simmer for an additional 10 minutes until the fruit is fork tender but not mushy. Transfer the fruit to a glass jar and cover in syrup. Serve right away or seal and refrigerate for up to 10 days.

MAKES GOOD LEFTOVERS: Yes.

MAKE AHEAD: Yes, bring to room temperature before serving.

SEASON: Fall.

Candied Cardamom Pistachios

Time: 5 minutes
Yield: ½ cup (75 g) pistachios

Lightly coated in salt, sugar, and hint of cardamom, these nuts go beautifully with poached fruit and smooth ice cream.

½ **cup (65 g)** shelled unsalted raw pistachios

1 tablespoon brown sugar

Pinch ground cardamom (or **2** pods fully crushed in a mortar and pestle, shells removed)

Pinch fine sea salt

Place the nuts in a small skillet over medium heat and stir until lightly toasted, 2 to 3 minutes. Add the sugar to the pan along with 1 teaspoon of water and stir with a wooden spoon to coat the nuts as the sugar dissolves. Remove them to a piece of parchment paper and sprinkle with a small pinch of cardamom and a pinch of sea salt and allow to cool.

MAKES GOOD LEFTOVERS: Yes.

MAKE AHEAD: Yes; store the nuts in an airtight container in a cool, dark place for up to 1 week.

SEASON: Year-round.

Chamomile-Poached White Peach

Time: 50 minutes, plus cooling
Yield: Serves 4

The subtle aroma of chamomile underpins the delicate complexity of white peaches. (This recipe works well with slightly underripe pears, too.) Serve the fruit with some of its syrup and save the rest for sophisticated mocktails. You can freeze the syrup in ice cube trays for later use.

2 cups (480 ml) filtered water

4 chamomile tea bags or **2 tablespoons** fresh chamomile flowers, plus more fresh flowers for serving

¼ cup (80 ml) light honey

2 tablespoons cane sugar

2 strips orange zest

2 tablespoons Calvados, St. Germain, or Lillet

4 ripe but firm white peaches, pitted and halved

Juice of **½** lemon

1. Trace the circumference of a heavy medium saucepan on a piece of parchment paper. Cut it out and snip a small hole in the center.

2. Place the water, tea bags or chamomile flowers, honey, sugar, and orange zest in the saucepan. Bring to a boil, lower the heat, and simmer for 10 minutes. Add the liquor. Slide the peaches in and cover with the parchment to keep the fruit submerged. Simmer for 8 to 10 minutes and remove the peaches to a large glass container with a tight-fighting lid. Simmer the syrup for an additional 30 minutes. Add the lemon juice and pour the syrup over the fruit. Allow the jar to cool. Serve right away, with additional fresh flowers for garnish if you have them, or seal and refrigerate for up to 10 days.

MAKES GOOD LEFTOVERS: Yes.

MAKE AHEAD: Yes.

SEASON: Summer.

HALLOWEEN PARTY
Julia Sherman and Adam Katz

Giving kids candy is no different than gifting them hard drugs, but even *I* don't want to be the woman on the block who hands out raisins on Halloween. So I thought about what I could give that people might actually want. Each year, we drag my photo studio out to the street (strobe lights, backdrop, fog machine, desktop computer, SLR camera), and shoot portraits that elicit not one, but many, cries of, "this is *better* than candy!"

No fancy equipment? No problem. All you need is a fabric or paper backdrop, some hardware store clamp lights, an extension cord, maybe a few decorative pumpkins, and yeah, the fog machine is a really nice touch. Invite trick or treaters to take their own photos using their phones. Their dentists will thank you.

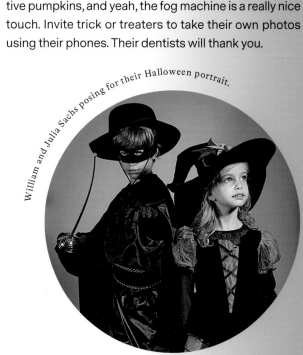

William and Julia Sachs posing for their Halloween portrait.

Anonymous trick-or-treater in Clinton Hill, Brooklyn.

HEADDRESSES FOR ANY OCCASION
Francesca DiMatteo

For artist Francesca DiMatteo, her son Bruno's birthday party is a thinly veiled excuse to create a Noah's Ark of wearable sculpture. Francesca tells me, "I start out doing projects for Bruno, but really, they are just as much for me."

Francesca's studio practice is woven seamlessly into her domestic life. A painter and self-taught ceramicist, on any given day her kiln might be stacked with the elements of totemic sculptures, handmade tile for her new kitchen, or a full porcelain table setting made in collaboration with her son. But on the occasion of Bruno's birthday, we find ourselves in her studio putting the finishing touches on a menagerie of papier-mâché headdresses for the kids to wear at tomorrow's pizza party in their Hudson Valley home. While the final result is nothing less than high art, DiMatteo assures me the process is easy to replicate with nothing more than papier-mâché, blue tape, and paint.

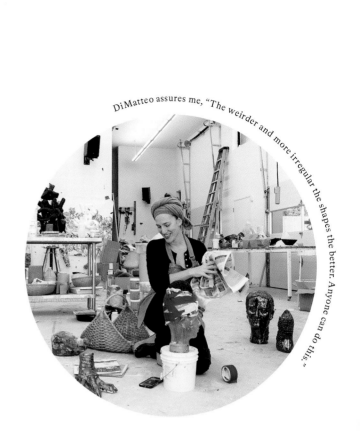

DiMatteo assures me, "The weirder and more irregular the shapes the better. Anyone can do this."

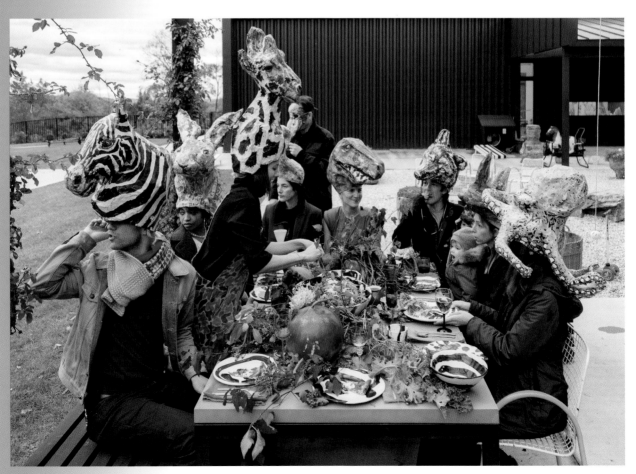

DiMatteo made a mask for every kid at the party, but in the final hour, Bruno refuses the ungainly headpiece and augmented footwear, and his friends follow suit. Francesca turns to her friends, who dutifully don the animal kingdom.

UKRANIAN EASTER
EGG PARTY
Joe and Lauren Grimm

Joe and Lauren Grimm are the Brooklyn-based artists-turned-brewers behind the label Grimm Ales. They gained a cult following with beer that knows no bounds. laced with nectarines, passion fruit pulp, spruce tips, and beets. It's a cerebral experience every time; nothing is ever quite what it seems.

At their annual Easter party, we came for the brew but found ourselves meticulously painting eggs in the Ukranian decorative style, a Grimm family tradition. The technique was new to everyone, so it didn't mater if this was your first Easter party (mine!), or your favorite holiday of the year.

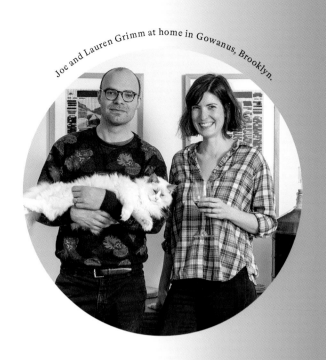

Joe and Lauren Grimm at home in Gowanus, Brooklyn.

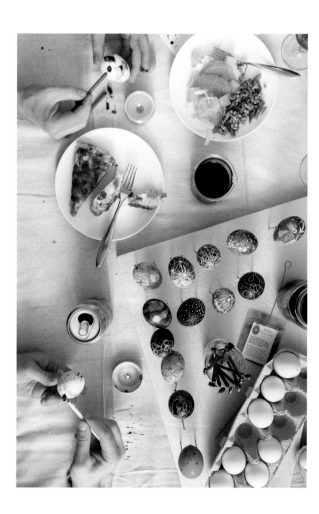

Using a stylus pen dipped in melted wax, we apply pattern to the surface of the eggs.

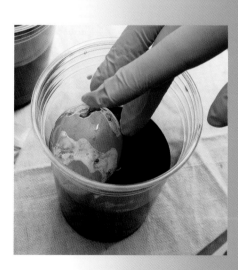

Next, the eggs are bathed in dye. Set in the oven, the wax melts away to reveal crisp white line-work, some psychedelic, some dense with a Fabergé-like pattern.

CHOOSE YOUR OWN ADVENTURE

LABOR DAY DYE PARTY
Julia Sherman

I have a compulsive habit of buying white clothes, though I have proven to be the last person on earth fit to keep to keep them clean. I used to beat myself up about it, but then, I realized I could dye them and give them a second life.

Labor Day is the ideal time to invite your friends to reinvent their condiment-stained summer duds in full color. If you're ambitious, dip your toes into the world of natural dyes. (Avocado pits, onion skins—all of them can be repurposed! There are some great books out there.) Or keep it simple and go the craft store route, preparing buckets of Rit color and rubber bands for tie dye.

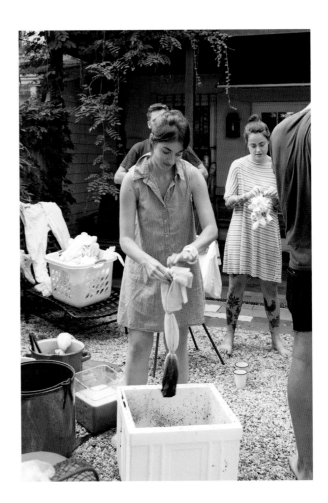

Hannah Goldfield tie-dyes a shirt in my backyard.

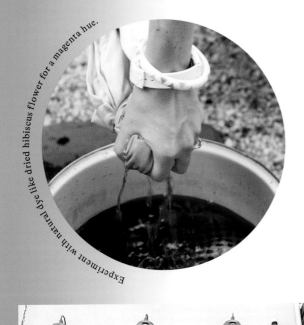

Experiment with natural dye like dried hibiscus flower for a magenta hue.

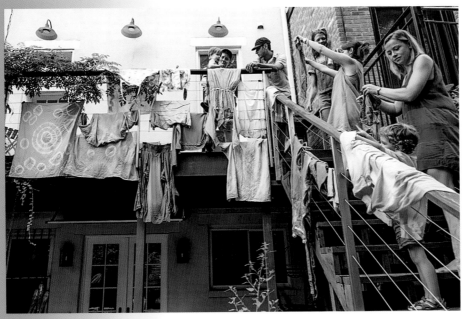

A SALAD, A THING, AND SOMETHING ELSE

My mother once gave me some hosting advice for the ages. "Start the party by pouring a really nice bottle of wine. Make it a conversation piece, talk it up, then downgrade throughout the night. People don't know what they are drinking after the second glass." In short, dangle something shiny in front of their eyes and blind them till it's time to stumble home. When it comes to entertaining, salad is my red herring. It's colorful, bountiful, and layered with texture and intrigue.

You can phone-in the bulk of the meal, but it will still feel home-made, thanks to salad. Wow them with a come-hither bowl of showy lettuces, fancifully dressed and studded with crunchy bits and bobs, then all you have to do is figure out something starchy and some kind of protein to bulk up the meal. It's "a salad, a thing, and something else."

PARTY TIPS: What to Do with Old Bread

Have a big party and you'd think "baguette" was the secret password at the door. The sentiment to bring a loaf of bread comes from the right place (and God, do I love bread), but when everyone has the same idea, your host will find themselves saddled with a cache of carbs with a half-life. But alas! Let nothing go to waste. I prefer day-old bread to fresh for many things, from Croutons (page 294) to Bread Crumbs (page 294) to candelabras.

If you're looking to really stretch that leftover loaf, look no further than Papa a la Pomodoro, an Italian tomato bread soup that sticks to your ribs and is made from pantry staples.

Papa a la Pomodoro (Italian Tomato-Bread Soup)

Time: 40 minutes
Serves: 4 to 6

¼ **cup** extra-virgin olive oil, plus more for serving

1 medium white onion, diced

Kosher salt

3 cloves garlic, thinly sliced

1 pinch red pepper flakes, plus more for finishing

1 28-ounce (794 g) can whole peeled San Marzano tomatoes

5 cups chicken or veggie broth, plus more as needed

2 tablespoon tomato paste

Parmesan rind and cheese (optional)

8 oz (½ loaf) stale sourdough or baguette, cut/torn into 2-inch chunks

1 small sprig rosemary (optional)

1¼ **cups (1 15.5 oz can)** cooked cannellini beans (optional)

1 bunch roughly torn dark leafy greens (optional)

For serving:

1 cup densely packed, roughly torn fresh basil, stems removed

Syrupy balsamic vinegar

Flaky sea salt

1. Sauté the onion with ¼ cup (60 ml) of olive oil and two generous pinches of kosher salt in a stockpot until soft, about 5 minutes. Add the garlic and crushed red pepper and sauté for one minute.

2. Add the can of tomatoes with all its juices, the broth, and the tomato paste. Add the Parmesan rind to the pot if you have one lying around. Raise the heat to high, bring to a boil for two minutes. Reduce to an active simmer and cook until the tomatoes fall apart, about 30 minutes. Smash the tomatoes with the side of a wooden spoon against the side of the pot to break them up as they cook.

3. Add the stale bread. Here you can also add canned cannellini beans, a sprig of rosemary, and/or dark leafy greens. Stew for 2 minutes, until the bread is soft and hydrated, adding more broth if the soup gets too thick.

4. Serve with torn basil over top, grated Parmesan cheese, and a drizzle of extra olive oil and fancy balsamic vinegar. Finish with some flaky sea salt, and there you go, old bread incarnate.

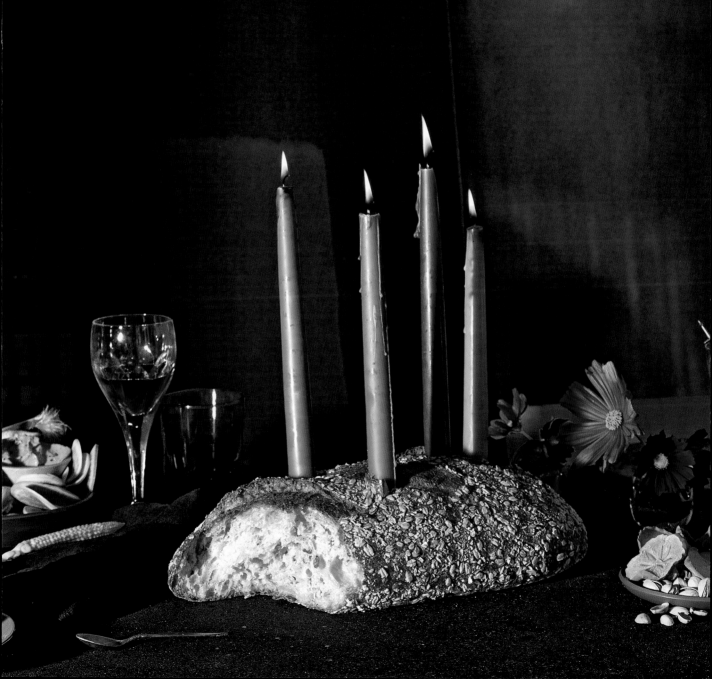

Citrus Pinwheels with Dukkah and Dates

Time: 15 minutes
Yield: Serves 4

Dukkah is a North African spice blend, fragrant and nutty with playful texture and infinite variations. Experiment with pistachios, pepitas, pumpkin seeds, or cashews for the nut element. Add a pinch of bee pollen to make it just a little bit sweet. (It tastes great on vanilla ice cream!) This recipe yields more than you need for this salad alone, so use the extra dukkah to season chicken or as a topping for grains or roasted squash.

For the dukkah:

¼ cup (35 g) raw pepitas or pistachios, toasted (see page 293)
¾ teaspoon coriander seeds
½ teaspoon cumin seeds
¾ teaspoon raw sesame seeds, toasted (see page 293)
⅛ teaspoon red pepper flakes
¼ teaspoon ground sumac
¼ teaspoon flaky sea salt

For the salad:

4 to 6 pieces (**2½ pounds/1.2 kg**) of varied citrus (tangerine, blood orange, cara cara, Sumo, mandarin)
Extra-virgin olive oil
Flaky sea salt
3 halawi or sticky Medjool dates, roughly chopped

Make the dukkah

1. Crush the toasted pepitas with a mortar and pestle until you have some larger pieces, but for the most part, the texture is that of coarse sand. (Work in batches if your mortar and pestle is small, or use a blender or coffee grinder to pulse and crush all at once.) Place the crushed pepitas in a small bowl.

2. In a small frying pan over low heat, toast the coriander and cumin seeds. When fragrant, transfer to the mortar and pestle, crush completely, and transfer to the bowl with the pepitas. Add the toasted sesame seeds, the crushed red pepper, the sumac, and the sea salt to the bowl and stir to combine.

Make the salad

3. Slice the ends off of the citrus. Working with one piece at a time, stand the citrus on its flat end and slice down toward the cutting board to remove the peel and the white pith from the fruit, careful not to remove too much of the flesh as you go. Work your way around the fruit until all you see is exposed flesh. Repeat with the rest of the citrus.

4. Slice the citrus into ¼-inch-thick rounds and arrange in a single or double layer on a large platter. Drizzle generously with olive oil and sprinkle generously all over with the dukkah. Season with flaky sea salt to taste. Scatter the chopped dates evenly over the citrus and serve immediately.

MAKES GOOD LEFTOVERS: No.

MAKE AHEAD: Prepare the dukkah ahead and store in an airtight container for up to 10 days. Slice the citrus and assemble just before serving

SEASON: Winter.

Cauliflower Salad with Curry Vinaigrette

Time: 45 minutes, plus time to marinate
Yield: Serves 4

Barberries are the Persian version of a dried cranberry, but so much better—pleasantly tart, most often with no added sugar. You can sub barberries with dried currants or high-quality small golden raisins. Slicing your cauliflower into steaks creates maximum surface area for browning on a hot pan. Marinating for a few hours isn't required, but it does make for a more evenly cooked result (say goodbye to dry, patchy florets forever.)

====

Make the cauliflower

1. Whisk together the grapeseed oil, sherry vinegar, and Microplaned garlic in a large bowl. Slice the cauliflower into ½-inch-thick steaks and gently toss with the marinade, coating every surface (don't worry if the cauliflower begins to crumble; the crumbly bits are good). Set aside for 3 hours or overnight in the fridge, tossing once or twice.

Make the pickled barberries

2. Combine the cider vinegar, sea salt, and honey in a small saucepan and bring to a boil, stirring to dissolve the salt. Put the barberries in a small ramekin or bowl and pour the hot liquid over the top. (This can also be done in the microwave). Set aside.

For the cauliflower:

1 tablespoon plus 2 teaspoons grapeseed oil
2 tablespoons sherry vinegar
1 clove garlic, Microplaned
1 medium cauliflower, leaves trimmed
1 teaspoon fine sea salt
Cracked black pepper

For the pickled barberries:

½ cup (120 ml) apple cider vinegar
¼ teaspoon fine sea salt
1 teaspoon honey
3 tablespoons dried barberries or currants

For the dressing:

1 small shallot, minced
¼ teaspoon curry powder
¼ teaspoon spicy powdered chile, such as Sanam, New Mexican red chile, or Korean chile flakes
¼ teaspoon fine sea salt
1 teaspoon Dijon mustard
2 ½ teaspoons light honey
¼ cup (60 ml) apple cider vinegar
¼ cup plus 3 tablespoons (105 ml) extra-virgin olive oil

For serving:

Flaky sea salt
2 tablespoons sunflower seeds, toasted (see page 293)
1 tablespoon torn fresh mint leaves

..

MAKES GOOD LEFTOVERS: Yes.

MAKE AHEAD: Yes; marinate the cauliflower ahead, but roast and dress just before serving. Make the dressing ahead, refrigerate, and bring to room temp before serving.

SEASON: Year-round.

..

A SALAD, A THING, AND SOMETHING ELSE

Make the dressing

3. Combine the minced shallot, the curry powder, chile powder, sea salt, Dijon, honey, and cider vinegar and whisk to combine. Add the olive oil in a steady stream, whisking to emulsify. Set aside while you roast the cauliflower.

4. Preheat the oven to 450°F (230°F) with a baking sheet on the middle rack. Season the cauliflower all over with a teaspoon of fine sea salt and cracked black pepper to taste. Place the cauliflower steaks on the hot baking sheet in a single layer and roast for 25 minutes, flipping each piece and removing those that are brown and roasty to a serving platter. Continue to cook the larger steaks on the opposite side for an additional 5 minutes or until deep golden brown and soft. Arrange the cooked cauliflower on a serving platter and season with a pinch of flaky sea salt.

To serve

5. Spoon the dressing over the cauliflower. Squeeze the barberries gently and scatter them over the dish. Top with the sunflower seeds and mint and serve.

Grilled Romaine with Celery-Kumquat Salsa

Time: 15 minutes
Yield: Serves 2 as a main, 4 as a side or an appetizer

Tossing the heads of romaine or little gems on a grill pan or the BBQ transforms the lettuce from filler fiber to entrée material. The salsa is versatile—spoon it over fish or roasted potatoes or simple grilled fish. If you don't have kumquats, substitute the zest of one lemon.

Make the salsa
1. Combine all the ingredients for the salsa except the lemon juice. Stir to combine.

Make the grilled romaine
2. Set a grill pan over high heat or fire up the barbecue.

3. Slice the romaine hearts in half lengthwise and drizzle with the grapeseed oil. Gently rub the oil over the leaves to coat so as to keep the lettuce intact. Sprinkle the fine sea salt over the entirety of the lettuce and season with freshly cracked black pepper.

4. When the pan is hot, place 2 romaine halves cut side down onto the pan and sear undisturbed for 3 to 5 minutes, or until you have deep brown grill marks on the surface and the edges of the lettuce begin to crisp. Flip and cook for 1 minute before transferring to a serving platter. Repeat with the remaining head of romaine.

To serve
5. Add the lemon juice to the salsa and stir to combine. Spoon the salsa generously over the lettuce. Finish with a healthy amount of Microplaned Manchego cheese, a scattering of celery leaves, and the sliced soft-boiled egg.

For the salsa:
½ cup minced celery (1 to 2 stalks)
⅓ cup (10 g) finely chopped fresh parsley leaves
½ clove garlic, Microplaned
1 green onion, ends trims, sliced in half lengthwise, and thinly sliced on the diagonal
6 kumquats, sliced into thin rounds (seeds removed as you slice)
½ teaspoon flaky sea salt
⅛ teaspoon smoked paprika
1 teaspoon red pepper flakes
2 teaspoons brined capers, squeezed dry and roughly chopped
⅛ teaspoon celery seed
¼ cup (60 ml) extra-virgin olive oil
Zest and juice of **½** lemon

For the grilled romaine:
2 romaine hearts or small farmer's market romaine
1¾ teaspoons grapeseed oil
½ teaspoon fine sea salt
Cracked black pepper

For serving:
Manchego cheese
1 to 2 soft-boiled eggs
Celery leaves, for garnish

..

MAKES GOOD LEFTOVERS: No.

MAKE AHEAD: Yes; make the salsa ahead but grill the romaine just before serving.

SEASON: Winter.

..

A SALAD, A THING, AND SOMETHING ELSE

Roasted Harissa Carrot Grain Salad with Yogurt Sauce

Time: 45 minutes
Yield: Serves 4 to 6

Harissa is a North African paste made from hot chile peppers and spices like cumin, coriander, caraway, and mint. Look for harissa at your specialty foods shop or Middle Eastern grocer. Shop for carrots that have tender fronds; the delicate fronds pack all the flavor of a carrot with a delicate green grass undertone.

Note: This recipe is for hard winter wheat berries, spelt, or farro. Prepare a scant 1 cup (180 g) of grain to yield 2 cups (305 g) cooked.

For the salad:
¾ cup (105 g) raw unsalted almonds, roughly chopped
3 tablespoons plus 1 teaspoon (50 ml) extra-virgin olive oil
Kosher salt
1 small shallot, minced
2 teaspoons sherry vinegar
1 pound (455 g) slender carrots, scrubbed, trimmed, cut on the diagonal into 2-inch pieces, tender fronds washed and reserved
2 teaspoons harissa
1 tablespoon plain full-fat yogurt
1 medium yellow onion, cut into 1-inch (2.5 cm) thick slices
2 cups (358 g) cooked hard winter wheat berries, spelt, or farro (see Note)
Flaky sea salt, to finish
½ cup (15 g) fresh cilantro leaves

For the harissa yogurt sauce:
½ cup (120 ml) plain full-fat yogurt
½ teaspoon harissa

1. Preheat the oven to 350°F (175°C) with the rack positioned in the center of the oven.

2. Toss the almonds with 1 teaspoon of the olive oil, season with 2 pinches of kosher salt, and spread them in an even layer on a baking sheet. Roast for 10 to 12 minutes until deep, dark brown. Transfer the almonds to a small bowl and return the baking sheet to the oven. (Wipe the surface clean of any remaining almond bits first.) Increase the temperature to 425°F (220°C).

3. Put the minced shallot in a serving bowl with the sherry vinegar and a pinch of kosher salt. Set aside to pickle.

4. Bring a medium pot of water to a boil with 1 tablespoon kosher salt. Add the carrots, return to a boil, and cook for 3 to 4 minutes until fork tender. Drain and spread in a single layer on a kitchen towel to dry.

5. In a large bowl, stir together the yogurt, harissa, and 2 tablespoons of the olive oil until well combined. Add the onion and carrots and toss to coat. Spread the vegetables on the hot baking sheet and season with a generous pinch of kosher salt. Roast on the center rack for 15 minutes or until the vegetables start to brown. Meanwhile, chop the reserved tender carrot fronds and set aside.

6. While the vegetables are in the oven, add the grains to the serving bowl with the pickled shallot, and toss with the remaining 1 tablespoon olive oil. Season with flaky salt. Add the carrot fronds and ½ cup (70 g) of the almonds (reserving the remaining ¼ cup/35 g for finishing), and toss. Transfer the cooked vegetables to the serving bowl and garnish with the cilantro and the remaining almonds.

7. To make the sauce, stir together the yogurt with the harissa and serve on the side.

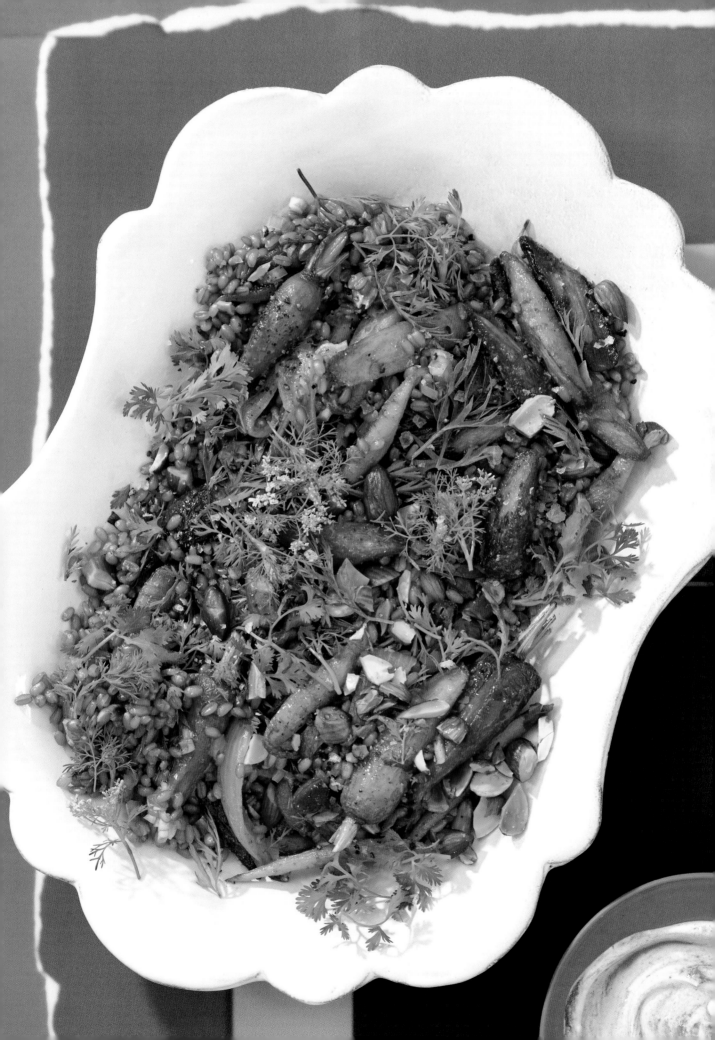

Green Salad with Asian Pear and Umeboshi Vinaigrette

Time: 10 minutes
Yield: Serves 8 as an appetizer or 4 as a main

Salty, sour, and fruity, umeboshi vinegar is the by-product of Japanese umeboshi plums, fermented for intense flavor. It's not only a zingy addition to club soda, but it's the je ne sais quoi of this delightful dressing. For the crunch, use plain rice crackers or, if you have a Korean market near you (or like to buy food items online), look for *nurungi*, a packaged snack approximation of the fought over crispy crust that forms on the bottom of the stone bowl of the bibimbap. Make this an entrée by adding sliced pan-seared flank steak. Yum.

For the Umeboshi Vinaigrette:

1 tablespoon plus ¼ teaspoon umeboshi vinegar

1 tablespoon light honey

1 tablespoon plus 1 teaspoon brown rice vinegar

¼ cup plus 1 tablespoon (75 ml) sesame oil

½ teaspoon toasted sesame oil

For the steak (optional):

One 2-pound (910 g) flank steak, well-trimmed

2 teaspoons kosher salt

½ teaspoon cracked black pepper

For serving:

14 cups (575 g) loosely packed sturdy Asian greens (tatsoi, pak choi, mustard greens, mizuna, chrysanthemum greens etc.), washed and spun dry

1 large Asian pear, cored, quartered and sliced ⅛ inch thick on a mandoline

½ cup lightly crushed plain, salted rice crackers, (approximately 20)

1 to 2 teaspoons toasted sesame seeds

MAKES GOOD LEFTOVERS: No.

MAKE AHEAD: Yes; make the dressing ahead and assemble the salad when ready to serve.

SEASON: Year-round.

A SALAD, A THING, AND SOMETHING ELSE

Make the vinaigrette

1. Combine all of the dressing ingredients in a mason jar, screw on the lid, and shake vigorously.

Make the steak

2. If making the flank steak, heat a large cast-iron skillet over medium-high heat. Pat the steak dry and season it all over with the salt and black pepper. When the pan is hot, sear the steak over high heat for 5 to 7 minutes per side for medium rare, depending on the thickness. If the steak starts to curl away from the pan, set a smaller cast-iron skillet on top to weigh it down. Remove the steak to a cutting board to rest for 5 minutes. Slice against the grain into ½-inch pieces.

To serve

3. Give the dressing another shake and toss the salad greens with the dressing in a large bowl. Top with the Asian pear, crushed rice crackers, and sesame seeds. Serve immediately with the steak on the side if using.

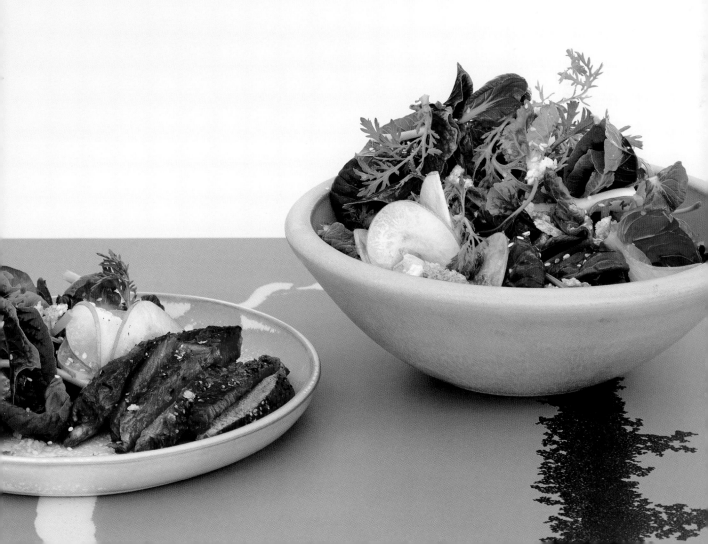

New Potatoes with Celery and Dijon Sauce Gribiche

Time: 25 minutes
Yield: Serves 8 to 10

Ah, my heart beats for sauce gribiche. Very French and traditionally served over asparagus, this sauce is salty and rich, the ideal companion for creamy potatoes.

For the salad:

2 small shallots, halved lengthwise and sliced into long strips

Fine sea salt

Pinch sugar

Juice of **1** lemon

Kosher salt

2 pounds (910 g) new potatoes, about 2 inches (5 cm) in diameter

⅓ cup (80 ml) extra-virgin olive oil

For the Dijon Sauce Gribiche:

¼ cup (60 ml) Dijon mustard

1 tablespoon white wine vinegar

¼ cup (40 g) brined capers, soaked, rinsed, and squeezed dry

10 cornichons, roughly chopped

2 stalks celery, diced

1½ teaspoons kosher salt

Cracked black pepper

½ cup (120 ml) extra-virgin olive oil

6 large eggs

For serving:

¾ cup (40 g) torn fresh parsley leaves

Minced fresh chives (optional)

MAKES GOOD LEFTOVERS: Yes. If you have leftover potato salad, spoon it over butter or gem lettuce lightly dressed in oil and red wine vinegar, and finish with an optional topping of Bread Crumbs (page 294).

MAKE AHEAD: Yes; store in the fridge, bring to room temperature, and finish with herbs right before serving.

SEASON: Year-round.

A SALAD, A THING, AND SOMETHING ELSE

Make the salad

1. In a small bowl, sprinkle the sliced shallot with a pinch of fine sea salt and a pinch of sugar and cover with the lemon juice. Set aside to pickle.

2. Heavily salt a large pot of water with kosher salt. (It should taste like the sea.) Add the potatoes, bring to a boil, and lower to an active simmer. Cook the potatoes until fork tender, about 10 minutes. Drain the water, cut the potatoes in half, and toss with the olive oil while still warm. Season with a pinch of fine sea salt. Strain the pickled shallot and toss with the potatoes.

Make the gribiche

3. In a medium bowl, combine the Dijon, vinegar, capers, cornichons, celery, kosher salt, pepper, and olive oil. Stir until creamy.

4. Fill a pot with 1 to 2 inches (2.5 to 5 cm) of water. Bring to a boil and carefully place the eggs in the pot in a single layer and close the lid. Steam the eggs for 7 minutes. Run the eggs under cold water and peel immediately. Roughly chop and gently fold the eggs into the saucy mixture.

To serve

5. Create one layer of potatoes in a serving dish. Spoon half of the sauce over the potatoes and sprinkle with half the torn parsley. Add another layer of potatoes and spoon the remaining sauce on top. Garnish with the remaining parsley and chives, if using, and serve at room temperature.

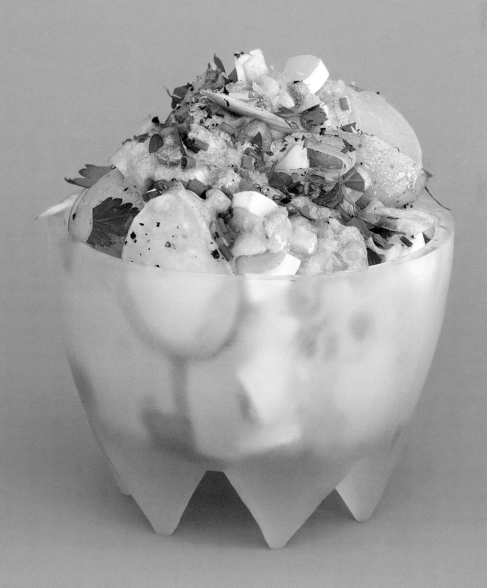

Pan-Seared Summer Squash with Mint and Feta

Time: 15 minutes
Yield: Serves 3

This is my solution for a glut of summer squash and zucchini in peak summer, when you just don't think you can handle another bite. Pan-searing in olive oil, the medallions absorb the silky olive oil and you really taste the sweetness in the vegetable. It's like falling in love all over again.

Note: Olive oil should never be brought past its smoke point (this is why we don't use it to deep-fry). Once smoking, olive oil becomes carcinogenic. Be sure to monitor the heat on the pan as you sear, keeping it nice and hot but never smoking.

⅓ cup (80 ml) extra-virgin olive oil
2 pounds (910 g) crookneck squash, grey squash, or other summer variety, sliced into ¼-inch-thick medallions
Fine sea salt
Zest and juice of ½ lemon
Flaky sea salt
Leaves of **1** sprig fresh mint, torn
1 tablespoon pine nuts, lightly toasted (see page 293)
Pinch ground chile pepper (Piment d'Espelette, Aleppo, or Silk chile)

1. Heat two large sauté or cast-iron pans over high heat. When the pans are hot but not smoking, add half of the olive oil to each and reduce the heat to medium-high. Cover each pan with a single layer of squash and season with a pinch of sea salt. Cook for 7 minutes on one side until golden brown. The oil should be sizzling hot, but not smoking. Flip and cook on the opposite side for 30 seconds. Using tongs, transfer the squash to a serving platter. Repeat until you have cooked all of the squash.

2. Once all of the squash is cooked, dress with the lemon zest and juice and season with flaky sea salt to taste. Finish with torn mint, pine nuts, and a pinch of chile pepper.

MAKES GOOD LEFTOVERS: Yes.

MAKE AHEAD: No.

SEASON: Summer.

A SALAD, A THING, AND SOMETHING ELSE

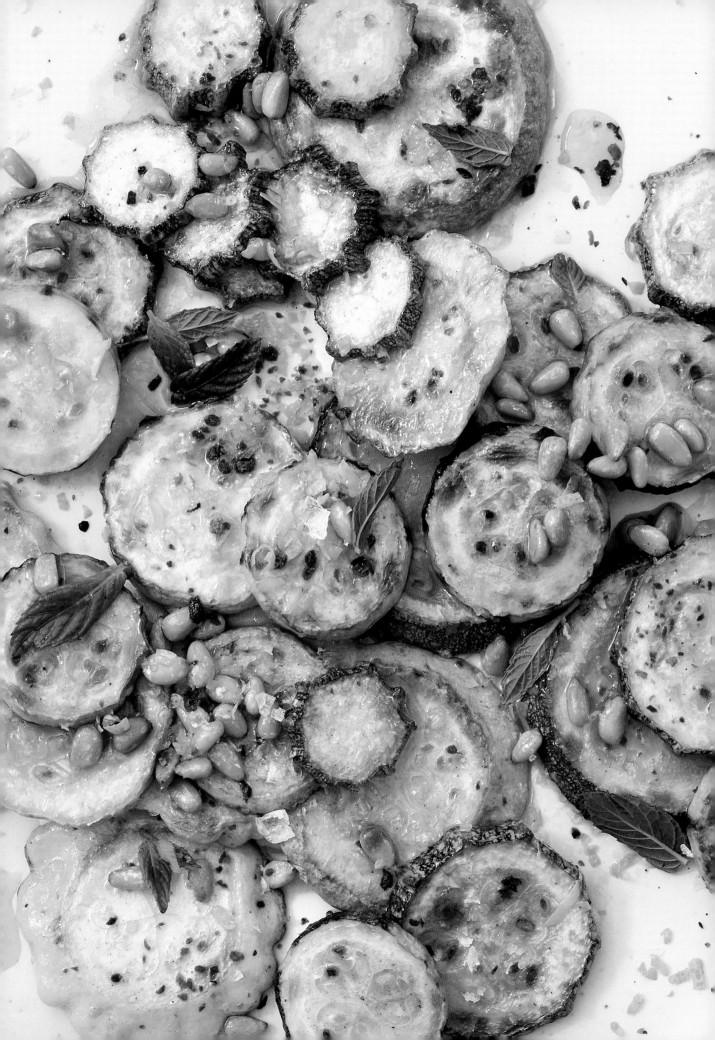

Zucchini alla Scapece

Time: 15 minutes, plus time to marinate
Yield: Serves 2 to 3 as a side

A sophisticated do-ahead vegetable side, the zucchini is cooked until golden brown, lightly pickled in oil and vinegar, and held in the fridge. Serve on its own, on top of crusty sourdough toast, or as the star ingredient in a salad. I top them with raw shaved fennel (tossed in olive oil and salt), mint, and an extra drizzle of olive oil (there's no need for any additional acid, since the squash is lightly pickled).

⅓ **cup (80 ml)** red wine vinegar

½ **teaspoon** honey

1 clove garlic, smashed with the side of a knife

⅓ **cup plus 2 tablespoons (105 ml)** extra-virgin olive oil

2 medium zucchini or summer squash, sliced into ¼-inch-thick medallions

¼ **teaspoon** fine sea salt

1½ **teaspoons** dried mint

Flaky sea salt, for serving

1. In a small saucepan, combine ¼ cup plus 2 tablespoons (90 ml) water, the vinegar, honey, and garlic and bring to a simmer, stirring to dissolve the honey. Add 2 tablespoons of the olive oil and set aside.

2. Cook the squash as described in the Pan-Seared Summer Squash with Mint and Feta recipe on page 234. Using tongs, transfer the medallions in layers to a glass food-storage container, seasoning each layer with a pinch of sea salt and a pinch of dried mint. Pour the vinegar solution over the squash. Refrigerate for at least 1 hour or store in the fridge for up to 1 week.

3. When ready to serve, bring to room temperature, transfer to a serving platter, season with a pinch of flaky sea salt, and enjoy.

MAKES GOOD LEFTOVERS: Yes.

MAKE AHEAD: Yes; prepare this up to 5 days before serving at room temperature.

SEASON: Summer.

A SALAD, A THING, AND SOMETHING ELSE

Spicy Carrot Ribbons with Preserved Lemon Vinaigrette

Time: 15 minutes
Yield: Serves 2 to 3

If there's one takeaway from this book, let it be the wonders that an ice bath can do for thinly shaved vegetables. Common carrots sliced paper-thin on the mandoline reemerge as fancy ribbons when shocked in freezing cold water. They will go from one-dimensional to spectacular in volume. Use this method for parsnips, green onions, and radishes, too.

This dressing is in my regular rotation. I love the floral funk of a preserved lemon. You can easily make these yourself in the winter citrus season and keep them all year round (see page 272). Or, look for them at your specialty food shop or Middle Eastern market.

For the Preserved Lemon Vinaigrette:

3 tablespoons finely minced preserved lemon peels (see page 272), inner pith removed (from 1 whole lemon)

1 teaspoon honey

1 teaspoon Dijon mustard

Juice of **1** lemon

¼ cup (60 ml) extra-virgin olive oil

For the salad:

1 pound (455 g) long, large carrots (5 to 6), peeled

1 teaspoon coriander seed

½ teaspoon caraway seed

½ teaspoon cumin seed

¼ teaspoon ground chile pepper (such as Piment d'Espelette, Aleppo, or Silk chile)

Flaky sea salt

Make the vinaigrette

1. Place the preserved lemon, honey, Dijon, and lemon juice in a high-speed blender and run on medium-low, adding the olive oil in a slow stream until everything is well combined and the dressing is smooth.

Make the salad

2. Prepare a bowl with ice and water. Using a Y-peeler, shave the carrot lengthwise to create long, wide ribbons. Add the carrots to the ice bath to curl for 10 minutes.

3. Strain the carrots, place them on a kitchen towel, and pat dry. Put the carrots in a serving bowl and toss with the dressing.

4. In a small pan, toast the coriander, caraway, and cumin seeds over low heat until fragrant. Transfer to a mortar and pestle and crush well. Toss the carrots with the spices, a pinch of ground chile pepper, and flaky sea salt. Serve immediately.

MAKES GOOD LEFTOVERS: Yes; the dressed carrots are good for 24 to 48 hours.

MAKE AHEAD: Yes; make the dressing ahead, refrigerate and bring to room temperature before serving. Shave the carrots and hold in ice water in the fridge until ready to pat dry, dress, and serve.

SEASON: Year-round.

A SALAD, A THING, AND SOMETHING ELSE

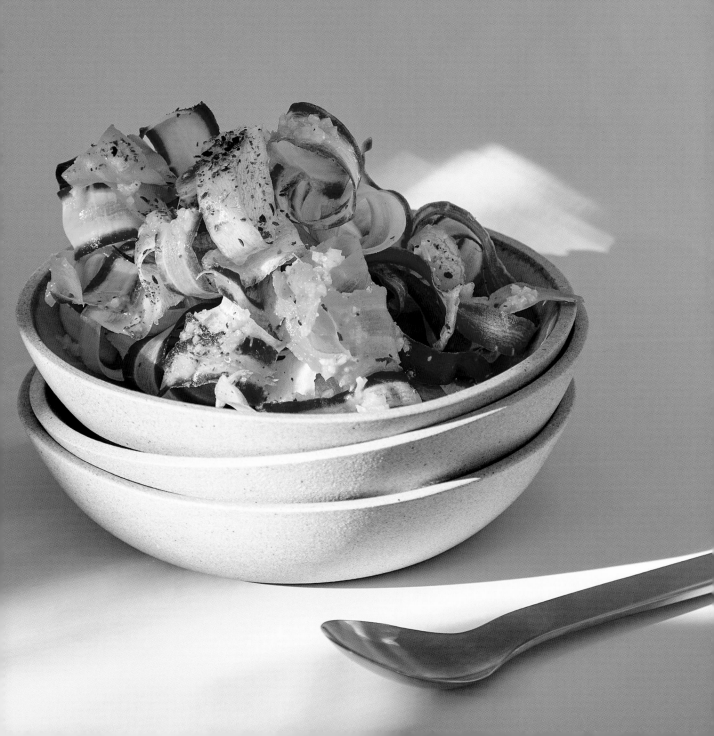

Crispy Broccolini and Blood Orange with Creamy Pepita Sauce

Time: 30 minutes
Yield: Serves 4

I discovered the pairing of blood orange and tender broccolini at my friends' restaurant, Kismet, in Los Angeles. It was one of those unexpected yet harmonious flavor combinations that left me wishing I had thought of it myself. I pair this duo with a pumpkin and tahini-based sauce—earthy and subtly sweet, creamy with a bit of texture.

1 pound (455 g; about 2 bunches) baby broccolini, stalks trimmed
1 tablespoon plus 1 teaspoon extra-virgin olive oil, plus more for finishing
1 teaspoon fine sea salt
½ teaspoon ground chile pepper (such as Piment d'Espelette, Aleppo, or Silk chile)
Scant ½ cup (30 g) toasted pepitas
1 pitted Medjool date
¼ cup (70 g) tahini
3 medium blood oranges
Flaky sea salt, for finishing

1. Preheat the oven to 425°F (220°C) with a large baking sheet on the middle rack.

2. Toss the broccolini with the olive oil, season with ½ teaspoon of the sea salt and the ground chile, and spread in an even layer on the hot baking sheet, being careful not to overcrowd. Roast the broccolini for 10 minutes until the stalks are fork tender and the leaves are crispy.

3. Place the toasted pepitas in a blender and process to the texture of coarse sand. Remove 1 tablespoon and set aside for finishing. Add the date, the tahini, and the remaining ½ teaspoon fine sea salt to the blender. Add water 2 tablespoons at a time, up to 8 tablespoons in all, and process until textured but well combined and almost smooth, scraping down the sides of the blender with a rubber spatula halfway through. (It should be the texture of a loose, spoonable hummus).

4. Slice the top and bottom ends off the blood oranges. Working with one at a time, stand an orange on its flat end and use a knife to cut away the peel and the pith, working from the top down toward the cutting board. You should see only flesh and none of the white pith when you are done. Rotate 90 degrees and slice into round pinwheels ¼ inch thick, removing the seeds carefully as you go.

5. Spread the pepita sauce on a large serving platter or the bottom of a shallow bowl using a rubber spatula. Pile the broccolini on top. Place the blood orange medallions in and around the broccolini. Season with a pinch of flaky sea salt and drizzle with high-quality olive oil. Scatter the reserved crushed pepitas over the top and serve.

...

MAKES GOOD LEFTOVERS: Yes.

MAKE AHEAD: Yes; make the pepita sauce ahead, refrigerate, and bring to room temperature before serving. Roast the broccolini and assemble the dish right before serving.

SEASON: Winter.

...

A SALAD, A THING, AND SOMETHING ELSE

Pizza Parlor Tomato Salad

Time: 5 to 10 minutes
Yield: Serves 4 to 6

All the salty, savory toppings from your classic pizza pie, crisped up with olive oil and tossed over beefy summer tomatoes. What more could you want from a salad experience?

1¼ pounds (570 g) heirloom tomatoes, sliced into ½-inch-thick (12 mm) rounds
Flaky sea salt
Aged balsamic vinegar, for drizzling
1 organic lemon, scrubbed clean
7 tablespoons (105 ml) extra-virgin olive oil
1 tablespoon brined capers, squeezed dry
½ cup (85 g) pitted Kalamata olives, squeezed dry and minced
3 cloves garlic, finely sliced
4 pepperoncini, stemmed and seeded, thinly sliced
A few fresh basil leaves, torn, for garnish
Cracked black pepper

1. Arrange the tomatoes fanned out in an even layer on a platter. Season generously with pinches of flaky sea salt, drizzle with balsamic vinegar, and set aside.

2. Using a Y-shaped vegetable peeler, remove three broad strips of lemon peel. Mince and set aside.

If using the stovetop
3. Add the olive oil to an 8-inch (20 cm) saucepan over medium heat. When the oil is hot but not smoking, add the capers and cook for about 2 minutes, stirring occasionally with a wooden spoon until they are splitting and the edges are just browning (they'll look a bit like mini popcorn kernels). Add the olives and minced lemon zest, stir to coat, and spread across the surface of the pan in an even layer. Cook undisturbed until the olives smell toasty and are beginning to dry out (about 1 to 2 minutes). Add the sliced garlic and stir for about 30 seconds until the edges begin to brown. Add the pepperoncini and stir constantly for about 10 seconds. Pour the mixture along with the oil directly over the tomatoes.

If using the microwave
4. Combine the capers, lemon peel, olives, garlic, and pepperoncini in a small ramekin. Cover with the olive oil and microwave for 1 to 2 minutes, until the oil is sizzling and the bits are crispy. Pour the whole thing over the tomatoes.

To serve
5. Scatter the tomatoes with torn basil and season with freshly cracked black pepper to taste.

MAKES GOOD LEFTOVERS: No.

MAKE AHEAD: No.

SEASON: Summer.

A SALAD, A THING, AND SOMETHING ELSE

(It's Really Not) Chinese Chicken Salad

Time: 15 minutes
Yield: Serves 3 to 4 as a main dish

There's nothing Chinese about the Chinese chicken salad that many of us grew up eating in the chain restaurants of America. It's a relic of nineties fusion cuisine. I hate to admit it, but I still find myself nostalgic for that sensory ball pit of textures and flavors. It hits nearly every zone of my taste bud topography—sweet, sour, and salty.

Here, voluminous vermicelli or Maifun noodles take the place of canned, fried wontons (OK, fine, I did learn that trick from the Cheesecake Factory), and I like to shred a rotisserie chicken, although you can use any leftover roasted or poached chicken you have.

For the dressing:

⅓ **cup (80 ml)** fresh lime juice
2½ **teaspoons** coconut sugar
1½ **teaspoons** fish sauce
¼ **cup (60 ml)** seasoned rice wine vinegar
1 serrano chile, minced
½ **teaspoon** orange zest
1 **teaspoon** toasted sesame oil
1 small clove garlic, smashed

For the salad:

2½ **cups** pulled rotisserie or roasted chicken (from about 1 small chicken), both white and dark meat
Kosher salt
⅓ **cup (35 g)** sliced almonds
⅔ **cup (160 ml)** peanut oil
2 **cups (55 g)** bean thread rice noodles, such as vermicelli or Maifun
5 **cups (350 g)** thinly sliced Napa or Savoy cabbage
4 green onions, ends trimmed, thinly sliced on a diagonal
3 Mandarin oranges, peeled, sliced into ¼-inch rounds, and quartered
⅓ **cup (10 g)** torn fresh cilantro leaves
⅓ **cup (35 g)** slivered almonds, toasted (see page 293)
3½ **teaspoons** raw sesame seeds, toasted (see page 293)

MAKES GOOD LEFTOVERS: No.

MAKE AHEAD: Yes; make the dressing ahead, but assemble the salad just before serving.

SEASON: Year-round.

A SALAD, A THING, AND SOMETHING ELSE

Make the dressing

1. Combine all the dressing ingredients in a small bowl. Let the garlic infuse into the dressing as you prepare the rest of the ingredients.

Make the salad

2. Toss the pulled chicken with 3 tablespoons of dressing, season with a pinch of salt, and set aside.

3. Preheat the oven to 350°F (175°C). Spread the sliced almonds on a baking sheet and toast for 3 to 5 minutes, until light golden brown. Remove from the oven and allow to cool.

4. Spread out two layers of newspaper on the counter next to the stovetop. Heat the peanut oil in a medium frying pan until hot. (Test this by adding a drop of water to the pan. It should crackle and pop.) Break the noodles so that you have wide, flat tangles and add them to the pan, spreading them out and turning with tongs so they make contact with the oil and puff up. Remove them from the pan with a fry skimmer as soon as they change shape (they will brown and burn quickly thereafter).

5. Remove the garlic clove from the dressing and discard. Toss the cabbage, chicken, and green onions with the dressing and a generous pinch of salt. Top with the sliced oranges, scatter with the cilantro, almonds, and sesame seeds, and finish with the crispy noodles.

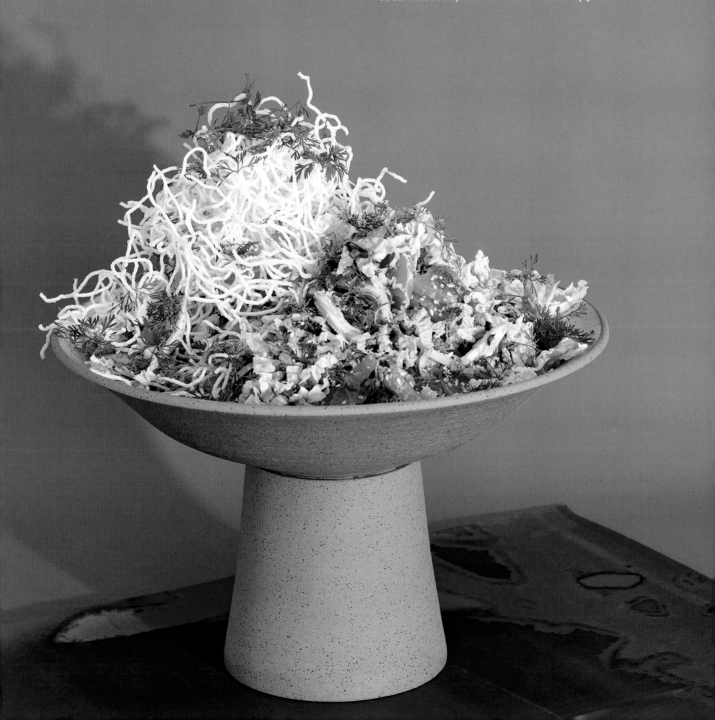

Orange-Marinated Beets and Their Greens

Time: 1½ hours
Yield: Serves 2 as a side

This is a foolproof method for beets that you can make ahead, marinate while still warm, and store in the fridge. They only get better with time, sitting in a pool of sweet and tangy marinade. Serve with warm goat cheese, add to salads, or just serve them on their own as an elegant side.

3 medium beets, peeled and quartered, their greens reserved, stems trimmed
1 clove garlic, skin on, smashed with the side of a knife
1 tablespoon extra-virgin olive oil, plus more to finish
½ teaspoon fine sea salt
2 tablespoons finely minced shallot
1 tablespoon plus 1 teaspoon sherry vinegar
¼ teaspoon sugar
½ small orange, sliced in half crosswise
Flaky sea salt, for finishing

1. Preheat the oven to 375°F (190°C).

2. Place the beets and the garlic in an 8-inch (20 cm) square baking dish. Toss with the olive oil and season with ¼ teaspoon of the fine sea salt. Add the orange half, cut side up. Add 2 tablespoons of water to the bottom of the dish, cover with aluminum foil, and bake for 50 minutes to 1 hour 10 minutes until they are tender when pierced with a paring knife.

3. While the beets cook, put the minced shallot, sherry vinegar, the remaining ¼ teaspoon fine sea salt, and the sugar in a medium bowl. Set aside to pickle. Slice the beet greens into 1-inch-wide (2.5 cm) ribbons.

4. Working quickly, remove the beets from the oven (reserve the foil). Squeeze the garlic clove into the bowl with the pickled shallots and smash with the back of a fork. Using tongs, squeeze the orange in a citrus press and add the orange juice to the shallots along with any pan juices from the roasting dish. Add the cooked beets and the raw greens and toss to coat. Cover with the reserved foil and set aside to marinate at room temperature for 10 minutes. When ready to serve, transfer to a small serving plate, drizzle with high-quality olive oil, and season with an extra pinch of flaky sea salt. Serve right away or store in a sealed container in the refrigerator for up to 5 days.

MAKES GOOD LEFTOVERS: Yes.

MAKE AHEAD: Yes; store the beets in their juices in the fridge. Bring to room temperature before serving.

SEASON: Year-round.

A SALAD, A THING, AND SOMETHING ELSE

Spicy Cucumber-Melon Salad with Toasted Coconut, Cashews, and Herbs

Time: 20 minutes
Yield: Serves 3 to 4 as a side

The beauty of this salad is that it can work wonders with a sub-par melon—you know, the one you waited so patiently to open only to find it was utterly lacking in character. Tossed with one of my favorite dressings of all time, Vietnamese *nuoc cham*, that mediocre melon is something new altogether. (Of course, with an excellent farmer's market melon, this salad is extra.) This rare example of a delicious oil-free dressing is one that you can pour on liberally, since you can't weigh the cukes and melon down. I encourage you to seek out herbs at your Southeast Asian grocer. Rau ram (also known as Vietnamese coriander), is the flavor I most associate with traveling and eating in Vietnam, and it is one of my most treasured herbs to grow in my garden.

Note: This salad works well if you only have melon or cucumber, as well as if you have both.

⅓ cup (40 g) raw cashews

¼ cup (20 g) unsweetened shredded coconut

2 pounds (910 g) room-temperature ripe green melon (honeydew, Galia, Canary, or casaba), cut into ½-inch-thick (12 mm) slices

1½ pounds (680 g) cold Persian or Armenian cucumbers (2 medium Armenian or 4 Persian), cut into 1-inch-thick (2.5 cm) chunks

Less than ¼ small red onion, sliced paper-thin

Juice of 2 limes

Flaky sea salt

¾ cup (25 g) mixed, torn, fresh herbs (any combo of basil, Thai basil, mint, and/or rau ram)

For the nuoc cham:

1 tablespoon coconut sugar, jaggery, or piloncillo

¼ cup (60 ml) unseasoned rice wine vinegar

1 teaspoon fish sauce

2 cloves garlic, gently crushed with the side of a knife, skins removed

½ serrano pepper, thinly sliced on a diagonal

MAKES GOOD LEFTOVERS: No.

MAKE AHEAD: Yes; prep the dressing and toasted toppings ahead.

SEASON: Summer.

1. Preheat the oven to 325°F (165°C).

2. Spread the cashews and the coconut out on a sheet pan. Toast for 15 minutes until golden brown. Remove from the oven and set aside to cool.

Make the nuoc cham

3. Combine the coconut sugar and the rice wine vinegar in a small saucepan over medium heat, swirling constantly until the sugar dissolves. Remove from the heat.

Stir in the fish sauce, garlic, and sliced serrano pepper and set aside to cool.

4. Combine the melon, the cucumber, and the red onion in a large shallow serving bowl. Add the lime juice to the dressing, stir, and remove and discard the garlic cloves. Pour the mixture over the top. Season with a generous pinch of flaky sea salt. Top with the toasted coconut and the torn herbs. Crush the cashews in your hands, scatter over the top, and serve.

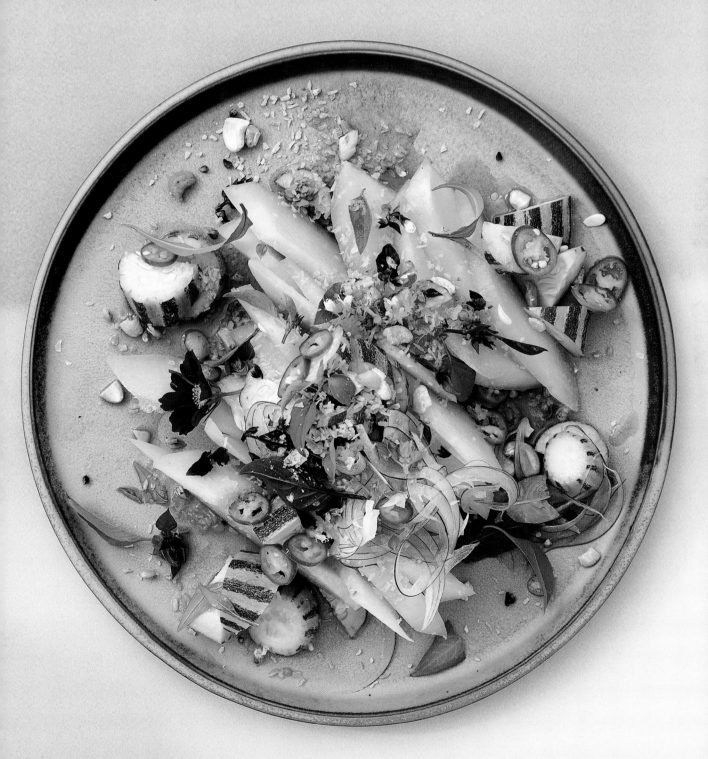

Parmesan-Braised Fennel and Shallot

Time: 30 minutes
Yield: Serves 4 to 6

The anise zip of raw fennel is tempered in a gentle bath of umami-rich Parmesan Broth, making this a favorite of even the most outspoken fennel skeptics. You can also braise the fennel in chicken broth if you aren't up for the Parmesan broth-making endeavor.

2 medium/large fennel bulbs, tops trimmed, root ends intact, tender fronds reserved

1 **tablespoon** unsalted butter

3 **tablespoons** extra-virgin olive oil

8 small shallots, peeled, tops and root ends trimmed

½ **teaspoon** kosher salt

Generous pinch dried sage

⅛ **teaspoon** red pepper flakes

1 **cup (240 ml)** Parmesan Broth (page 158)

½ lemon

1. Quarter the fennel bulbs lengthwise into 8 roughly equal-sized wedges. Place the butter and 2 tablespoons of the olive oil in a large skillet with a lid over medium-high heat. When the butter is melted, add the fennel wedges in a single layer, cut side down. Sear until golden brown, about 5 minutes. Flip and cook on the opposite cut side for 3 to 5 minutes. (If all of your fennel doesn't fit in the pan, cook in two batches. Do not overcrowd the pan.) Transfer the cooked fennel to a plate.

2. Add the remaining 1 tablespoon olive oil to the skillet and cook the shallots on one side for 2 minutes. Flip and cook for an additional 2 to 3 minutes until they have a nice sear. Lower the heat if the oil starts to smoke.

3. Return the fennel to the pan, season with the salt, dried sage, and red pepper flakes. Add ½ cup (120 ml) of the Parmesan Broth, cover, and reduce the heat to medium. Cook for 10 minutes.

4. Remove the vegetables to a plate. Add the remaining ½ cup (120 ml) of Parmesan broth to deglaze the pan, raising the heat to bring it to a boil, scraping the bottom of the pan to remove any bits stuck to the surface. Simmer on low heat for 2 minutes to reduce. Add the juice of the half lemon and stir. Pour the pan sauce over the fennel. Roughly chop the reserved fennel fronds and scatter them over the dish. Serve warm.

MAKES GOOD LEFTOVERS: Yes.

MAKE AHEAD: Yes.

SEASON: Year-round.

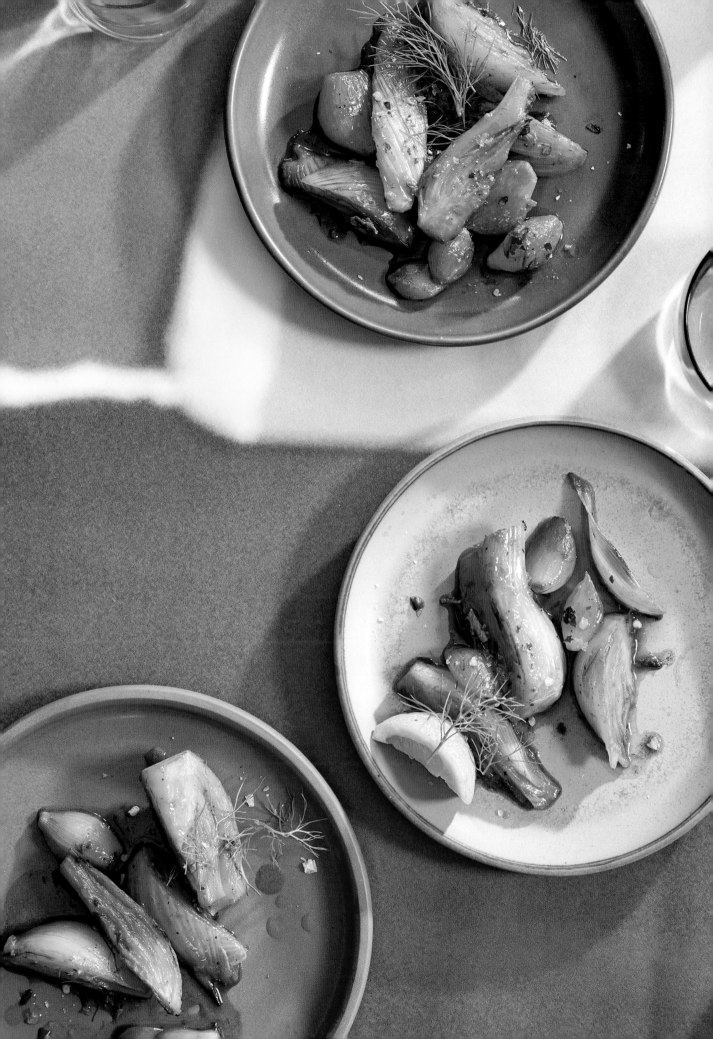

Savory Quince Poached in Pink Peppercorn Verjus Syrup

¼ cup (55 g) dark brown sugar

1½ cups (360 ml) verjus (see Note)

1 teaspoon pink peppercorns

2 bay leaves

1 lemon, scrubbed

2 medium quince, peeled and cored, sliced into 1-inch (2.5 cm) crescents

Time: 2 hours

Yield: 2 poached quince, 4 to 6 servings

Quince is one of those fleetingly seasonal fruits that inspires me to cook it every which way. I was once intimidated by its fuzziness, its gnarly profile, and its refusal to be consumed raw, but ever since I broke the ice I have been transfixed by its potential.

When cooked, the pale flesh blushes, turning warm and rosy, and its hidden flavor is unleashed. The aroma blooms like a tart baked apple, but infinitely more enchanting. (My mouth is watering just writing about it.) This savory quince preparation can be served warm alongside meat. (A slow roasted pork or lamb would cozy up to it real nice.) Or, use it as I do in the Savory Quince and Chicory Salad (page 254) as the sweet and tart complement to bitter greens and creamy goat cheese.

Note: If you don't have verjus, you can make this with a dry white wine and add the juice of the entire lemon (instead of the juice of one half) to the cooking liquid. When buying quince, look for those with a chartreuse color, not green.

1. Preheat the oven to 325°F (163°C).

2. Trace the circumference of a 10- to 12-inch (25 to 30.5 cm) cast-iron pan on a piece of parchment paper. Fold in half and cut a hole the size of a quarter in the center.

3. Add the brown sugar, 1 cup (240 ml) of water, verjus, peppercorns, and bay leaves to the cast-iron skillet. Squeeze the juice from half of the lemon into the liquid and toss the lemon half into the pan. Stir to combine and bring the solution to a boil.

4. Arrange the quince in a spiral pattern around the edge of the pan, moving inward until you fill the pan. They should be halfway submerged in the liquid. Cover with the parchment circle.

5. Bake for 1 hour 15 minutes. Remove the paper, flip the slices, and continue to bake for an additional 20 minutes or until the quince is fork tender. Remove the quince to a plate with a slotted spoon and discard the half a lemon. Set the pan over a medium-low heat and reduce the syrup for 10 to 15 minutes, or until the liquid is viscous but spoonable, like maple syrup. Reserve ¼ cup (60 ml) of the syrup for the salad dressing in the Savory Quince and Chicory Salad on page 254 if making, and pour the remaining syrup over the quince.

MAKES GOOD LEFTOVERS: Yes; store the cooked quince in its syrup for up to 5 days.

MAKE AHEAD: Yes; prepare the quince and the salad dressing ahead. Gently warm the quince with its syrup and bring the dressing to temperature and assemble just before serving.

SEASON: Fall.

Savory Quince and Chicory Salad

Time: 10 minutes
Yield: Serves 6 as an appetizer or side

For the dressing:

¼ **cup (60 ml)** warm quince syrup (see previous spread)

1 ½ **teaspoons** Dijon mustard

1 **tablespoon plus 1 teaspoon** sherry vinegar

½ **cup (120 ml)** extra-virgin olive oil

For the salad:

2 medium heads chicory lettuce, cored, torn into large pieces

Flaky sea salt

Cracked black pepper

1 recipe warm poached quince (see page 252)

One 8-ounce (225 g) log chèvre

¾ **cup (70 g)** walnut pieces, toasted (see page 293)

===

Make the dressing

1. In a large serving bowl, mix together the warm quince syrup, Dijon, and sherry vinegar. Stream in the olive oil and whisk to emulsify.

Make the salad

2. Toss the chicory with the dressing, a pinch of flaky sea salt, and cracked black pepper to taste. Top with warm quince, chèvre, and toasted walnuts and serve.

..

MAKES GOOD LEFTOVERS: No.

MAKE AHEAD: Prepare the quince and the salad dressing ahead, bring to room temperature, and assemble just before serving.

SEASON: Fall.

..

A SALAD, A THING, AND SOMETHING ELSE

THE TABLESCAPE, SKEWERED

Sophia Moreno-Bunge

"My family life has always revolved around food," says the celebrated Los Angeles florist Sophia Moreno-Bunge, who hails from a family of restaurateurs that has been feeding Los Angeles Argentinian-inspired cuisine since the 1990s.

A SALAD, A THING, AND SOMETHING ELSE

Sophia is known for her signature mix of traditional flowers with the less predictable, seasonal material she gathers on the streets and hillsides of Los Angeles—grasses, husks, and dripping palm dates like weeping strands of pearls. Sophia tells me, "In the fall, I collect milky oats in the Malibu hillsides, when they are dry and golden. In the spring, there are giant explosions of invasive, bright-yellow mustard flowers, and in the summer, I use lots of wild fennel (also invasive and extremely abundant)." Her aesthetic lends itself to so many different worlds and clients, from luxury interior designer Kelly Wearstler to fashion brands like Rachel Comey and Eckhaus Latta; she creates arrangements and installations for hotels, stores, and restaurants, and styles photoshoots, events, and weddings. So, in trying to imagine a resourceful, affordable yet chic take on the tablescape, Sophia was my girl.

Given that it was late fall, Sophia's mind went first to the hearty, oft-overlooked flowers of the season—carnations, marigolds, and mums. These hearty flowers can even stand to sit without water for a night. When arranged in an unexpected way, they go from Trader Joe's to fanciful and sharp. I watched Sophia forgo the standard vase and fill a shallow pasta bowl with water. She trimmed the stems to a mere ½- to 1-inch (12 mm to 2.5 cm) length. She nestled them in the bowl like a primi piatti from heaven, the larger stemmed flowers subtly propped up by an understory of floating blossoms below (she recommends any variety with a broad face for this approach). For some variation in height, she grabbed a 6-inch (15 cm) salad plate and clustered another 5 or 6 blossoms together, letting them spill off the edge and onto our "tablecloth," a standard moving blanket over a piece of plywood resting on sawhorses.

Now to the vegetables. Sophia and I made a trip to my local farmers' market, where we shopped not for a meal, but with an eye for color, form, and texture. Our flowers were rich yellows, muted pinks, and oranges. We echoed those hues with the powdery film on the skins of fresh plums, delicate grapes, and the nearly translucent white bitter melons. For contrast, we grabbed green zebra-skinned eggplant that reminded me of Christmas ornaments, and long, curvy Japanese eggplant with waxy royal-purple skins. We both gravitated toward an Opo squash, so resolved in its totemic form it read like an edible Brancusi sculpture. We found ladylike apples so subtle in color they seemed to glow from the inside, and Indonesian "water apples" that tasted, well, like nothing more than water, but did wonders for our composition. The only tool we would need to bring it all together was a handful of shish kabob skewers.

With the flowers arranged on the table, Sophia teetered the produce on top of one another, pinning them together by piercing the wooden skewers through their centers. "Aim for hills and valleys in your composition. Lean into asymmetry, too," she advised. We tossed the extra fruit in a basket, and just like that, our table was set. Now all we had to figure out was what to make for dinner.

BE MY GUEST, BUT NEVER SHOW UP EMPTY-HANDED

Pardon the Emily Post in me, but you should never show up to a party empty-handed. If your hostess insists that they have everything covered, ignore them completely and lean into the spirit of the gesture. This is your moment to shine.

Beyond the rote bottle of vino, I keep a bomb shelter of a pantry stocked with homemade treats and bubbling experiments, ready to toss into a jar and bring as an offering to a fellow host. Whether it's seasoned Lovage or Chinese Celery Salt (page 278), Fermented Chiles and Kombu Seaweed (page 268), or Boozy Cherries (page 280), nothing can compare with the impact of handing someone something you made yourself.

JORDAN CASTEEL Always Brings the Cake

Standing in Jordan Casteel's kitchen on a Sunday morning, I watch her confidently arrange globs of pigmented buttercream frosting on a cutting board like paints on a palette, a fitting approach for one of the most celebrated American portraitists du jour. Her paintings render the passing city tableau iconic—a child's head resting heavily in a parent's lap while riding the subway, a shopkeeper posing in front of signage for ice cold beer, a man wearing sunglasses while walking his dogs at night. If you have ever taken a stroll above 125th Street, then you will have the uncanny sensation of having seen these people before, each of them made so familiar yet larger than life as only a great painter can do. In Jordan's hands, portraiture is the ultimate compliment. It's her way of saying, "I see you."

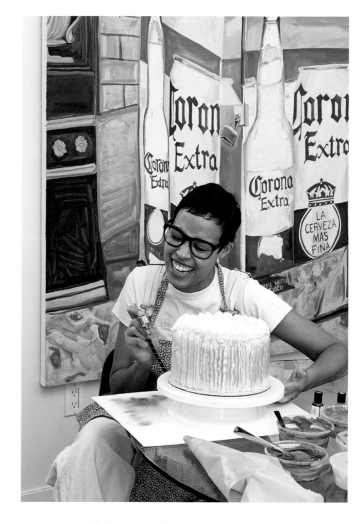

Painter Jordan Casteel airbrushes a cake in her Harlem, NYC, apartment, seated in front of one of her own works.

 I stand alongside Jordan in her Harlem kitchen and watch in awe as she applies her painterly skills to her second favorite canvas: cake. Like her paintings, every cake that she bakes is its own intimate gesture. Having assumed the role of designated baker among her cohorts, she takes the concept of never showing up empty-handed to

new heights, tailoring each creation and never making the same thing twice. "I do have a closeted addiction to the reality show *Cupcake Wars*," Jordan tells me, but the baking is more than mindless distraction, it's therapy. "If I'm unsure in the studio, I go to the kitchen. It's a free space where I can create without the pressure I feel with painting." Thus, a friend's birthday is a welcome opportunity to take a break from the demands of the studio and apply her painterly chops to her confectionary pastime.

Back in the kitchen, Jordan and her partner, David Schulze, are eating bodega sandwiches and brainstorming the fate of the naked two-layer yellow cake that sits expectantly on the dining table. Jordan turns to me and asks, "Did you meet Jared, our doorman, on your way in? Let's make the cake for him!" It's a surprising dedication, but Jordan explains, "Jared is more than a doorman, he's an everyday superhero." Jared injects fantasy into the banalities of everyday life. He adorns his drab uniform with Superman accessories and on occasion he even shows up to work in a head-to-toe homemade costume. Jordan trolls Jared's Instagram account looking for the right reference photo. She finds a gem— Jared, suited-up in latex, posing with plastic figurines. Aaaand, she's off. She lays down dabs of frosting, defining the contours of his face with a steady hand, mixing

Casteel dedicates the cake to her doorman, Jared, using a photo from Instagram as inspiration.

subtle skin tones to summon her subject to life with buttercream. She adds the final touch, a radiant halo of blue and red around the face, and a delicate lenticular airbrushing of pigment on the outer walls of the cake.

Jared is on duty. Jordan rings down to the front desk and calls him up to her apartment. She leads him toward the cake, and he is thoroughly befuddled. Confronted with the beauty of his own image, he is brought to tears. "This is the nicest thing anyone has ever done for me," he says. He beams with pride, worthy of a masterpiece not long for this world.

The finished cake by artist Jordan Casteel.

BE MY GUEST, BUT NEVER SHOW UP EMPTY-HANDED

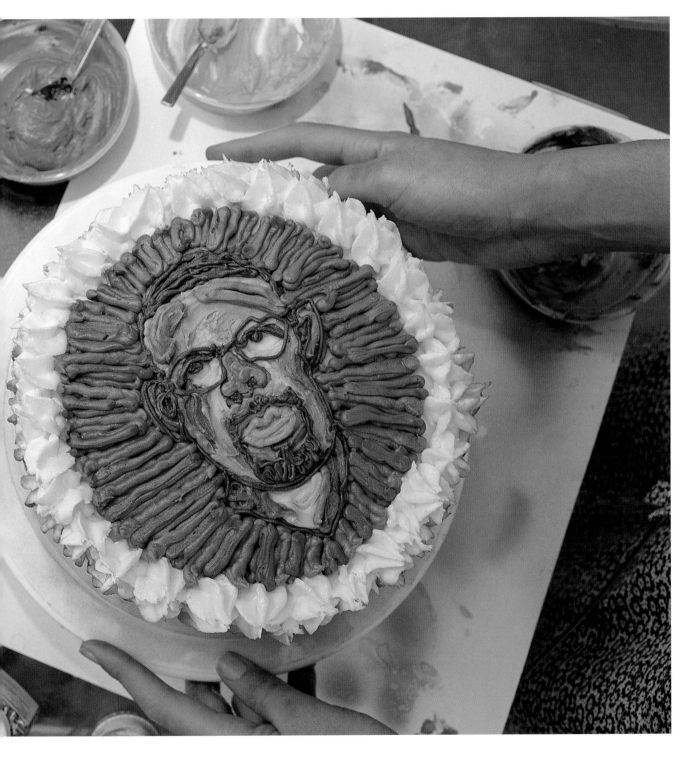

Smash Cake

Time: 1 hour 15 minutes (plus overnight for coconut cream to chill)
Yield: One 8-inch (20 cm) double layer cake

For my daughter's first birthday, I wanted to treat her to a classic cake (for the photo op), but I wasn't quite ready to give in to refined sugar and flour (the sweetest thing she had ever tasted was a blueberry). This cake is naturally sweet and somewhat nutritious, and includes homemade rolled oat flour.

Scant 3 cups (285 g) rolled oats
¾ cup (90 g) whole wheat pastry flour
¾ cup (85 g) almond flour
1 tablespoon baking powder
¾ teaspoon kosher salt
6 large eggs, at room temperature
2 small ripe bananas, mashed (1 cup/340 g)
¾ cup (180 ml) maple syrup
1 tablespoon vanilla extract
1½ cups (360 ml) coconut oil, melted and cooled
1 pint (12 ounces/340 g) organic strawberries, quartered and thinly sliced
Edible flowers, for decoration

For the Coconut–Yogurt Frosting:
2 cans (13½ ounces/405 ml) unsweetened coconut cream
1 fresh vanilla bean (substitute 1 teaspoon vanilla extract)
¼ cup + plus tablespoon (80 ml) plain full-fat Greek yogurt
2 teaspoons light maple syrup (optional)

1. Place the cans of coconut cream in the fridge the night before, or at least 5 hours before you plan to make the frosting.

2. Preheat the oven to 350°F (175°C). Trace the base of the cake tin onto two pieces of parchment paper. Cut out both circles. Oil the pans, then line the bases with the parchment circles and oil again.

3. Put the oats in a blender and blend to a nearly consistent powder. Combine with the flours, baking powder, and salt in a bowl. Whisk to combine and break up any clumps.

4. Put the eggs, banana, the maple syrup and the vanilla extract into a blender and blend until smooth. Add the coconut oil in a slow stream with the blender running on low until combined.

5. Add the wet ingredients to the dry ingredients one-quarter at a time, mixing to combine. Split the batter between the prepared cake pans and bake on the center rack for 25 to 30 minutes, until light golden brown on the surface and a paring knife stuck into the center comes out clean. Remove from the oven and allow to cool completely (20 minutes).

6. Open the chilled cans of coconut cream and scoop the solids into a bowl using a slotted spoon, leaving all of the viscous liquid behind. Using a paring knife, slice the vanilla bean in half lengthwise. Scrape the seeds

of the bean and add them to the bowl along with the Greek yogurt. Using a hand mixer on medium-high speed, whip until smooth and airy, about 3 minutes. Transfer to the fridge while the cake cools.

7. When the cakes have cooled completely and you are ready to serve, run a knife along the edge of the pans. Place a serving plate over the top of the first layer and flip it over. Remove the parchment. Spread half of the frosting over the top, leaving the sides bare. Create a single layer of strawberries on top, and place the second cake, upside down on top, removing the parchment before scooping the remaining frosting on top and pushing it out to the edges using an angled rubber spatula. Top with sliced strawberries and cover completely with edible flowers. Serve immediately.

MAKES GOOD LEFTOVERS: Yes, but the texture of the cake changes in the fridge. Best eaten fresh from the oven.

MAKE AHEAD: Make the frosting ahead and store in the fridge. Make the cake up to 4 hours before serving and hold at room temp. Frost and decorate just before serving.

SEASON: Year-round, summer for seasonal berries.

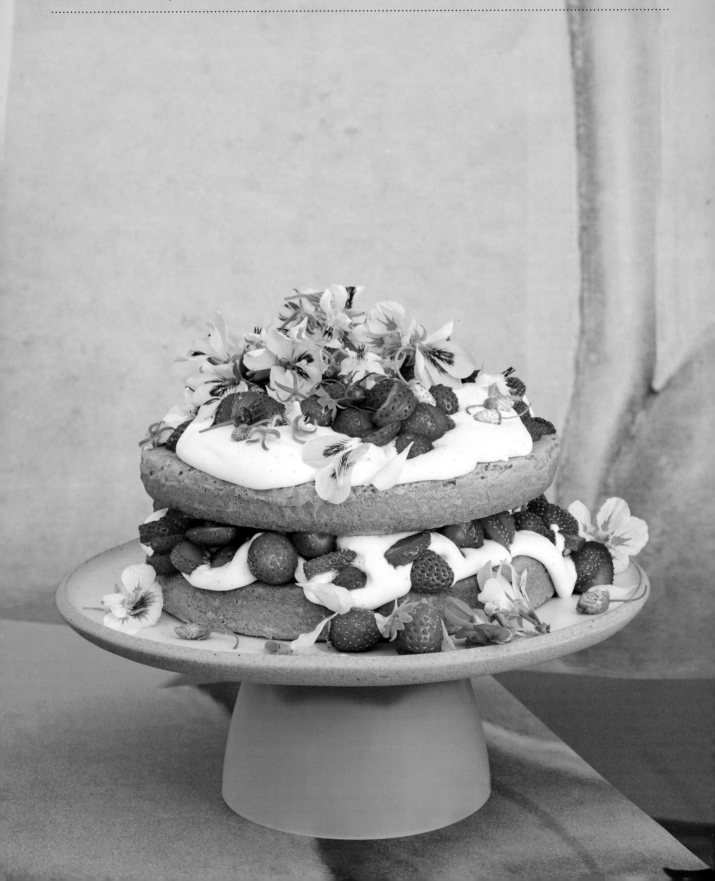

Fermented Chiles and Kombu Seaweed

Time: 30 minutes, plus time to ferment
Yield: 2 quarts (1.8 L)

At the end of the summer pepper season, the farmer's market (and the garden) should be teeming with all the varieties of chile. Fermenting them allows you to use them for months—and makes them infinitely more delicious. Keep them in your fridge, covered in their own brine, and give them to all your friends come winter, when fresh chiles are a distant memory, or use them to make a knock-out hot sauce (see page 270).

8 cups (2 L) filtered or spring water
2 tablespoons (35 g) kosher salt
3 pounds (1.4 kg) mix of hot and mild chile peppers (Jimmy Nardello, Habanada, or paprika, Fresno, cayenne, etc.)
4 cloves garlic, smashed
1 (5 by 7-inch / 13 by 18-cm) sheet kombu, cut in ¼-inch by 2-inch pieces with kitchen shears
Fermentation weight or a small ramekin
Plastic wrap
Plastic gloves
Clean kitchen towel and rubber band

1. Prepare a 2-quart (2 L) glass jar by washing it well with hot water and soap.

2. To create the brine, combine the salt and filtered water in a medium saucepan. Simmer and stir until the salt is dissolved. Remove from the heat and allow to cool.

3. Wearing gloves, slice and seed the peppers. Slice off the stem end of the larger chiles and discard. Using a paring knife, try to scrape out and discard the seeds and pith from inside the chiles, moving the knife around the cavity in a rotating motion. Slice the chiles into ¼ inch thick rounds and place them in the strainer basket of a salad spinner set inside the bowl filled with cold water. For medium/small-sized chiles, remove the stem end and slice them in half lengthwise. Using the paring knife, remove the seeds and the pith and discard (you might want to use your gloved fingers here). If you have any tiny chiles or ones with particularly pleasant shapes in the mix, you can leave them whole and toss them in the strainer basket. Rinse and agitate with your hand so any residual seeds fall to the

bottom. Repeat this a few times, changing out the water in between.

4. Layer the peppers in the glass jar with the smashed, whole garlic cloves and sliced kombu. When all the ingredients have been added, press them down using a blunt object or your fist. Pour the brine over the top, covering the peppers completely, leaving an inch of head-space at the top. Cover the surface with a piece of plastic wrap. Place your fermentation weight or ramekin on top of the bag to keep the peppers under the brine. Cover the top of the jar with a clean kitchen towel and secure it with a rubber band. Place in a temperate spot (70°F/20°C degrees is ideal), away from direct sunlight.

5. Check on the peppers every few days. Don't freak out if you see some milky film at the top, just skim and discard. If you see black or fuzzy green mold, you should throw the jar away. Taste it every few days after the first 5 days using a clean spoon, and when the funk level is to your liking, transfer the jar to the fridge (I like mine after about 10 days).

MAKES GOOD LEFTOVERS: Yes.

MAKE AHEAD: Yes; keep in the fridge for 6 months.

SEASON: Summer.

Fermented Chile Hot Sauce

Time: 10 minutes
Yield: 1 cup (240 ml)

If you're making a large batch of fermented chiles, consider blending them to make the hot sauce of your dreams. Lightly spicy with a vinegary funk, the complexity in this sauce will be the finishing touch for eggs, tacos, soups, and more.

1 cup (240 ml) Fermented Chiles and Kombu Seaweed (page 268)

3 tablespoons brine from the Fermented Chiles and Kombu Seaweed (see page 268)

6 tablespoons (90 ml) apple cider vinegar

3 tablespoons filtered water

1 tablespoon sugar

Remove any stems from the peppers and discard. Place all the ingredients in a high-speed blender and blend until well combined. Store in an airtight jar in the fridge.

MAKES GOOD LEFTOVERS: Yes; keep the hot sauce in the fridge for up to 6 months.

MAKE AHEAD: Yes.

SEASON: Summer.

Preserved Lemons

Time: 10 minutes, plus time to ferment
Yield: 18 lemon halves

It was a revelation for me to discover the role of the electric juicer in making preserved lemons, a condiment I always keep on hand, turning to the funky, floral lemon peels for everything from salad dressings (see Spicy Carrot Ribbons with Preserved Lemon Vinaigrette on page 238) to cheese plates, stews, and dips (see Roasted Beet and Goat Cheese Dip on page 45). When cooking with preserved lemon, we usually cut away and discard the interior of the fruit, interested solely in their softened peels. The juicer makes for tidy little lemons cups that are easier to work with later. If you don't have an electric juicer, use a hand juicer.

One 1-quart (960 ml) glass Ball jar, preferably with a narrow mouth
13 organic Meyer lemons, scrubbed clean and sliced in half crosswise
2½ teaspoons kosher salt
¾ teaspoon whole coriander seed
½ teaspoon dried rose petals (optional)
½ teaspoon whole pink peppercorns
1 bay leaf
1 star anise

1. Prepare the Ball jar by washing it with soap and hot water.

2. Using an electric juicer, juice the lemons.

3. Put 18 of the juiced lemon halves (discard the extra halves) in a large bowl and sprinkle the salt all over, coating them inside and out. Add three halves at a time to the jar, layering in all of the other spices. Push them down with your fingertips to squish them in there and compress. Pour the lemon juice through a fine-mesh sieve and into the jar to completely cover the lemons (they should be fully submerged).

4. Cover the jar with a clean kitchen towel and secure it using a rubber band. Let the lemons ferment in a temperate place (70°F/20°C degrees is ideal), away from direct sunlight for 1 month, checking on them periodically to make sure the lemons stay below the surface, and skimming any white film that might materialize on the surface. Once the peels are soft and easy to eat, you can store them in the refrigerator or keep them in your pantry, as long as the lemons remain below the juice. The brine can be reused to kickstart your next batch.

MAKES GOOD LEFTOVERS: Yes; store in a sealed container for up to a year (make sure the lemons are submerged in their brine).

MAKE AHEAD: Yes.

SEASON: Winter.

Mango Tajín

Time: 5 minutes
Yield: Makes ⅓ cup (30 g)

Tajín is a magical Mexican spice blend used to rim micheladas and to dust freshly cut fruit spritzed with lime. You will surely find yourself dipping your finger into the jar and eating it like a grown-up Pixy Stix. I do love the cheap, off-the-shelf packaged Tajín, but this version is more complex with freshly toasted chiles and freeze-dried mango. Citric acid amplifies the tartness, but it is by no means required—the mango brings the punch.

6 dried guajillo or pasilla chiles, seeded and stemmed
1 dried ancho chile, seeded and stemmed
1 teaspoon kosher salt
One ¾-ounce (20 g) packaged freeze-dried mango
½ teaspoon citric acid (optional)

Toast the chiles in a hot dry skillet for 1 minute until fragrant but not burned, moving them constantly in the pan. Remove from the heat to a blender and let them cool completely. Once cooled, start the blender on low and slowly increase the speed, pulverizing as finely as possible. Add the salt, the mango, and the citric acid, if using, and blend until the mango becomes a dust.

MAKES GOOD LEFTOVERS: Yes; store in an airtight container for a month. Mix before using.

MAKE AHEAD: Yes.

SEASON: Year-round.

Cacao Buckwheat Granola

Time: 2 hours
Yield: 2 quarts (2 L)

I once lamented the excessive amounts of sweeteners and oil most recipes rely on to achieve generous shards of granola goodness. Then I discovered how instead, hydrated flax and chia seeds can act as granola "glue." Add about 1 tablespoon of the powdered supplement of your choice if you're looking to optimize (I like moringa and cricket powder). Always use hulled buckwheat for this recipe (see headnote, page 76). Unhulled buckwheat is tough to the bite and slightly bitter.

¾ cup (130 g) hulled buckwheat groats

2 cups (180 g) rolled oats

¼ cup (40 g) flax meal

1 tablespoon chia seed

⅓ cup (50 g) golden raisins or goji berries

⅔ cup (95 g) pepita seeds, roughly chopped

1 teaspoon ground cinnamon

⅛ teaspoon ground cardamom

2 tablespoons sesame seeds

3 tablespoons raw cacao nibs

¾ teaspoon kosher salt

⅓ cup plus 1 tablespoon (95 ml) maple syrup or honey

¼ cup plus 1 tablespoon (75 ml) extra-virgin olive oil or coconut oil

Flaky sea salt

1. Preheat the oven to 300°F (150°C). Place the rack in the top third of the oven. Spread the buckwheat groats and the oats on a baking sheet in a single layer and bake for 15 minutes. Remove from the oven and lower the heat to 275°F (135°C).

3. Place the flax meal and chia seeds in a small bowl with ⅔ cup (120 ml) water. Stir to combine and set aside.

4. In a separate small bowl, pour hot water over the raisins/goji berries and set aside to hydrate.

5. Transfer the toasted buckwheat and oats to a bowl with the pepita seeds, cinnamon, cardamom, sesame seeds, cacao nibs, and salt. Mix to combine. Line the baking sheet with parchment paper.

6. Warm the olive oil or melt the coconut oil in a small saucepan over low heat (or add it to a medium non-reactive bowl and microwave until just warm or melted). Add the maple syrup/honey and the chia/flax mixture to the warm oil and stir to combine. Add the wet ingredients to the oat mixture, and stir to evenly coat the dry ingredients.

7. Gently squeeze excess water from the dried fruit and scatter it evenly across the baking sheet. Spread the oat mixture onto the baking sheet in an even layer on top, covering the dried fruit completely. Sprinkle the top with 2 pinches of flaky sea salt. Cook for 35 minutes, rotate the pan, and cook for an additional 40 minutes. Turn off the oven and leave the granola inside for 30 minutes to dry out.

8. Remove from the oven and allow to cool undisturbed on the baking sheet until room temperature. Break the granola into large pieces keeping clusters intact.

MAKES GOOD LEFTOVERS: Yes; store in an airtight container for up to 10 days. If you live in a humid climate, you can refresh the granola in the oven at 250°F (120°C) for 10 minutes if it gets stale.

MAKE AHEAD: Yes.

SEASON: Year-round.

Lovage or Chinese Celery Salt

1 cup (10 ounces/285 g) kosher salt
1¼ cups (1½ ounces/45 g) packed lovage or celery leaves

Yield: scant 2 cups (about 380 g)
Time: 5 minutes

In general, I like to season and spice my food independently. But the flavor in this fresh herb salt is so intense, I find infinite uses for it in my kitchen—think salt-baked fish, salt-rimmed Bloody Mary's, or Lemon Smashed Potatoes with a Pile of Herbs (page 68) with a finish of briny celery flavor.

Lovage packs the flavor of an entire head of celery into just one sprig. Look for it at your farmers' market, grow it yourself, or use more readily available Chinese celery leaves (the Asian market usually has Chinese celery, which has a great leaf-to-stalk ratio, since we are not interested in the fibrous part of the plant for this recipe).

Add the salt to a food processor with the lovage leaves and pulse for 15 seconds. Scrape the salt from the corners of the bowl. Continue to process until you have a uniform lime green color, about 30 seconds. Use the salt fresh or spread it in a thin layer on a baking sheet. Dry it in the sun or in the oven with the pilot light on for a few hours or overnight. The salt should be dry to the touch.

MAKES GOOD LEFTOVERS: Yes; store in an airtight container for up to 4 months. The color will start to fade, but the flavor will remain.

MAKE AHEAD: Yes.

SEASON: Year-round.

BE MY GUEST, BUT NEVER SHOW UP EMPTY-HANDED

Boozy Cherries

Time: 1 hour active time plus 2 weeks to rest
Yield: 1 quart (960 ml)

My husband and I wait all year for sour cherries to appear. It's a fleeting week before: *poof!* They are a distant memory and we are left cursing ourselves for not having bought the farmer out. The freshly picked luminescent sour cherry is a fair weather friend, but fortified with alcohol, spices, and sugar, the *boozy* cherry sticks around for the last call. We keep them in the fridge for nearly the whole year, adding them to mixed drinks, ice cream sundaes, and as a topping for pancakes (see page 76). These are my favorite hostess gift, especially for cocktail parties.

1½ pounds (680 g) sour cherries
1½ cups (330 g) light brown sugar
6 whole cloves
1 teaspoon grains of paradise or black peppercorns
1 cinnamon stick
2 whole star anise
1 large strip orange zest
1 cup (240 ml) vodka

1. Wash the cherries thoroughly, leaving attached stems intact and removing any loose stems from the bunch. Pack half of the cherries into a large glass Mason jar, being careful not to squish them.

2. In a saucepan, combine the sugar, 1½ cups (360 ml) water, cloves, peppercorns, cinnamon, star anise, and orange zest. Bring to a boil, then lower to a simmer and cook for 45 minutes until reduced by half. Remove from the heat and allow to cool for 15 minutes.

3. Add the vodka to the cooled syrup. Pour the mixture over the cherries to just cover (spices and zest included). Fill the jar with the remaining cherries and top off with the hot liquid. Allow to cool, then seal and refrigerate. The cherries will be ready to eat after 2 weeks.

MAKES GOOD LEFTOVERS: Yes; store in an airtight container in the fridge for up to 6 months.

MAKE AHEAD: Yes.

SEASON: Summer.

BE MY GUEST, BUT NEVER SHOW UP EMPTY-HANDED

Lactation Bars

Time: 1½ hours
Yield: 16 bars

Before my daughter was born, I was both terrified and excited by the challenge of breastfeeding. Lactation cookies were the final item on my preparatory to-do list, but the available recipes were crappy chocolate chip cookies with brewer's yeast (said to induce milk production). I developed this recipe, packed with nutrients and good fats. Ultimately, they didn't make me into an earth mama with award-winning mammary glands, but they kept me alive as a new mom. Now, I gift these bars to mom friends (with a box of formula), and dads love them too.

2½ cups (225 g) rolled oats
½ cup (100 g) millet
1 cup (85 g) shredded unsweetened coconut
½ cup (70 g) dried chopped, pitted prunes (or other dried fruit)
½ cup (70 g) dried unsweetened cherries (or other dried fruit)
⅓ cup plus 3 tablespoons (125 ml) warm water
2 tablespoons plus 2 teaspoons chia seeds
3 tablespoons ground flax meal
¼ cup plus 1 teaspoon (65 g) brewer's yeast
1 tablespoon moringa or spirulina powder
1 teaspoon fine sea salt
½ cup (120 ml) smooth, unsweetened peanut or almond butter
½ cup (120 ml) tahini
⅓ cup (80 ml) maple syrup
¼ cup (60 ml) light honey
⅓ cup (80 ml) ghee
2 large organic egg whites

1. Grease an 8-inch (20 cm) square baking pan and line it with parchment paper hanging just over the sides.

2. Preheat the oven to 300°F (150°C). Spread the oats and the millet on a baking sheet and toast for 30 minutes. Spread the coconut on an additional baking sheet and toast for 15 to 20 minutes, until golden brown. Reduce the heat to 275°F (135°C). Cover the prunes and dried cherries in some warm water and set aside to plump. In a small bowl combine ⅓ cup plus 3 tablespoons (125 ml) of warm water, the chia seeds, and the flax meal. Mix well and set aside to hydrate.

3. In a large bowl, mix together the toasted coconut, brewer's yeast, moringa, salt, and toasted oats and millet.

4. In a small saucepan, warm the nut butter, tahini, maple syrup, honey, and ghee over low heat, stirring until smooth. Drain the dried fruit, gently squeezing to remove excess water. Add the dried fruit to the warm wet ingredients along with the hydrated chia and flax paste. Stir to combine.

5. Add the wet ingredients to the dry ingredients and mix well.

6. Gently beat the egg whites with a fork until frothy. Fold into the batter until evenly distributed.

7. Transfer the batter to the prepared pan and pat evenly with a rubber spatula, pressing across the surface to compress. Bake for 1 hour to 1 hour 10 minutes, until firm to the touch and golden brown. Remove from the oven and allow to cool. Cut into 2-inch (5 cm) squares.

MAKES GOOD LEFTOVERS: Yes.

MAKE AHEAD: Yes, and freeze for later use, or store in an airtight container at room temperature for up to a week.

SEASON: Year-round.

Hand-Harvested Wild Fennel Pollen

Time: 1 to 2 weeks

I always keep a pair of kitchen scissors and pair of garden sheers in my glove compartment. I screech to the side of the road at the sight of fluffy wild fennel pollen in its starburst constellations. I take as much as I can get, tie it in a bundle with kitchen twine, and hang it upside down over a large kitchen bowl until the flowers dry. The delicate pollen drops from the stems, and even more comes loose with a little coaxing—rub the bud between your fingertips and tap the bundle into the bowl. A little bit goes a long way, so don't be disheartened if you don't get heaps from just one bunch.

Use the pollen to season croutons (see page 294), to finish soups like the Carrot-Fennel Seed Soup (page 148), and as a last sprinkling on a piece of fish or fresh melon.

MAKES GOOD LEFTOVERS: Yes; store in an airtight container for up to 6 months.

MAKE AHEAD: Yes.

SEASON: Summer.

BE MY GUEST, BUT NEVER SHOW UP EMPTY-HANDED

Sesame Chews

Time: 10 to 15 minutes
Yield: 24 to 28 pieces

A fast, do-it-yourself candy, these are rich but nutritious. Think of all the iron you'll get from that molasses! They're the homemade redux to the classic Bit-O-Honey, but so much better. If you have a reusable silicone baking liner, you can use that for one or both of your layers in lieu of parchment.

⅔ cup plus 2 teaspoons (106 g) raw sesame seeds, toasted (see page 293)

¼ cup (60 ml) light or amber honey

1 tablespoon blackstrap molasses

1 tablespoon plus 1½ teaspoons ghee

½ teaspoon vanilla extract

⅓ cup (80 ml) tahini

1. Spray two 12-inch-long (30.5 cm) pieces of parchment paper with cooking oil to lightly coat. Lay one of the pieces flat on the kitchen counter, sprayed side up.

2. Place the sesame seeds in a medium bowl.

3. In a heavy-bottomed saucepan, add the honey, molasses, and ghee and bring to a boil. Stir constantly for 1 minute, until the mixture thickens. Add the vanilla extract and tahini and remove from the heat. Stir vigorously until the mixture is smooth and pliable, about 30 seconds.

4. Add the tahini mixture to the bowl with the sesame seeds and stir quickly to combine. Spoon the mixture onto the prepared parchment. Cover with the second piece of parchment. Using the palms of your hands or a rolling pin, press or roll into a ½-inch-thick slab. Remove the top paper and allow to cool for 15 minutes.

5. When the candy has cooled, slice it into ½-inch-wide by 1½-inch-long (12 mm by 4 cm) bars. Individually wrap in wax paper rectangles twisted at the ends, or store with space between each candy and wax paper in between each layer to prevent sticking.

MAKES GOOD LEFTOVERS: Yes.

MAKE AHEAD: Yes; they will keep for a week on the counter, or for a month in the freezer.

SEASON: Year-round.

BE MY GUEST, BUT NEVER SHOW UP EMPTY-HANDED

All-Natural Spray Cleaner

Time: 3 minutes
Yield: One 16-ounce (480 ml) bottle

No! Spray cleaner is not for dinner! My friend Catalina Rojas once showed up to a raucous party at my house with a glass spray bottle hand-labeled *limpiador*, and it was the perfect gift for a hostess who was in the process of destroying her own home. With this simple recipe made from nontoxic household ingredients, you'll never need to buy surface cleaner again (think of all the single-use plastic you'll save). If you have delicate stone countertops, omit the vinegar, as it can be too abrasive for some surfaces. (This also makes a great yoga mat spray.)

One 16-ounce (480 ml) glass spray bottle
15 drops essential oil (peppermint or tea tree are nice)
½ teaspoon unscented castile soap
2 tablespoons rubbing alcohol
1 tablespoon white vinegar (optional)
Water

Using a funnel, add the essential oil, castile soap, rubbing alcohol and white vinegar to the glass bottle. Fill the rest of the way with water. Secure the spray top, shake, and use.

PANTRY

I love to shop. I am in it for the hunt, for the satisfaction in sourcing the most unusual ingredients and nailing it with the very best of the basics. My food is clean and straightforward. It's the kind of cooking where the quality of the materials is critical to the final result. I encourage you to experiment, to find your favorite tahini or olive oil based on what's available near you, but here I share some guidelines for how to shop for and prepare some of the elemental components that will reoccur as you cook your way through this book.

THINGS TO BUY

CHILE FLAKES

I have an impressive collection of dried whole and ground chiles in my spice cabinet. I collect them when I travel and I use them frequently. I encourage you to get to know the subtle differences between varietals: Urfa chile is chocolatey and rich, Silk chile is piquant, Aleppo fruity and mild. If I call for a specific chile in a recipe, feel free to substitute it with another variety that you have on-hand (red pepper flakes are always easy to find).

When purchasing spices, consider the politics of the spice trade and look toward companies with ethical sourcing and transparent practices. There are more and more of them popping up, and while the price tag is certainly a jump from the supermarket options, get into the habit of purchasing spices in small quantities and replenishing them often. Check out Burlap & Barrel and Daphnis and Chloe.

KOSHER SALT

Kosher salt does my heavy lifting: salting pasta water, soaking beans, dry brining chicken, baking, seasoning raw meat, seasoning sauces, et cetera.

FINE SEA SALT

I use fine sea salt when I want to sprinkle an even blanket on vegetables or when I want the salt to easily dissolve into liquid off of heat.

FLAKY SEA SALT

Flaky sea salt is the final flourish of most of my food, the last little flick of the wrist that brings it all together. I use Maldon or Jacobsen, but I never use it to season the bulk of a dish or to dissolve into a sauce or liquid. It's expensive, but it has its place.

FLAX MEAL

Rehydrated flax meal is a brilliant, flavorless binding agent to form sturdy granola, bars, or seed crackers. It is also a great source of dietary fiber (toss a teaspoon of dry meal into your smoothie in the morning). You can buy flax already ground or whole flaxseed and grind it in a spice grinder or blender (I prefer to work with whole flaxseed and grind periodically so it's fresh).

GHEE

Ghee is made by browning butter to enhance its flavor, and then removing the milk solids to produce a shelf stable fat that is lactose and casein-free. It has a high smoke point, and an amplified buttery taste, and it's one of the reasons Indian food is so damn good. The most flavorful and nutritious ghee is derived from cultured butter. It's pricey but worth it.

NEUTRAL OIL

Neutral oils include all flavorless oils with a high smoke point: grapeseed, avocado, peanut, safflower, sunflower, and untoasted sesame oil. I call for neutral oil when cooking at high temperatures, or when I need to use a large volume of oil for a cooking method but not for flavor. Look for oils that are labeled "expeller pressed" or "cold pressed."

OLIVE OIL

I keep two kinds of olive oil on hand at all times—one for the bulk cooking, roasting, and sautéing, and one for finishing and for use in raw dishes like salads or fish. The workhouse bulk oil should be of decent quality, extra-virgin if you can swing it (it has more of the phenols that make it extra healthy), and virgin if not (still a healthy fat). If you're on a budget, extend your cooking olive oil by purchasing an extra-virgin olive oil and cutting it with 1 part neutral oil (see above) to 2 parts olive oil.

When shopping for a high-quality finishing oil, look for something to linger on your palate once the bite is long gone. I love to experiment with different brands, to collect olive oil when traveling, and to buy it directly from real people who make it themselves. Find the fancy olive oil that speaks to you, whether it's young and spicy or more fruity and mellow. When splurging, always look at the bottling date printed on the label—it should have been pressed within the last one to two years.

COCONUT OIL

I like to use virgin, cold-pressed, unrefined coconut oil. Refined coconut oil is absent of the coconut flavor and I want that nutty, sweet taste. Both refined and virgin have a high smoke point and are suitable for pan-frying.

HIGH-QUALITY TAHINI

There is a world of difference between cheap tahini and the good stuff. Look for a brand that remains consistent, and doesn't separate into oil and solids, requiring lots of mixing before use. I love Seed + Mill.

DRY WHITE WINE

I cook with white wine a lot. I usually purchase the cheapest pinot grigio or sauvignon blanc I can find at the wine shop or liquor store (six dollars is usually an option). I do not use the "white cooking wine" sold in the grocery store—it has a skanky aftertaste that lingers in the finished dish, whereas a benign cheap white cooking wine underpins your cooking in a smooth, subtle way.

RED WINE VINEGAR

I keep mid-range-quality red wine vinegar in my pantry for pickling and a higher-end variety for salad dressings. (I am obsessed with Camino red wine vinegar made in Northern California.) I use the cheaper one more often. (I love me a pickle!)

SHERRY VINEGAR

Sherry is my favorite type of vinegar for adding acidity to soups and vinaigrettes. It's more complex than red wine vinegar, with a subtle oakiness and body that most red wine vinegars lack. Authentic sherry vinegar will be labeled from the Spanish city Jerez. Get the good stuff.

THINGS TO MAKE

BROTH

Broth is the foundation of my cooking. I use it whenever I can—when making soups, to simmer grains and steam rice, to deglaze a pan, or to braise vegetables. Homemade broth brings a world of depth that the packaged stuff lacks, and house-made store-bought broth from the butcher is prohibitively expensive to use with abandon.

My prescription: a weekly routine of broth-making with kitchen scraps. Keep a large storage bag in the freezer at all times and collect the discarded bits that pile up each day in the kitchen. When the bag is full-up, make a batch of broth and store it in the fridge, or freeze it in 1 cup (240 ml) portions for easy use later on.

This miserly method works for both vegetable and meat-based broths, and most often I do amend the scraps with a few basics to round it out. If you are looking to produce the exact same broth week after week, or if you like a perfectly translucent final product, this is not your recipe. This is a quick and dirty use-what-you-got and waste-nothing approach that is indeed rich and flavorful enough to sip on its own. (You can simmer with fresh ginger, lemongrass, and some garlic and drink this from a mug!)

Note: I keep my broth unsalted so I can control the salt levels from dish to dish when cooking. My recipes that call for broth assume you are doing the same. If using store-bought broth, always buy low-sodium or unsalted.

Here's what I hoard throughout the week:

Bones: Collect all the bones and cartilage from all chicken or meat dishes, including the picked-over chicken carcass, the neck that comes in the little baggy inside the chicken cavity (don't add the heart or liver), lamb shanks, or the T-bone from your steak. (I roast the raw neck with my chicken and set it aside for broth once its browned). Don't be afraid to collect the bones straight off your dinner guests' plates. (You're going to boil them, so germs aren't a factor.)

Eggshells and apple cider vinegar: The calcium in eggshells leaches into the bubbling broth when simmered with 1 tablespoon of apple cider vinegar, so save a couple shells from your weekly omelets for a (flavorless) mineral boost.

Allium: That's everything in the onion family—root ends and trimmed tips of any kind of onion, the wilted

greens on leeks and scallions, the nubs of garlic cloves, or sprouting bulbs. I remove the outermost skin of the onion, but it's OK if some gets in.

Aromatics: The stems of oregano, thyme, tarragon, and parsley or any herb that looks like it's on its last legs (but never moldy or rotten).

Carrots, parsnips, and celery: Rescue flaccid carrots or parsnips and their end-nubs and trimmed tips, the butt of the celery, and any wilted celery leaves.

Mushrooms: Mushroom stems add umami to the broth, even if they are super dry and woody.

Kombu: toss a sheet or two of dried kombu seaweed in, especially if you are making a vegetarian broth. It adds umami and salinity, and a deep flavor.

Place a few tablespoons of olive oil in a large stock pot on medium-high heat. When the oil is hot, add the basics—the onion, the garlic in its skin, bay leaves, and the peppercorns—and sauté for 5 minutes, until the onion begins to brown. Add the contents of your freezer bag and any additional basics and toss.

Fill the pot three-quarters of the way with full filtered water and bring to a boil. Reduce to a simmer, partially cover, and cook on low heat for at least 6 hours, or until the broth has reduced so the pot is two-thirds of the way full. The broth should taste flavorful. If it is weak, let it reduce uncovered for another hour or until it tastes good to you. Remove from the heat and let the broth cool to room temperature.

Drain the liquid through a fine-mesh sieve and into a large storage container with a tight-fitting lid. Press the solids with the back of a wooden spoon to extract all the liquid and discard the remains. Store in the fridge for up to 2 weeks, or in the freezer for longer. (Freezing in labeled 1 cup/240 ml portions is handy.)

PICKLED RED ONION

Time: 5 minutes, plus at least 4 hours
Yield: 1 pint

1 medium red onion
1½ teaspoons sugar
1 teaspoon fine sea salt
⅔ cup (160 ml) filtered water
⅓ cup (80 ml) red wine vinegar

Slice and remove the ends of the onion, then slice the onion in half lengthwise. Peel and reserve the skin (that's what will give these pickles that bright magenta color). Slice the onion crosswise as thinly as possible (use a mandoline if you have one).

Line the bottom of a 12-ounce (360 ml) Ball jar or similar lidded container with one large piece of red onion skin. In a small bowl, combine the sugar and the salt. Add a small layer of onions to the jar and sprinkle with a pinch of the sugar-salt mixture. Continue to layer the onions with the seasoning until the jar is full. Top with another red onion skin and cover with the water and vinegar. Secure the top tightly and shake. Open the jar and push the onions to submerge them in the liquid once more. Close the lid and refrigerate for at least 4 hours, or until the onions are magenta all the way through. Store in the fridge for up to 10 days.

PRESERVED LEMONS
(PAGE 272)

TOASTED NUTS AND SEEDS

A lot of my recipes call for toasted nuts or seeds, but I start with raw seeds and toast them for each use, which freshens them up and allows me to dial in their colors and flavors. Keep seeds in the freezer for long-term storage (their oils can easily turn rancid at room temperature).

Pumpkin seeds: To toast pepitas, preheat the oven to 350°F (175°C), and spread the seeds on a baking sheet in a single even layer. Toast on the center rack for 10 minutes until they are evenly golden brown. Cool to room temperature before using.

Sunflower seeds: Preheat the oven to 350°F (175°C). Spread the seeds in a single layer on a baking sheet, and toast in the oven on the center rack for 7 to 8 minutes until light golden brown. Cool to room temperature before using.

Sesame seeds: Toast the sesame seeds in a small frying pan, in as even a layer as possible, stirring occasionally. Toast for approximately 5 minutes, or until the seeds turn golden brown.

Pine nuts: Place a small frying pan over medium heat. When the pan is hot, add the pine nuts and toast for 1 to 2 minutes, stirring frequently to promote even browning.

Almonds, walnuts, and pistachio nuts: Preheat the oven to 350°F (175°C). Spread the nuts in a single layer on a baking sheet and toast in the oven on the center rack for 8 to 10 minutes, until brown. Cool to room temperature before using.

SPROUTED-ROASTED SNACKING ALMONDS

These are my go-to snack as-is, but chop them up and they also come in handy in the kitchen. The soaking and roasting makes them supremely crunchy all the way through, but it also makes them more nutritious, removing antinutrients that inhibit the body's absorption of minerals and vitamins.

2 teaspoons kosher salt
1 pound (455 g) raw almonds
Zest and juice of 1 lemon
Extra-virgin olive oil
Fine sea salt
Nutritional yeast (optional)

Dissolve the kosher salt in warm water in a large bowl. Add the raw almonds to the bowl and fill with water so the nuts are submerged by about 2 inches (5 cm). Cover the bowl with a clean kitchen towel and leave it on the countertop overnight. Drain and pat the nuts dry, then return them to the dry bowl. Toss with a glug of olive oil and season with a pinch of fine sea salt. Spread them in a single layer on a large baking sheet. Roast on the center rack of a preheated 350°F (175°C) oven for 40 minutes, tossing halfway through. Turn the oven off and leave the almonds inside (keep the door closed!) for 1 hour. If you have a food hydrator, spread the nuts in a single layer on the individual trays and dehydrate for 12 to 24 hours at 125°F (50°C). While the nuts are still warm, toss them with an additional glug of olive oil and a generous sprinkle of nutritional yeast (optional).

CROUTONS

Time: 15 minutes
Yield: 2 cups (115 g)

Two 1-inch-thick (2.5 cm) slices sourdough bread
1 clove garlic
⅛ teaspoon red pepper flakes
Pinch fine sea salt
3 tablespoons extra-virgin olive oil

Preheat the oven to 375°F (190°C) on convection setting, if available, and place the rack on the lower third of the oven. Cut the bread into ½-inch (12 mm) chunks. Microplane the garlic clove into a bowl, and add the red pepper flakes, a pinch of fine sea salt, and the olive oil. Toss the bread with the seasonings and spread on a baking sheet. Bake for 12 to 15 minutes, flipping halfway through, until golden brown. You can store these for up to 3 days in an airtight container.

BREAD CRUMBS

Time: 15 minutes
Yield: 2 cups (115 g)

Store-bought bread crumbs are acceptable when it comes to breading and frying, but use more rustic homemade bread crumbs to thicken soups (see Perennial Saffron Tomato Soup, page 142) or to give some texture to roasted veg and salads.

Two 1-inch-thick (2.5 cm) slices sourdough bread
1 clove garlic
⅛ teaspoon red pepper flakes
Pinch fine sea salt
3 tablespoons extra-virgin olive oil

Tear bread into ½-inch (12 mm) pieces and toast in the oven at 250°F (120°C) until dry, about 40 minutes to an hour, depending on how fresh your bread is. Pulse in the food processor to reach the texture of coarse sand and store in the freezer until ready to use. For use in breading and frying, use as-is. For finishing dishes, toss every ½ cup (55 g) of bread crumbs with 1 tablespoon of olive oil and a pinch of salt, and toast in the oven at 300°F (150°C) for 15 minutes. Use immediately or store in the freezer.

TOASTED SHREDDED OR FLAKED COCONUT

Preheat the oven to 325°F. Line a baking sheet with a baking mat or parchment paper. Spread the shredded or flaked coconut out evenly on the sheet and toast for 3 minutes before gently stirring and spreading out evenly once again. Continue to bake for 3 minutes, or until evenly golden brown. Remove from the oven and cool before using.

Recipe Index

BE MY GUEST, BUT NEVER SHOW UP EMPTY-HANDED

PANTRY

Ingredient Index

Artisan Credits

Acknowledgments

Thank you to everyone who gave me the space to move across the country and start a family while I pieced this book together over the course of three years. Thank you to Holly Dolce, my editor, who lets me do pretty much whatever I want—except use the words "Dirty Dishes" in the book's title. Thank you to Kitty Cowles, my agent, who rejected me as a client six years ago, but who embraced me with open arms once I had proven my chops with my first book. I love a woman with high standards, and for that, you never fail.

Thank you to all the friends who contributed their time to this project. Hannah Goldfield, for muscling through the foreword (twice), and for being the only person who can convince me to eat in a restaurant (tolerating my amateur food criticism with every bite). Thank you to artist Daniel Gordon who, with two kids and no childcare during lockdown, somehow found time to collaborate on the chapter openers, the cover art, and the backdrops for all of the food photography in this book. You are a brilliant artist, but more than that, you are a mensch.

Thank you to my heart, Emily Wren, who would drive up from Philly at the drop of a hat to help me shoot, and who is the only person I trust to take my portrait. Life is not the same when you are more than a car ride away. Thank you to Laurie Ellen, recipe tester extraordinaire, who spent countless hours cooking with me, eating orange cake, and encouraging my borderline perverse love of cabbage. Thank you to the most coveted book designer, Brian Roettinger, whose endorsement and enthusiasm for this project makes me look much better than I am.

Love and appreciation for my dedicated photoshoot crew, whose individual perfectionism rivals my own: Vivian Liu, Peter Baker, and Andrea Loeffler. Because of you, I can say that shooting this book was a highlight of my career.

Thank you to my husband, Adam, who really believes I can do anything, and who always does the dishes when "anything" leaves behind a big fat mess. I love you for being the person who never says no to a houseguest, to hosting a dinner party, or a project. Through you, I understand the true meaning of generosity. We are an unstoppable (and exhausting) team, and we throw a righteous party. Thank you to my parents, who have indulged my every creative impulse since I could speak, and who raised me to honor my curiosity. Infinite thanks to my in-laws, Nonny and Pita, who study my every written word, and who love me like one of their own.

Last but not least, so much gratitude to all the artists who invited me into their homes and studios, and who put thought and care into their contributions to this book. You inspire me to never be boring, and to remember: joie de vivre is a magically contagious condition.

Bios

Daniel Gordon is an artist living and working in Brooklyn, NY. Julia and Daniel collaborated to create the cover, the chapter openers, and the backdrops for the food photography in this book, working in Gordon's signature, layered, photocollage style. Daniel is not only one of Julia's favorite contemporary artists (his subject matter is ninety-nine percent plant-based, so that's no surprise), but he and his wife, artist Ruby Sky Stiler, are outstanding hosts in their own right. Daniel holds a BA from Bard College and an MFA from the Yale School of Art. He is represented by James Fuentes Gallery in New York, and has shown his work in venerable institutions such as the J. Paul Getty Museum in Los Angeles, the Museum of Modern Art in New York, and Foam Museum in Amsterdam. His work resides in the collections of the Museum of Modern Art and the Guggenheim in New York, Pier 24 in San Francisco, and on the walls of Julia's bedroom in Pasadena, CA.

Julia Sherman is an artist, author, photographer, and a passionate cook. She spent her early career as an exhibiting artist, having shown her work at institutions in New York such as the Museum of Modern Art, SculptureCenter, and the Jewish Museum. After completing her MFA at Columbia University, she found herself less interested in making art objects, consumed instead by the pursuit of making salad with her favorite artists. In 2012, Julia created *Salad for President*, an evolving publishing project that draws a meaningful connection between food, art, and everyday obsessions. This online platform serves as a springboard for events, collaborations and public programming. Her Instagram account is a resource for elevated yet accessible recipes, savvy kitchen tips and tricks, and inspiring ideas for how to shop, cook, and eat like a (vegetable possessed) artist. In Spring 2017, Sherman's cookbook, *Salad for President: A Cookbook Inspired by Artists*, was published by Abrams Books; it is a compendium of inventive vegetable recipes and Sherman's intimate meals with exceptional people. Julia, and her writing, have been featured in *Vogue*, the *New York Times*, *T* magazine, *Domino*, *Art in America*, *The Paris Review*, *Food & Wine*, and *Bon Appétit*, among others, and she is the creator of Jus Jus, the first ever, all natural, sparkling, low alcohol verjus.

Editor: Holly Dolce
Managing Editor: Glenn Ramirez
Design Manager: Danielle Youngsmith
Production Manager: Rachael Marks

Book design by Brian Roettinger, Perron-Roettinger

Library of Congress Control Number: 2021932418

ISBN: 978-1-4197-4785-4
eISBN: 978-1-64700-473-6

Printed and bound in China
10 9 8 7 6 5 4 3 2 1

Abrams books are available at special discounts when pur-
chased in quantity for premiums and promotions as well as
fundraising or educational use. Special editions can also be
created to specification. For details, contact specialsales@
abramsbooks.com or the address below.

Abrams® is a registered trademark of Harry N. Abrams, Inc.

ABRAMS The Art of Books
195 Broadway, New York, NY 10007
abramsbooks.com